TACOMA **ART** MUSEUM

PICASSO

A DIALOGUE WITH CERAMICS

CERAMICS FROM THE
MARINA PICASSO COLLECTION

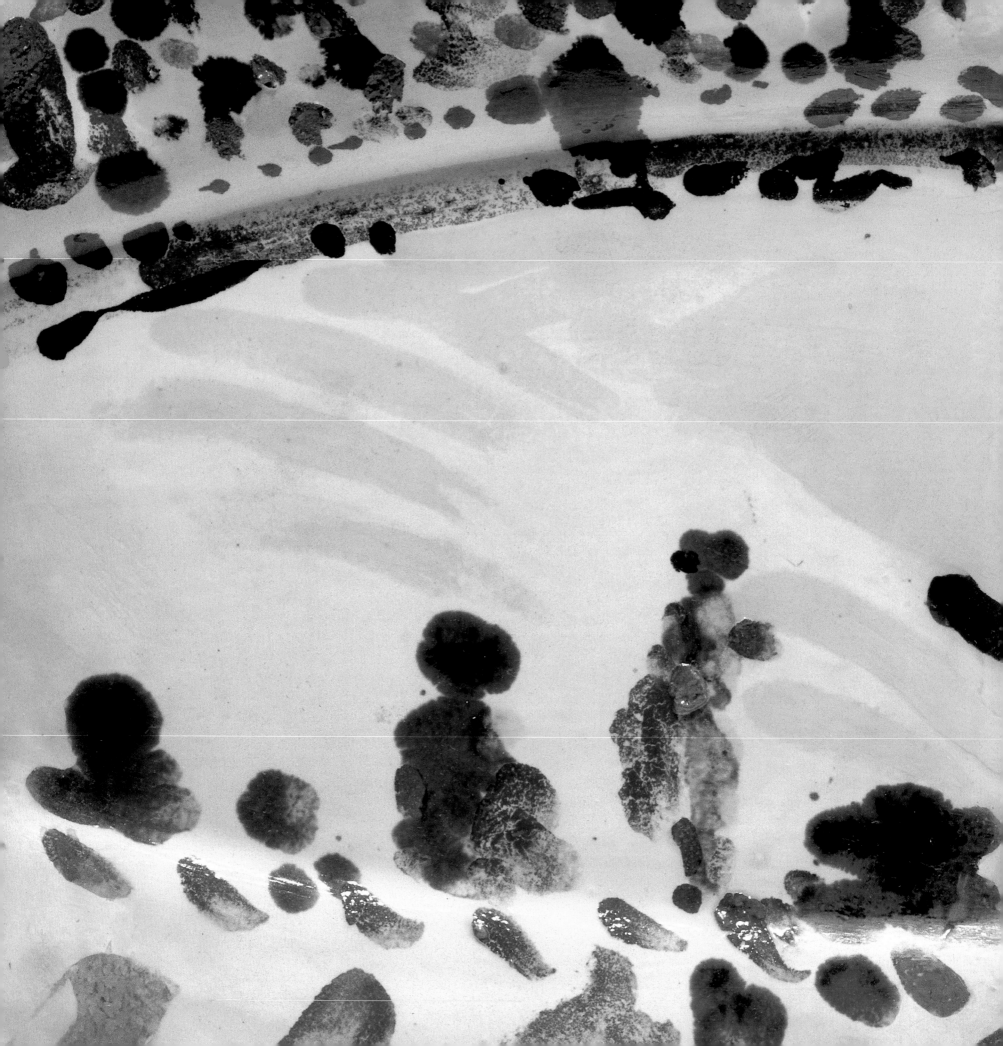

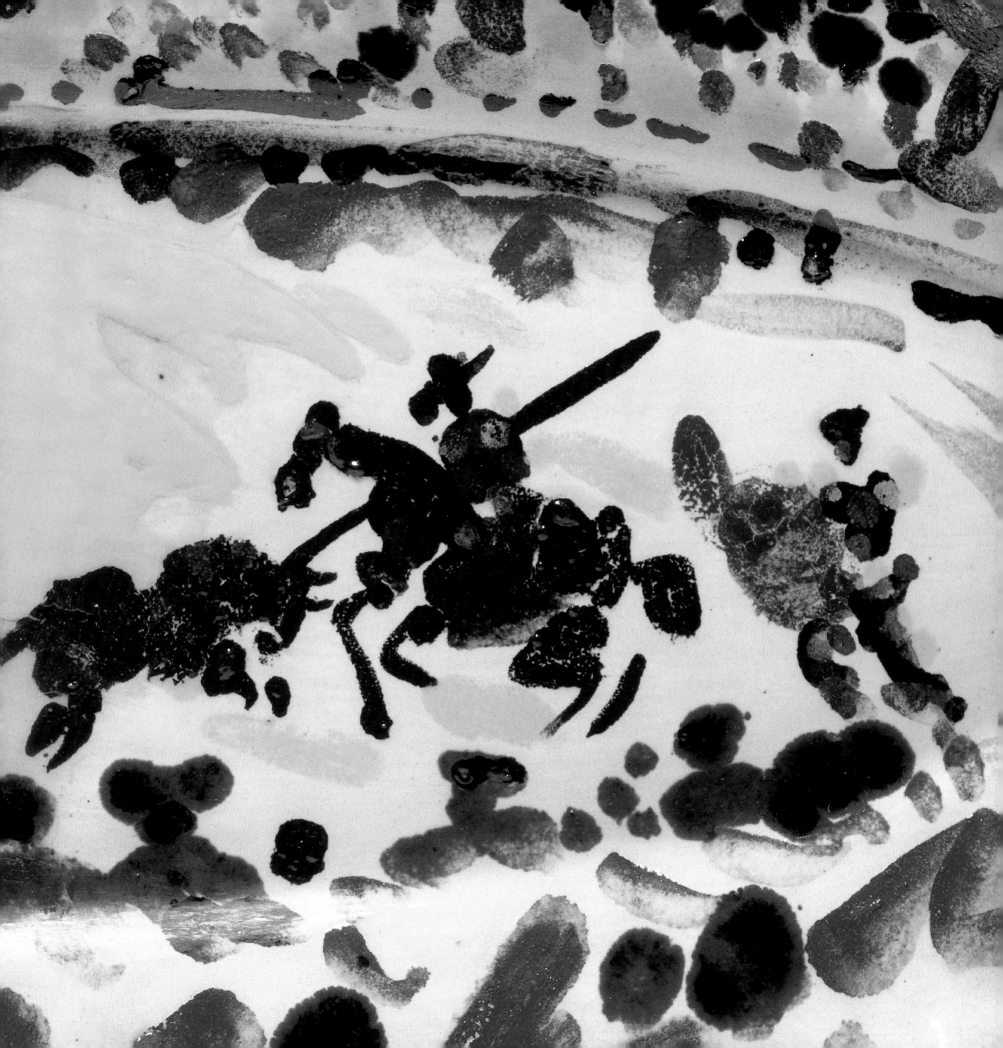

**Honorary President,
Fundación Bancaja**

S.A.R. la Infanta Doña Cristina,
Duquesa de Palma de Mallorca

**Exhibition Curator
and Catalogue Director**

Kosme de Barañano

Exhibition Designer

José Luis Íñiguez de Onzoño

Exhibition Fabrication

Taller Creativo

Transportation

Artistica Transporte Especial, S.L.

Insurance

Nordstern Assurances, Paris

Translations

Jennifer Beach
Josephine Watson

Photography

Patrick Goetelen
©Franz Hubmann pp. 214, 227,
courtesy of Galerie Klewan, Munich

Graphic Designer

Pepe Gimeno - Proyecto Gráfico

Printer

Gráficas Vernetta, S.A.

© texts: the authors,1998

Spanish-language Edition

© Fundación Bancaja, 1998

ISBN

84-89413-36-3

DL

V-3322-1998

This English edition of the catalogue
is produced in conjunction with the
exhibition *Picasso: Ceramics from the
Marina Picasso Collection* at the
Tacoma Art Museum, Tacoma,
Washington, U.S.A., September 27,
1998, to January 10, 1999.

Editorial review

Sigrid Asmus

Additional translations

Marisol Meléndez, Tacoma
Community House

Shipping

Harsch Transport

English-language Edition

© Tacoma Art Museum, 1998

Printed and bound in Spain.

All rights reserved.

Tacoma Art Museum
1123 Pacific Avenue, Tacoma WA
98402
(253) 272-4258

The art of ceramics, the use of fired clay to create everyday utensils and art objects, goes back to the dawn of time. Since then, the many civilizations that have inhabited the shores of the Mediterranean have used the potter's wheel to produce a great variety of beautiful pieces.

The work of Pablo Picasso emerged within the framework of this tradition. Those who love his genius will be beguiled by this exhibition of pieces whose everyday shapes were transformed by the artist's magic touch.

In addition to the large selection of sixty-one pieces in the exhibition, covering almost the whole range of forms and styles produced by the artist, we have included the comments of seven specialists on Picasso's work as a ceramist. Three are experts of international prestige on the technical aspects of ceramics, and the remaining four are artists from the current Spanish panorama who have also faced the challenges of clay and its firing. We thank all of them sincerely for their rapid response to our invitation to discuss Picasso's work.

Our deepest gratitude goes to Marina Picasso, who has once again very kindly placed her collection at our disposal, and to her representative the Galerie Jan Krugier, Ditesheim & Cie in Geneva. In particular we would like to thank Jan Krugier and François Ditesheim, who have lent their constant support to this project and made it a reality, and to Evelyne Ferlay and Roger Bonetti for the time they have devoted to its preparation.

We have also compiled an extensive glossary of terms (pages 213 – 226) that provides an explanation of ceramic techniques. Not just for experts, it is designed to assist the wider public we aim to reach from Fundación Bancaja.

FUNDACIÓN BANCAJA

**The exhibition in Tacoma
is co-sponsored by**

BOEING

Kilworth
F o u n d a t i o n s

with major support from

M. Russell

and generous funding from

IBERIA
AIRLINES OF SPAIN

I·V·E·X
Instituto Valenciano de la Exportación
GENERALITAT
VALENCIANA

Additional support is provided by

Amtrak West
Daniel Smith Artists' Materials
Gordon, Thomas, Honeywell, Malanca,
Peterson & Daheim, P.L.L.C.
Raleigh, Schwarz & Powell, Inc.
Turrón de España
Woods & Associates

The media sponsors are KING 5, KPLU
88.5, Washington Transit Advertising,
and *The News Tribune*.

The Tacoma Art Museum is a
membership supported, nonprofit
organization. Exhibitions and programs
are supported, in part, by the Pierce
County Corporate Council for the
Arts/ArtsFund, the City of Tacoma, and
the Washington State Arts Commission.
Important support is provided by Annual
Artistic Fund donors and the Activities
Council of the Museum.

978 8489413368

The City of Tacoma is honored to host the exhibition *Picasso: Ceramics from the Marina Picasso Collection*. The Tacoma Art Museum's leadership in bringing this outstanding exhibition to the United States creates a singular opportunity for the City and the Northwest. We join the Museum, as have numerous cultural and educational institutions, in creating a dynamic regionwide partnership in support of this project.

The City of Tacoma has rededicated itself to being recognized as a livable and progressive international city. Our people live in a setting of unsurpassed natural beauty and contribute their rich multicultural heritage, experience, and aspirations. The city's port is thriving, its downtown displays innovative new forms of development, and its neighborhoods pulse with the varied daily energies of home, school, work, and personal exchange.

Since the beginning of human history, and long before there was a written history, the arts have served as an essential form of human expression. The arts have existed alongside work and the various forms of education through which tradition, skills, and knowledge are taught. As we continually build our city and community, what better occasion to celebrate than this unique presentation of work by one of the greatest artists of our time.

Brian Ebersole
Mayor, City of Tacoma

**Tacoma Art Museum
Board of Trustees**

President
Joanne Bamford

Vice President
Bradley B. Jones

Treasurer
John D. Barline

Secretary
Peter Darling

Constance T. Bacon
Gretchen Bittmann
James F. Brown
John Butler
Gwen Carlson
Rick Carr
John J. Cogley
John G. Dillon
Lillian Ebersole
John P. Folsom
Maria Isabel Esteban
Wendy S. Griffin
Rod Hagenbuch
Patricia Hansen
Anne Gould Hauberg
George Hoguet
Brian J. G. Lachance
John E. Lantz
Richard W. Larson
James E. Layton
Bruce H. Marley
Kristine Grant McLean
Richard D. Moe
Martin J. Neeb
Philip M. Phibbs
Wendy J. Pugnetti
Barry Rosen
Frank Sánchez
Benjamin F. Scott
Jacki Skaught
Stephen Smith
Donn N. Spencer
Philip T. Stanley
Barbara N. Street
Constance Tice
Sara Little Turnbull
Elvin J. Vandeberg
Kathryn Van Wagenen
Carolyn Ibbotson Woodard
Judy Woodworth
Lenore Wyatt

Honorary Trustees
Mrs. Lester S. Baskin
Alan Liddle
William K. Street
Annette B. Weyerhaeuser

Honorary Committee

Co-Chairs
Brian Ebersole,
Mayor, City of Tacoma
Lillian Ebersole,
Tacoma Art Museum Trustee
Luis Fernando Esteban,
Honorary Vice Consul of Spain
Maria Isabel Esteban,
Tacoma Art Museum Trustee

Dr. Loren J. Anderson,
President, Pacific Lutheran University
Ida Ballasiotes,
Washington State Representative
Dr. Terry Bergeson,
*Superintendent of Public Instruction,
State of Washington*
Elizabeth Brenner, *Publisher,*
The News Tribune, *Tacoma*
Susan L. Brinkman, *Trust Officer,
Kilworth Foundations*
Lowell Anne Butson, *Executive
Director, Murray Foundation*
Mike Carrell, *Washington State
Representative*
Dr. Vicky Carwein, *Dean and Vice
Provost, University of Washington,
Tacoma*
Dale Chihuly
Phil Condit, *President and CEO,
The Boeing Company*
Ray E. Corpuz, Jr., *City Manager,
City of Tacoma*
Norm Dicks, *United States
Representative*
Peter Donnelly, *President,
Corporate Council for the Arts*
Phil Dyer, *Washington State
Representative*
Ruth Fisher, *Washington State
Representative*
Rosa Franklin, *Washington State
Senator*
Slade Gorton, *United States Senator*
Esther and R. Gene Grant
David Graybill, *President and CEO,
Tacoma-Pierce County Chamber
of Commerce*

Dr. Joye Hardiman, *Executive
Director, Evergreen State College,
Tacoma Campus*
Betty and Richard Hedreen
Tim Hickel, *Washington State
Representative*
Tom Huff, *Washington State
Representative*
John Kennedy, *Executive Director,
World Trade Center, Tacoma*
Patricia Lantz, *Washington State
Representative*
Gary Locke, *Governor, State
of Washington*
Gilbert Mallery, *President,
Amtrak West*
Dr. Richard L. McCormick, *President,
University of Washington*
Erling O. Mork, *President, Economic
Development Board for
Tacoma-Pierce County*
Babbie and Jim Morris
Sid Morrison, *Secretary of
Transportation, State of Washington*
Ralph Munro, *Secretary of State,
State of Washington*
Patty Murray, *United States Senator*
Bob Oke, *Washington State Senator*
Brad Owen, *Lieutenant Governor,
State of Washington*
Aija and Art Ozolin
Dr. Susan Resneck Pierce, *President,
University of Puget Sound*
Debbie Regala, *Washington State
Representative*
Andrea Riniker, *Executive Director,
Port of Tacoma*
George F. Russell, Jr., *Chairman,
Frank Russell Company*
Jane T. Russell, *Director of Corporate
and Community Relations, Frank
Russell Company*
Dr. Antonio Sánchez, *Research
Analyst, Washington State House
of Representatives*
Karen Schmidt, *Washington State
Representative*
Ray Schow, *Washington State
Senator*

Dr. James F. Shoemake,
*Superintendent, Tacoma School
District No. 10*
Kathryn L. Skinner
Mary Skinner, *Washington State
Representative*
Doug Sutherland, *Pierce County
Executive,* and Grace Sutherland
Gigi Talcott, *Washington State
Representative*
Dr. Pamela Transue, *President,
Tacoma Community College*
Steve Van Luven, *Washington State
Representative*
Nancy Watkins, *President,
Tacoma-Pierce County Visitor
& Convention Bureau*
Annette B. Weyerhaeuser
Drs. Gail and William Weyerhaeuser
Mr. and Mrs. James H. Wiborg
Shirley Winsley, *Washington State
Senator*
R. Lorraine Wojahn, *Washington
State Senator*
Jeannette Wood, *Washington State
Senator*
Ron Woodard, *President, Boeing
Commercial Airplane Group*
Virginia and Bagley Wright

A C K N O W L E D G M E N T S

In 1946 Picasso began a long exploration of ceramics in the French Provençal town of Vallauris. In the same year, the exhibition *Picasso: Fifty Years of His Art* opened at the Museum of Modern Art in New York. Together the two events testify to the artist's vigorous investigation of the territory between two-dimensional and sculptural form and to his formidable creative energy—already subjects of an impressive record. Wrote museum director Alfred H. Barr, Jr., in the catalogue introduction, "Probably no painter in history has been so much written about . . . at least during his lifetime." Picasso lived and worked nearly another three decades, and in the more than fifty years since Barr's remark, the literature about Picasso and his work has grown exponentially.

Now this splendid exhibition *Picasso: Ceramics from the Marina Picasso Collection* displays the work the artist produced during his many years in Vallauris. Curator Kosme de Barañano has chosen well, and his essay vividly underscores the relationship of Picasso's ceramics to the painterly compositions and themes for which the artist is best known. Most of the ceramics are unique, that is, were not editioned, and have been selected by Professor de Barañano for their individual sculptural qualities. This catalogue, aptly titled *Picasso: A Dialogue with Ceramics*, is invaluable for its comprehensive documentation of Picasso's approach to clay.

The Tacoma Art Museum is honored immeasurably by the opportunity to present *Picasso: Ceramics from the Marina Picasso Collection* as the centerpiece of an exhibition of Picasso's work. The ceramics exhibition, initiated and first presented by the Fundación Bancaja in Valencia, is presented in Tacoma as its exclusive venue outside Spain. With this presentation, we build upon the excellent relationships with Spain and the record of accomplishment established during *Catalan Masters of the 20th Century,* an exhibition presented here in 1997.

As with all undertakings of this import, this one is achieved through the good will and actions of many individuals. We are deeply indebted to Marina Picasso, who graciously consented to the Tacoma presentation of work from her rarely shown collection, for making the exhibition possible. Representing the Marina Picasso Collection, Galerie Jan Krugier, Ditesheim & Cie of Geneva, Switzerland, and particularly François Ditesheim, were instrumental in making arrangements for this special loan. We extend appreciation for their assistance.

Kosme de Barañano, through his friendship with Marina Picasso, initiated the original exhibition in Valencia and, in a parallel act of professional friendship, proposed that it come to Tacoma. He has helped guide the process from proposal to realization. At the organizing institution in Valencia, we thank Julio de Miguel Aynat, President of Bancaja, and Ricard Pérez Casado, President of Fundación Bancaja, for graciously agreeing to share the entire ceramics exhibition as it was originally conceived. Petra Joos, director of the Fundación art program, was responsible for managing the production of the Valencia exhibition and its handsome catalogue. She has been an invaluable ally throughout the planning of the Tacoma exhibition and especially the production of the revised English edition of the catalogue.

In a complementary exhibition, *Picasso's Studio,* the Tacoma Art Museum presents a selection of the artist's drawings and prints (a checklist can be found at the back of this catalogue). We are indebted to the lenders for their generous cooperation. From Madrid, the Museo Nacional Centro de Arte Reina Sofía has sent preparatory drawings the artist made for *Guernica,* perhaps the museum's most famous work of art, in addition to numerous prints. We express special gratitude to Excmo. Sr. Miguel Angel Cortes, Spain's Secretary of State for Culture, and to Museum Director José Guirao Cabrera, Chief Curator of Collections Paloma Esteban, and the Trustees of the Reina Sofía. The Grunwald Center for Graphic Arts, UCLA at the Armand Hammer Museum of Art and Cultural Center, committed early and generously to lending, thanks to the guidance of David Rodes, Director, and Cynthia Burlingham, Associate Director and Curator. The Achenbach Foundation for the Graphic Arts at the San Francisco Fine Art Museums sent significant objects from the collection, for which we thank Museum Director Harry S. Parker III and Robert Flynn Johnson, Curator of Prints and Drawings. To the individual collectors who lent prized works of art, we extend sincere appreciation.

In its full form, this Picasso exhibition could not have been realized without the extraordinary participation of Luis Fernando Esteban, Honorary Vice Consul of Spain for Washington State, and Maria Isabel Esteban, Tacoma Art Museum Trustee. On innumerable occasions, Mr. Esteban steered negotiations to successful conclusion. We deeply thank the Estebans for their dedication to the Tacoma Art Museum and the City of Tacoma. Brian Ebersole, Mayor of

the City of Tacoma, took early leadership to endorse the exhibition in recognition of the Tacoma Art Museum's contribution to the city's vitality, especially in its newly invigorated downtown. Numerous Northwest cultural institutions and business organizations have extended the reach of the exhibition regionwide by sharing ideas and developing collaborative programs.

When the Board of Trustees committed to the large undertaking this exhibition encompasses, several foundations and corporations stepped forward to provide the crucial financial leadership. The Kilworth Foundations, The Boeing Company, the Frank Russell Company, Iberia Airlines of Spain, Amtrak, and IVEX (Instituto Valenciano de la Exportación) all made major commitments that were truly essential for the presentation in Tacoma. We are grateful for their support.

This Picasso exhibition comes at a remarkable time in the life of the Tacoma Art Museum. Within a decade of our having established a newly expanded vision, with attendant commitment to a dynamic mix of exhibitions, educational outreach, public programs, and active community participation, the Museum's membership and attendance have multiplied dramatically. Recognizing that the current facility constrains our ability to support this growing audience, the Tacoma Art Museum has launched plans for a new facility. As visitors enjoy the Picasso exhibition in the current galleries, the need for a new building will no doubt be evident. We are confident that the art of Picasso will spark the desire to achieve an even greater level of excellence in the new facilities now being planned. There, as always, our commitment is to bring people together through art.

TACOMA ART MUSEUM

Chase W. Rynd, **Barbara Johns**,
EXECUTIVE DIRECTOR CHIEF CURATOR

TABLE OF CONTENTS

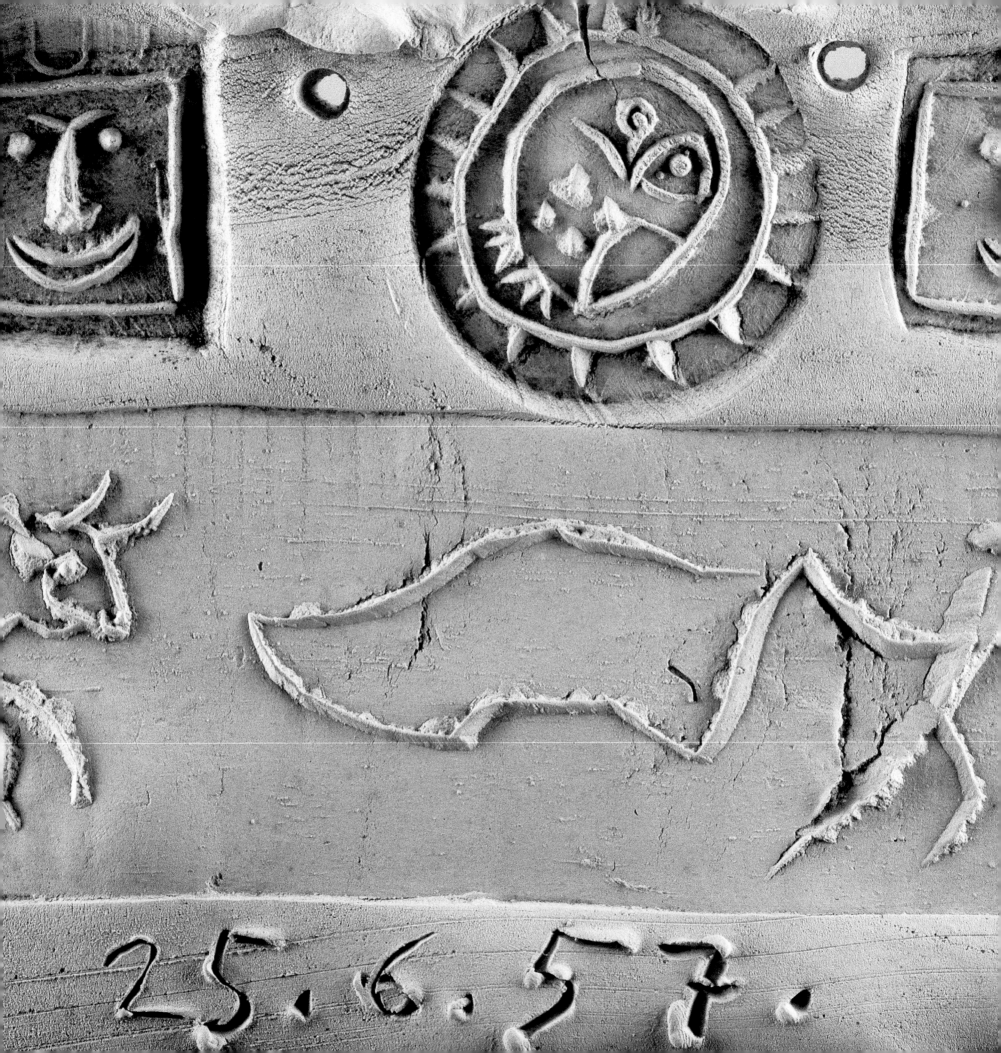

25.6.57.

PICASSO
A DIALOGUE WITH CERAMICS

Kosme de Barañano

Picasso's interest in ceramics arose at the turn of the century (for a brief period) and later, between 1945 and 1973, ran parallel to or alternated with his painting, sculpture, and engraving. When in his sixties, Picasso tackled ceramics again and again, attracted by the material's potential, by the way its plastic properties allowed him to adapt it to his imagination, and by the large number of skilled ceramists living near his home in the town of Vallauris, from Jules Agard to the Ramié family, whose Madoura workshop produced the vast majority of the Spanish artist's work.

The exhibition drawn from the Marina Picasso collection presents sixty-one ceramic pieces by Picasso that range from unfired clay to ceramics fired at high temperature and porcelain decorated with paint and enamel. Works in the exhibition include plates, dishes, vases, bottles, and zoomorphic jugs; wall, floor, and roof tiles; and fragments of brick handled and metamorphosed by the artist's hand.

Also included are pieces that are not simply decorative, but sculptures in their own right. Some items are enameled or painted, others incised or engraved, while the function of still others was transformed through the magic power of the artist. Some pieces belong to editions, numbered and signed by Picasso; most are unique.

In the history of art, ceramics is an unpretentious genre, one that reflects the taste of a particular age. It possesses a long tradition of artistic freedom and moreover one that never pursues nonessentials. It is also a craft which repeats itself time and time again—from the Greeks to Byzantium, from Volterra in Italy to the faience of Alcora in Spain, to modern times. Picasso was to make use of this material and the objects formed from it in order to display two specific personal touches: economy of line, and humor, whether these are found in the stylized forms of classical porcelain or in intentionally distorted forms. In his *poterie* (popular ceramic work), the artist introduced his calligraphy, his arrangements of planes and volumes, and his repertoire of scenes, which is to say, his visual magic. Using the kilns in the town of Vallauris, Picasso succeeded in giving Mediterranean ceramics new impetus, in tune both with his genius and twentieth-century art.

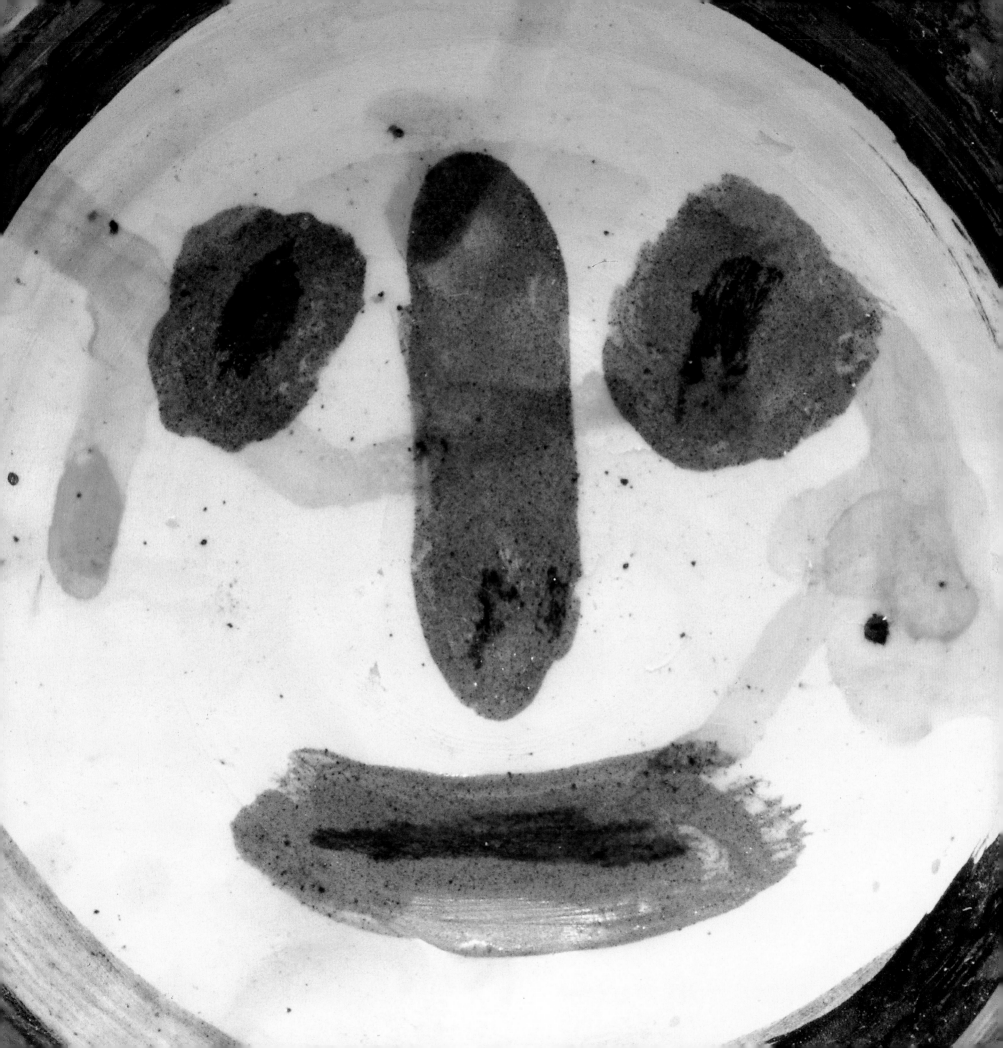

Picasso erased the division between pottery and ceramics, between simple fired clay and clay with enamel or sheen, between those pieces that are fired simply to make them hard and sound, and those that are more refined in their textural and tactile components. Basically, *ceramics, pottery*, and *terra cotta* are synonymous nouns, whereas the term *cerámica* is also used as an adjective. In Castilian Spanish there is always confusion since the term *cerámica* covers all objects made with argillaceous or siliceous matter, whether enameled or not, whether fired at a low temperature (between 700 and 1160°C) or a high one (over 1190°C).

Picasso's mastery of the material was important, as clay is a plastic element, one capable of taking on a variety of forms and of adapting to the artist's intentions. Plasticity is the ability of substances to acquire and hold a given form. A clay is considered plastic when it is easy to model with the hands, and to throw and shape without cracking. This means that it has to contain a specific amount of water, to enable the particles to slide over each other without losing contact, so that cracks will not appear.

The material used in self-glazing is not worked like clay, since it is much less plastic and less malleable in the artist's hands. It is difficult to throw, and is not suitable for large objects, yet Picasso used it—not molding it, but constructing with it—sculpting. Then he delivered it to the kiln.

The iconography that Picasso used on his ceramics keeps to the same frame of visual reference as all his other work: bullfights, women, and numerous echoes and memories from the history of art. The number of themes portrayed in his painting and engraving was vast, but it is **the way** he depicted such themes on ready-made pieces, **the way** he applied and outlined them on a new support, and **the way** he made use of the qualities of this support that makes these pieces an important part of Picasso's oeuvre.

In the 1950s, Picasso used every technique he could find: glazes, enamels, englobes, and more, but, skipping over the traditional pottery genres, he put his sense of irony and his inventiveness into the craft. First he experimented with the thrown objects, breaking them and "deconstructing" them; for example, he smashed the top of a well-thrown bottle by Jules Agard (1905 – 1986) and, employing the break in its neck and a new position, turned it into a dove. Picasso also transformed the rules of modeling, leaving the marks of his hands on parts that were already perfectly adequate. For example, he changed the position where the traditional handles were attached, thus turning old forms into something new. Furthermore, he made changes to the decoration by introducing all his experience in the field of engraving. Picasso not only experimented with raw materials (such as clay, sand, quartz), but also with prepared materials (frits, glazes, and so on), and with their different states, in accordance with the technique used to obtain vitrification (self-glazing, enameling, glazing). In addition, as he listened to and learned from the potters, he experimented with the physical phenomena (drying out, efflorescence) and chemical processes (oxidation, reduction) that occurred in the firing and vitrification of his objects.

He also tried out various manufacturing and technical procedures before placing the pieces in the kiln; he made use of what might be called enhancing processes (modeling, shaping, and throwing) as well as processes for transforming the material during the firing (biscuit firing, enameling, self-glazing, enameling by cementation, and so on).

Moreover, he used constructed clay pieces, which instead of ceramics became sculptural objects in ceramics, sculptures derived from assembled parts—just as he did with found objects. As his potter, Georges Ramié (in *Cerámica de Picasso,* Barcelona 1984), explained: "They are in fact constructions whose theme does not derive from

modeling by means of successively adding material, but rather from juxtaposed fragments previously made on the potter's wheel" (page 216).

Consider, for example, those hands of 1947, one in varnished plaster and the other in painted and enameled ceramic (Catalogue nos. 2 and 3); Ramié describes them as "fine hands, of an almost unreal realism, which emerge from the rigid piqué of solemn cuffs and seem to evoke the perfect pianistic mechanism of a dead virtuoso. All these items should be seen as exercises of skill; they occupy a decisive position in this ceramic work, bearing witness to the extent of the research Picasso carried out so successfully" (page 222).

Picasso retrieved objects which had been thrown out, pieces of dry or fired clay discarded by the potters, and with the magic of his brush turned them into paintings—on a support that was now not cloth but hard—or reliefs fashioned with paint. Ramié described such pieces as "multiform compositions sculpted from completely dried-out lumps of raw material. Their consistency can be compared to that of certain soft woods which, with well-sharpened tools, can be carved easily to obtain the greatest of subtleties. With the advantage, however, that once the work is regarded as finished, a high-temperature firing forever gives it the appearance and resistance of the hardest stone. The proportions and themes of these studies were mostly determined by the forms of the found pieces, following the earlier and sometimes dangerous circumstances that had occurred to roughhew these hardened lumps of clay. They were frequently the remains of lumps of clay prepared for use that had been broken or crushed and left out in the air in some out-of-the-way place" (page 245). The best examples are the bricks and roof and paving tiles he re-used and transformed into sculpture. Everything served his purposes—for Picasso, with his hands, paintbrush, and imagination, transformed these pottery remains and, by giving them up to the flames, provided them with a life of their own.

Picasso's ceramics can be grouped into several types, according to:

—their shape (plates, dishes, vases, zoomorphic jars, vessels, bottles, pendants, and so on);

—the material used (types of clay and coloring);

—the technique (type of kiln, degree of temperature, type of firing of the enamels);

—their thematic repertoire (decoration, representation of figures or objects, Greek themes, Spanish myths);

—the manner in which they were represented (drawn with pigment or with enamel, using graffiti, incised, built

up in relief);

—their use (service ware such as plates or dishes, different kinds of tiling, bricks, or decorative pieces);

—their plastic sense (thrown pieces from the applied arts genre, or pieces intended as sculpture);

—their edition (unique pieces, numbered pieces).

But image and form (as a result of Picasso's hand) were *superimposed* on every variety of shape or way of firing. And

although each has a clear and fundamental identity, the hand of their creator turned them all into personal works of

Picasso.

We must bear in mind that for Picasso ceramic material was just one more support to work with. The creative magic

of signs was projected onto the clay, modeling them in all their states and forms with the wealth and diversity of his

plastic expression in all its states and forms. Picasso built his ceramic poems from a kind of playful meditation on the

mineral world and its transformation by fire.

This piece in Athenian style has black figures on a red background. It shows a potter attaching a handle to a large pot while his dog watches. The potter is seated on a small stool and the piece, rather unstable, rests on the wheel. Above the scene you can see a shelf full of other pieces, some finished, others yet to be decorated. The etymology of the word ceramics comes from *Keramon* or potters clay. It is a generic term used to describe any object made with clay or siliceous material. It does not need to be but is often glazed, and can be fired at high or low temperatures. The terms ceramics (Greek origin), terra cotta (Latin origin), and pottery (Arabic origin) can have the same meaning.

This image from Yemen represents a woman seated on a curule chair. She has very wavy hair. Her head and legs are seen from the side while her torso is in three-quarter profile. In her right hand she has a small bowl with two handles, and in the left she holds a small statue of a gazelle. Her feet are resting on a lightly engraved stool. In front of her is a smaller masculine figure standing on a stool. He is heavily armed, with a sword in his left hand, a dagger in his belt, and a quiver over his back. Both figures wear pleated clothing. At the top of the stone, between them, is a written dedication, and in the middle there is a disk representing Venus and a quarter moon. At the same height as their heads is a square incense table, and over it a cross of the type that was an essential object in this cult.

In his narrative images, Picasso displays a similar quick and playful—not monumental—writing, with characters sketched quickly but in detail. They look like quick graffiti but Picasso registers many details.

Stele with Offering Scene
First century
Alabaster
7 7/8 × 4 3/8 × 1 5/8 inches
NATIONAL MUSEUM OF SANAA, TAN'IM

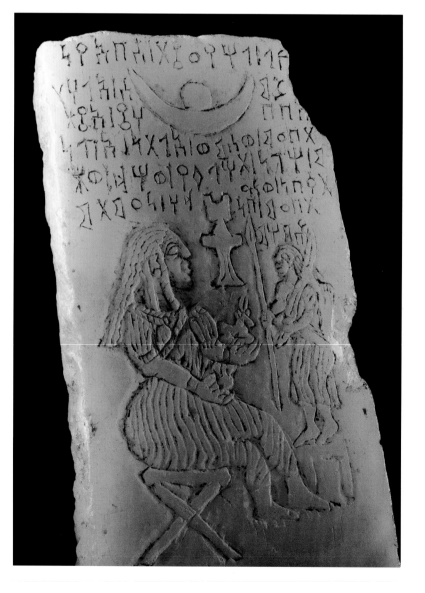

Grecian Vessel with Ceramist
ca. 490 B.C.
Terra cotta with oxide
2 1/2 inches in diameter
BRITISH MUSEUM, LONDON

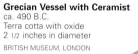

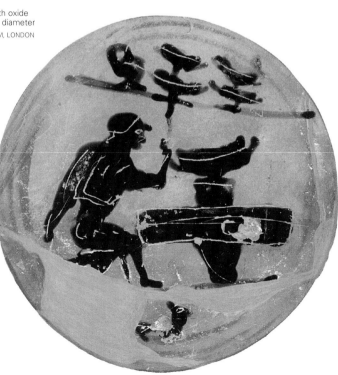

This Greek ceramic piece was designed to store perfume. Here a stylized torso presents sexual iconography. Picasso brings similar sexual references to his ceramics, both from popular pottery and from Etruscan and Greek art.

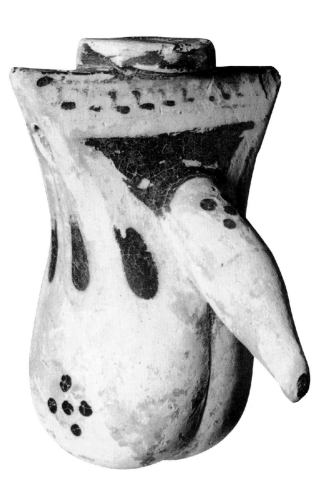

Vessel for Perfume
ca. 600
Corinthian terra cotta
11 inches high
THORVALDSENS MUSEUM, COPENHAGEN

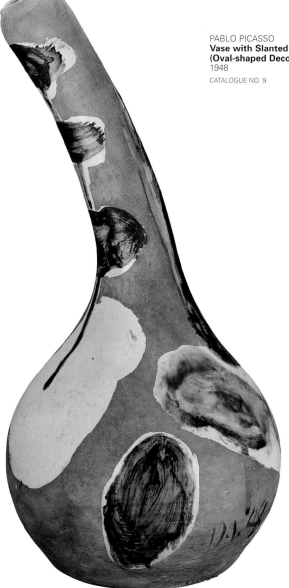

PABLO PICASSO
**Vase with Slanted Neck
(Oval-shaped Decoration)**
1948

CATALOGUE NO. 9

Urn of an Ancestor
Twentieth century
Baked clay with black and white englobe
12 1/8 inches high
Ghana-agui, Coast of Marfil
NAPRSTEK MUSEUM, PRAGUE

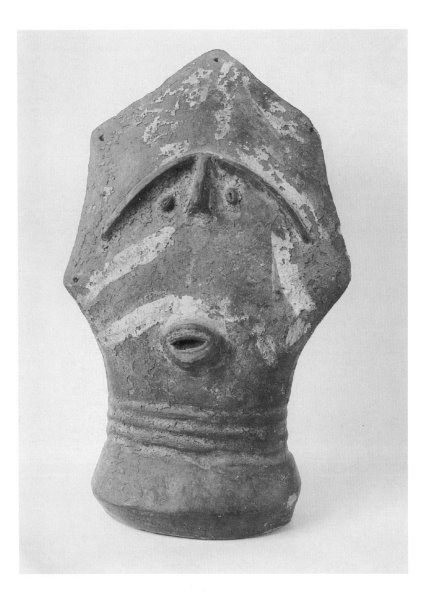

PABLO PICASSO
Large Vase with Sun God
1956
White pottery with incisions
12 1/8 inches high
Editioned piece

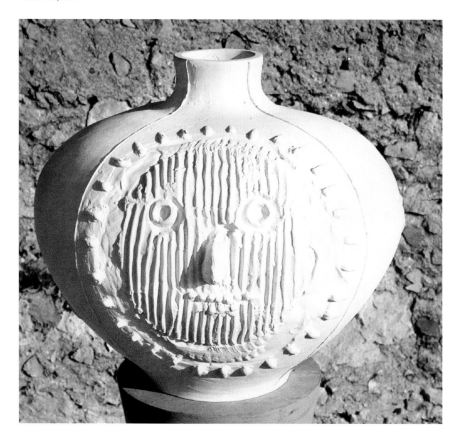

The simplicity of the movement, the softness of the white coat that creates the towel, the torso covered by wavy hair—Picasso achieves all this, and with less than four inches of clay creates a monumental image, beautiful all around.

This plate shows the hero Didenes Akritas, and the Amazon queen Maximo, in a garden. He has long hair and she is seated on his lap. A climbing plant surrounds the curule chair, while a rabbit moves toward a mountain, and on the other side of the couple part of a tree can be seen. The legs of the characters as well as the legs of the chair cross the border of the image, bringing it to life. Picasso uses similar compositional or formal tricks to make his scenes and the structure of his plates more dynamic.

PABLO PICASSO
**Seated Woman with
Crossed Legs**
1950
CATALOGUE NO. 13

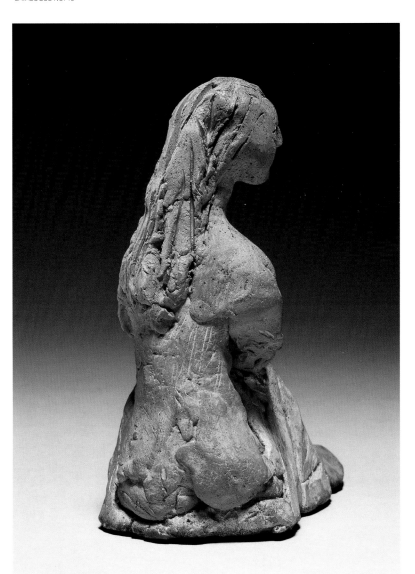

Plate with Lovers in a Garden
End of the twelfth century
Corinthian ceramic
9 7/8 inches in diameter
ARCHEOLOGICAL MUSEUM OF CORINTH

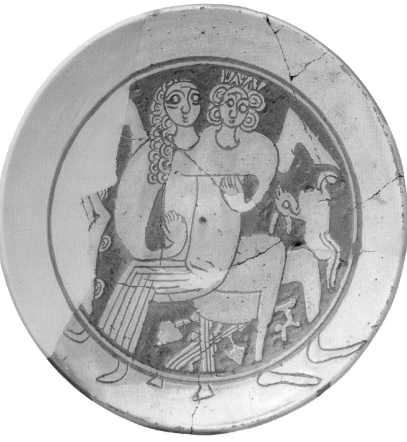

32

The potter Georges Ramié has published more books on Picasso's ceramics than anyone else, from the first

one, *Céramiques de Picasso* (Albert Skira, Geneva 1948), followed by *Ceçi est notre temoignage* (which he and

his wife Suzanne published in Vallauris in 1971), to his *Céramique de Picasso* (Albin Michel, Paris 1984,

translated into Spanish by Fernando Gutiérrez for Polígrafa, Barcelona 1984). The Madoura workshop directed

by the Ramiés published a short monograph (with an essay by Georges Ramié and a number of photographs

by Edward Quinn and Marc Lacroix) which was printed by Art de Adriaen Maeght in May 1984. Also interesting

is the point of view of the dealer Daniel-Henry Kahnweiler in *Picasso Keramik* (Fackelträger-Verlag, Hannover

1957, reprinted in 1970).

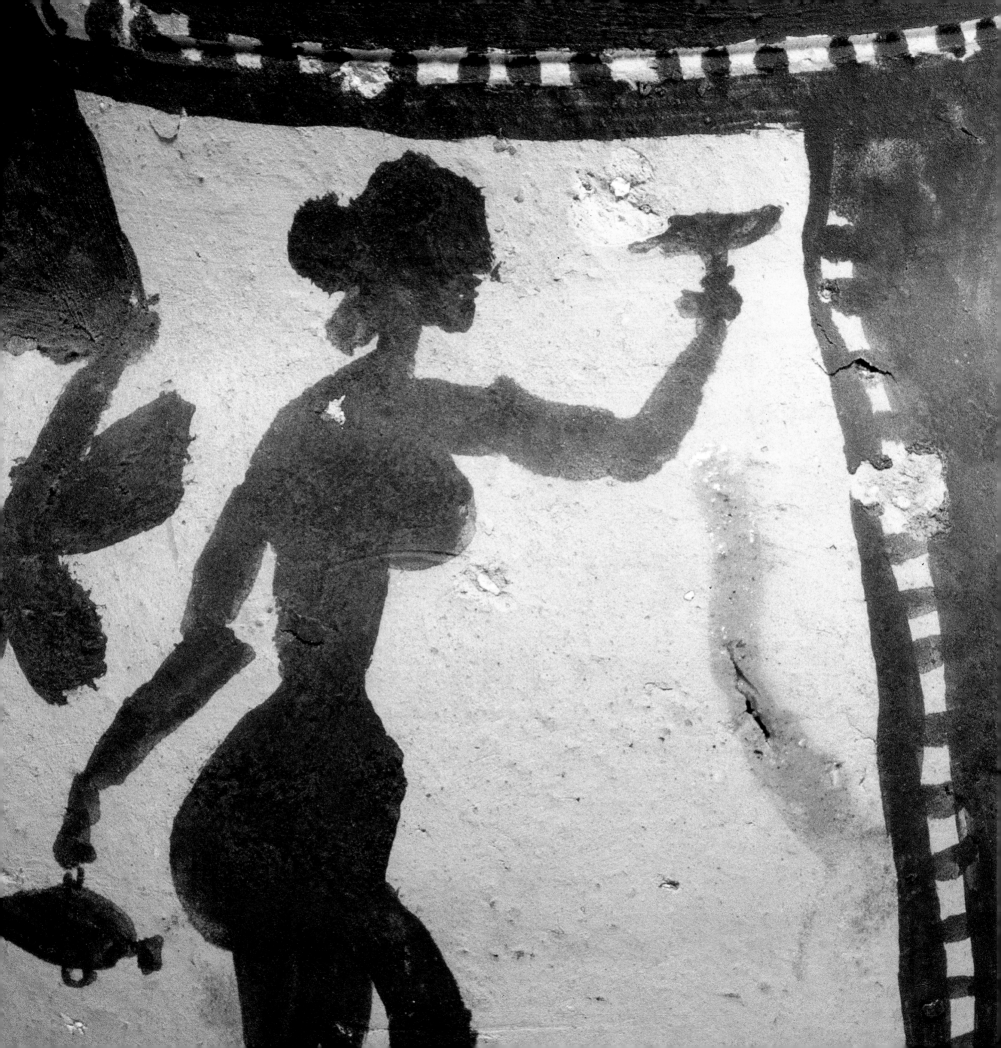

The key work is a *catalogue raisonné* by Alain Ramié: *Picasso: Catalogue of the Edited Ceramic Works 1947 – 1971*, published by Madoura and printed in Lyon in 1988.

On the town of Vallauris ("golden valley") and its dedication to pottery, the following studies are of interest: Paul Mejean, *Vallauris-Golfe Juan, 3000 ans d'histoire et de céramique* (Édition Foucher, Paris 1975), Camille Bartoli, *Vallauris-Golfe Juan, Tradition et Exotisme* (Édition Serre, Nice 1983), Anne Lajoix: *L'âge d'or de Vallauris,* "Les éditions de l'amateur," Vallauris 1995; and the 1989 film by Roger Capron, *Mémoire de Vallauris* (with Marius Musarra and Jean Petrucci).

Apart from these books and film, there are short but interesting essays on Picasso's ceramics, beginning at the time he began working with this medium, written by a number of authors and artists. For example the painter and sculptor Lucio Fontana wrote the preface to the brief catalogue for an exhibition at the Naviglio Gallery, Milan 1951. The following year André Verdet wrote *Faunes et nymphes de Pablo Picasso* (Pierre Cailler, Geneva 1952), and Jaume Sabartès, "Picasso Ceramista," for the gallery and publisher L'insegna del pesce d'oro, Milan 1953. Also noteworthy is the essay by the architect Gio Ponti in *Cerámica* (Number 4, April 1953), on the occasion of the IX Milan Triennial.

In the Anglo-Saxon world, one of the main champions of Picasso's ceramics was Curt Valentin (1902 – 1954), the German gallery owner who had settled in New York. On November 24, 1953, the year before he died (in Forte dei Marmi while visiting the sculptor Marino Marini), Valentin opened an exhibition of works by Picasso (including ceramics) in his gallery at 32 East 57th Street, entitled *Pablo Picasso 1950 – 1953*. In the brief catalogue Valentin published for this exhibition, he included Paul Éluard's essay "Picasso, Good Master of Liberty," translated by

Roland Penrose (see Note 1). In 1984, Sir Richard Attenborough wrote an essay on Picasso and ceramics for an exhibition at the Nicola Jacobs Gallery in London.

In 1960 the Museo Internazionale de Faenze, in Italy, organized an exhibition of forty-two ceramics by Picasso, with a study by Giuseppe Liverani, and in 1964 the Decorative Arts Museum of Hamburg organized another, whose catalogue contained an essay by Liselotte Moeller and the Kahnweiler essay mentioned above. Three years later the Tate Gallery, London, under the directorship of Roland Penrose, held the exhibition, *Picasso: Sculpture, Ceramics and Graphic Work*.

In 1983, Jean Leymarie presented *Picasso e il Mediterraneo* at the Villa Medici in Rome, with an essay by Marie Louise Bernadac, and on June 22, 1985, the Museum Het Kruithuis, at Hertogenbosch, The Netherlands, opened the *Picasso Kerameik* exhibition, whose catalogue contained essays by Yvonne Jris, Lambert Tegenbosch, François Mathy, and Roland Doschka. On November 1, 1989, *Picasso nella Cerámica*, organized by Trinidad Sánchez Pacheco, with essays by herself and Dolores Giral Quintana, was presented at the Palazzo Brugiotti in Rome.

At his gallery in Basel, in March 1990, Ernst Beyeler exhibited 116 Picasso ceramics from the Jacqueline Roque collection (lent by her daughter, Cathy Hutin). The catalogue contained Kahnweiler's 1957 essay and another by Pierre Daix. The gallery owner Elvira González showed some of these pieces at the Sala Cellini, in Madrid, on January 4, 1991. The collection of Marina Picasso, presented at the Fondazione Ambrosiana of Art and Culture on the Santa Croce square in Florence from June 6 to September 30, 1994, included a number of ceramics. Another exhibition was held at the Galerie Orangerie-Reinz in Cologne (November 5, 1994, to January 15, 1995)

with a catalogue that included an essay by Werner Krüger. On April 24, 1997, the Galerie Gmurzynska in Zug, Switzerland, presented *Pablo Picasso Céramiques* with seventeen pieces. The introduction to the catalogue was written by the artist's son Claude. Called "Picasso in Vallauris," it was illustrated with beautiful photographs by Robert Otero. This exhibition subsequently traveled to the Cologne branch of the gallery, and to the Gmurzynska stand at the Basel Art Fair in June; the installation at each venue was designed by Claude Picasso.

On December 8, 1997, Christie's in South Kensington, London, auctioned an important lot of ninety-three ceramics—both unique and numbered pieces. To add an anecdote, the famous New York restaurant, The Manhattan Ocean Club, has had two Picasso ceramics on exhibition in its vestibule since it opened.

In Spain, however, the first exhibition of Picasso's ceramics was held at the Sala Gaspar in Barcelona in 1957, with catalogue essays by Jaume Sabartès and Daniel-Henry Kahnweiler. A beautiful exhibition with essays by Trinidad Sánchez Pacheco, Christian Zervos, and Josep Palau i Fabre was held in 1982 at the Museo de Cerámica in Barcelona. In 1957, Picasso gave sixteen pieces to Lluis Llubià who, in 1966, was to become the director of that institution, the first Spanish museum to present in its permanent collection ceramics by the artist.

On March 8, 1997, the Miguel Espel-Casa Bella gallery presented an exhibition of Picasso's drawings and ceramics together with work by Jules Agard, one of the Vallauris ceramists. In December 1997 the Galería Levy in Madrid also showed a wide range of work on paper and ceramics.

Today, there are Picasso ceramics in the Museo de Cerámica in Barcelona, the Museo Nacional de Cerámica "González Martí" in Valencia (Picasso's work is on temporary loan to the IVAM), and in the Picasso Museums in

Barcelona, Paris, Antibes, and Buitrago de Lozoya (the Eugenio Arias Collection). The Musée d'Art Moderne in Céret, France, and the Museum für Kunst und Gewerbe in Hamburg also have good collections. There are also two fine private Spanish collections of Picasso ceramics. In Spain, however, there has not been an exhibition of this importance devoted exclusively to Picasso ceramics or with so many pieces exhibited for the first time until now.

Note 1: Valentin began his career at the Alfred Flechtheim Gallery in Berlin. In 1933 he went to work for the Karl Buchholz Gallery and Bookstore. Upon emigrating to the United States in 1937, he opened the Buchholz Gallery with Buchholz's support. In October 1951 this became the Curt Valentin Gallery. As Max Beckmann's dealer from 1945, Valentin obtained a teaching post for him at the Washington University of Saint Louis, which was then vacant, as Philip Guston was taking a sabbatical year. Beckmann did a portrait of the gallery owner with the art historian Hans Schwarzenski (1903 – 1985) in 1946. Perry Rathbone organized the exhibition *In Memory of CV* and wrote the essay. The show was held in New York in 1954 and at the St. Louis Art Museum in 1955.

The character riding the camel, and all the other animal figures here, was done in relief. The blue of the sky organizes the deepness of the space. Picasso also makes use of relief in many of his plates, and unifies the composition with the colored glaze. These two plates offer a good comparison.

Brahman Hunting Gazelles
Sixteenth century
Round wall tile
10 5/8 inches in diameter
NATIONAL GALLERY, PRAGUE

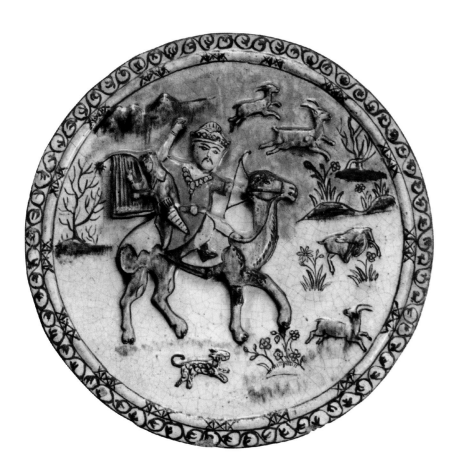

PABLO PICASSO
Flute Player
1951
9 3/4 inches in diameter
Editioned piece
The satyr's body and the sun are modeled in relief; metal oxides gave them their color as the piece was fired.

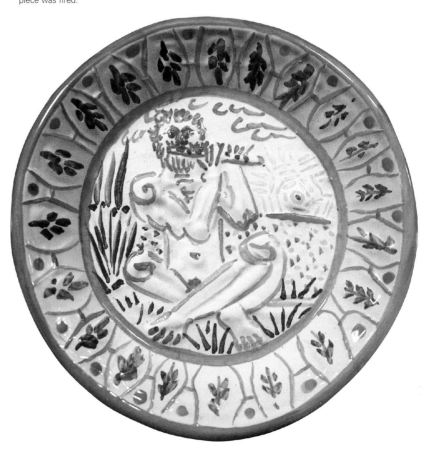

One of Picasso's favorite colors is cobalt blue, which he sometimes used full strength for the purpose of making black. In Italian, blue color is called *zaffera*, a word derived from the Persian *al-safra*, which designates the mineral cobalt, both the oxide and its salts. To make the color stand out, it is contrasted with a white glaze, already well-known by potters in Tuscany during the Renaissance. Here, the *bianchetto* is used to bring out the highlights of modeled figures in a montage of white over white.

PABLO PICASSO
Large Dish (Three Bulls and One Face in the interior)
1957
Catalogue No. 45

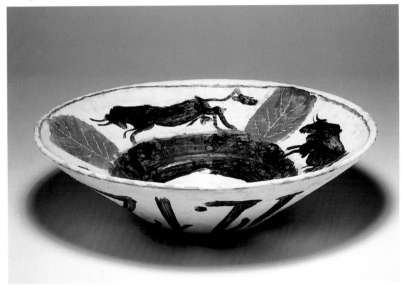

Pitcher with Animals and Oak Leaves
1430–60
Florentine ceramic, with relief and cobalt blue decoration
14 1/2 inches high
VICTORIA AND ALBERT MUSEUM, LONDON

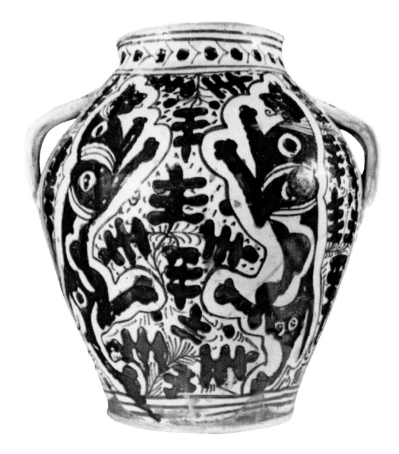

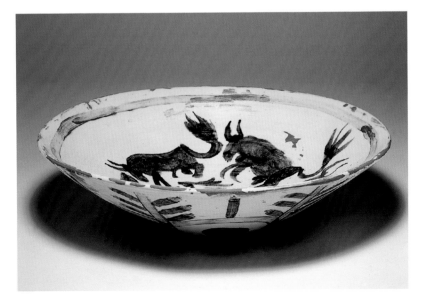

PABLO PICASSO
Large Dish (Bulls in the interior)
1958
Catalogue No. 46

Arabic gravestones are sometimes schematic, as this one is. With eyes and an inscription, their purpose was to scare away grave robbers by reminding them of a watchful human presence.

Picasso represents a person by just two rhomboidal eyes or by a circular impression with a point in many of his tiles and bowls. Both the Arabic gravestone and Picasso's pieces share a deceptive simplicity. This representation has not been realized by engraving but rather by bas-relief, and the surface had to be handled with great care. Many of Picasso's images look very simple, because of the minimal strokes used, but they are more complex than what they appear to be at first glance.

Stele with Eyes
Third century, Saba
Alabaster
14 1/8 × 6 3/4 × 1 5/8 inches
NATIONAL MUSEUM, ADEN

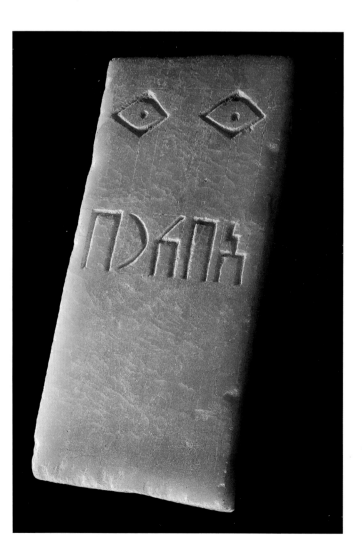

PABLO PICASSO
Elongated Face
1948
White faience, enameled and engraved
22 5/8 × 14 1/2 × 1 1/8 inches

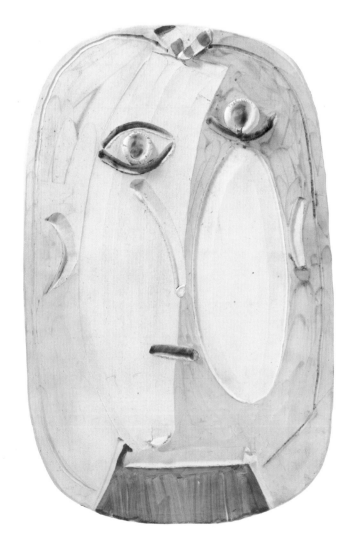

This vase is an ocarina, or a vessel of ceremonial style, perhaps a funeral offering to accompany the corpse to the grave and in so doing assuring him vitality, with its water used to quench the thirst. The artist utilized the *botijo,* a type of short-necked jug, to represent a priestess whose figure he made dynamic by using an amusing and simple drawing of the clothing and the arms.

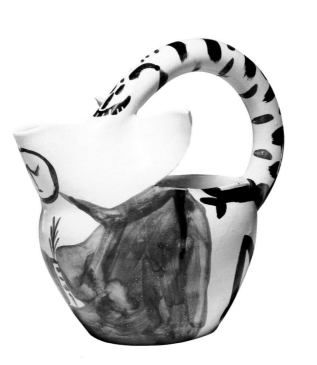

Here Picasso transforms a pitcher into an ironic figure. He represents a nun with an unhappy face at the spout of the pitcher, and uses the handle of the vessel to make a satyr who is at once over her head, and holding her from the back. Once Picasso said: "A pot can scream. Everything can scream. A simple bottle. And Cézanne's apples ..."

PABLO PICASSO
Pitcher (Nun and Faun)
ca. 1954
CATALOGUE NO. 32

Jar with Priestess
Sixteenth century, Peru
Terra cotta with oxide design
3 1/8 inches
BRITISH MUSEUM, LONDON

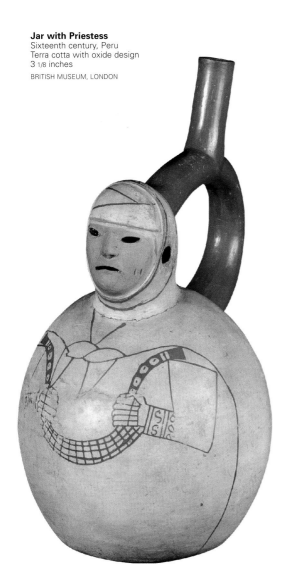

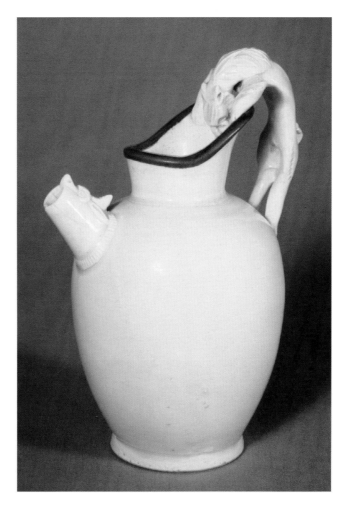

Just as Picasso's vessel plays with a faun's image by using the handle of a pitcher, in this white porcelain, we see how the handle becomes a lion while the spout looks like a monster's face. This porcelain piece is has a transparent glaze that demonstrates the degree of technical perfection achieved in oriental ceramics.

Jar
Seventh century
White porcelain
5 7/8 inches high
T'ang Dynasty
THE FREER GALLERY OF ART, WASHINGTON

Picasso exploits that vein in ceramics that respects both the popular and the refined. In his pieces with narrative, relief motifs, or those with a wide range of pigments, Picasso is not looking for the formality and ornamental complexity of European porcelains, but instead the joyful qualities found in popular tiles, with their representations of popular characters, courtesans, satyrs, soldiers, or perhaps the outline of a nobleman done with four funny strokes. There is a coarseness in the expression that can only be managed by a skillful hand like Picasso's. This quality can also be observed in the iconography of the ceramics of Montelupo, as in its plates with harquebusiers attacking fortresses singlehanded. This style is called by the Italians *a compendiario*, or succinct. Moreover, it uses a reduced palette, and does not attempt to cover the ceramic piece totally or convert it to a heavily decorated piece. Instead, the artist just provides an image that brings the plate to life without dominating it, so that the plate is still a the plate, without the artist enriching it all over. In both his brushstroke and his color Picasso prefers this sober style, which is lively without the perfection of a miniature or a decal. Here he follows an iconography more influenced by Mediterranean popular tradition than by that of French ceramics.

GIUSEPPE AND DONATO MASSA
Wandering Musicians
1741–42
Tile from the cloister
4 × 4 inches
CONVENT OF SANTA CLARA, NAPLES

Plate with Harquebusiers
ca. 1630
13 inches in diameter
Ceramic from Montelupo
VICTORIA AND ALBERT MUSEUM, LONDON

Tiger, Figure of Offering
Twentieth century
7 7/8 inches long
Red clay, from Gujarat, India
BRITISH MUSEUM, LONDON

In 1957, Picasso created various
animals with the characteristics
seen in *Goat*, three inches in height,
CATALOGUE NO. 39.

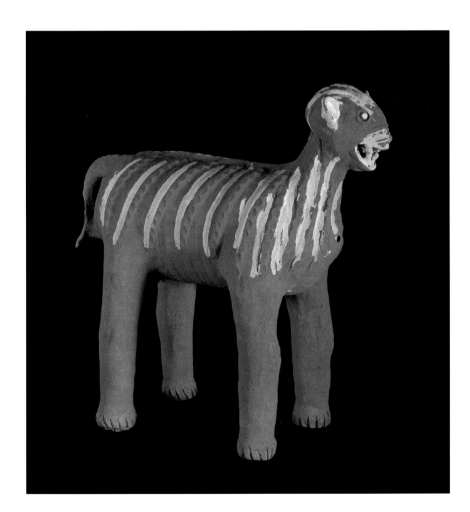

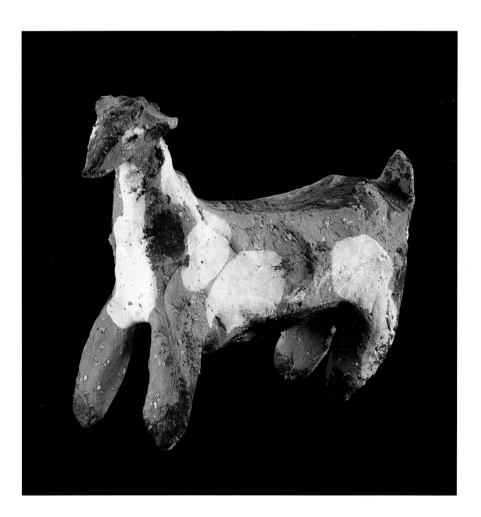

44

In *El joven Picasso antes de Picasso* (Barcelona 1946), Alexander Cirici wrote that Picasso made a trip to Majorca to study

ceramic techniques. However, Werner Spies, in *Picasso: Das plastische Werk* (Hatje Verlag, Stuttgart 1971; Spanish

edition *La escultura de Picasso,* Gustavo Gili 1971; new enlarged edition, Polígrafa 1989), in note 2) said that Cirici's

statement was not exact and that Picasso himself had denied it, and that he had begun using clay in Paris at the studio

of a sculptor from Bilbao at the turn of the century: "Picasso met Paco Durrio before 1906 and it was in Durrio's workshop

where he made the ceramics *Mujer peinándose* (Woman Combing her Hair) and *Cabeza de hombre* (Man's Head).

Máscara de mujer (Mask of a Woman) and *Mujer sentada* (Seated Woman) were likewise done in clay. At that time the

fauvists were also experimenting with ceramics. In 1907, the ceramist André Metthey allowed them to use the kiln he

owned in a Paris suburb. Matisse, Rouault, Derain and Vlaminck decorated ceramic items but did not alter their form.

Picasso went far beyond this. After the First World War, the Catalan ceramist Llorens Artigas settled in Paris and Dufy,

Miró, Braque and Max Ernst made clay sculptures in his workshop" (page 210).

At the beginning of his study the German critic Spies (now director of the Musée National d'Art Moderne in Paris) also said: "The fact that Picasso did not work with Durrio and yet kept company with him has not been thoroughly researched. Durrio's works were strongly pervaded with that decorative lineality which characterized turn-of-the-century art. This influence is especially noticeable in Picasso's treatment of the hair in *Mujer peinándose*. Women's wavy hair was a central theme of Art Nouveau; at the same time it allowed countless stylistic and thematic variations and permutations (fire, water)" (page 28).

The sculptor from Bilbao, Francisco (Paco) Durrio (1868 – 1940) was, at the beginning of Picasso's stay in Paris, his help and support. It was Durrio who gave him his first lessons on how to handle clay. Durrio was fond of Picasso and admired him; those were the days when Picasso's aesthetic was very close to Paul Gauguin's. Later, when he moved toward Cubism, "Durrio's indignation at the act of folly that for him the new Picassian theory represented was such that he considered it an attack on the propriety and dignity of painting. At the beginning he must have thought it was just a curiosity, but as soon as he was convinced that Picasso was in earnest, he broke off not only their artistic relationship but also their personal one. Nevertheless I have recently read a letter in which he spoke with bitterness and pain of that broken friendship" (Crisanto Lasterra, in his book *Con Durrio en París de los años veinte,* Bilbao 1966, page 85).

Paco Durrio met the nineteen-year-old Pablo Ruíz Picasso in his Bateau-Lavoir studio, at number 13, *rue* Ravignan. It was probably here where he passed on Gauguin's aesthetic message to the young artist as well as the love of every kind of material, including ceramics. Claude Picasso, in his excellent essay "Picasso in Vallauris" (in which he said that Durrio was Catalan instead of being from Bilbao) wrote: "Le travail avec l'argile allait vite, chose qu'il avait connu au début du siècle à Barcelona et à Paris. Il avait realisé ses premières sculptures sur l'insistance de Paco Durrio, un

ami catalan qui travaillait lui aussi avec ce médium. La majorité des sculptures réalisée a cette époque par Picasso étaient en argile ou en terre cuite." (The work with clay was going fast; it was something he had known at the beginning of the century in Barcelona and in Paris. He had created his first sculptures upon the insistance of Paco Durrio, a Catalonian friend who was also working in the same medium. The majority of the sculptures made during this period by Picasso were of clay or terra cotta.)

Paco Durrio's relationship with Picasso began with the Picasso's first trip to Paris, which took place before October 25 (his birthday), 1900. On this trip Picasso went with his friend Casagemas to the studio of the theater designer, Oleguer Junyent. Durrio must have already known Picasso at this time, since he had obtained works by Gauguin and Picasso for the first Modern Art Exhibition held in Bilbao in 1900 in which he himself exhibited jewelry.

Picasso made his second trip to Paris around the middle of May 1901, to take part in a joint exhibition with the Basque painter Francisco Iturrino that opened on June 24 at the Vollard Gallery.

However, before his third trip to Paris on October 29, 1902 (on which he was accompanied by Josep Rocarol and Julio González), an exhibition was held from June 1st to 15th at the Berthe Weill Gallery in Paris where, together with work by Francisco Iturrino, Manuel Losada, Ignacio Zulaoga, Isidro Nonell, and others, Picasso paintings were shown. The promoter of his participation in this exhibition was Durrio, as is confirmed by a letter Durrio wrote on March 1 to the painter Darió de Regoyos: "As far as Picasso is concerned I believe you are wrong, since, according to what he said to me, he is not going to exhibit his work and I think you should write to him as he has a great deal of talent and I am sure that he would contribute to the success of your efforts." Clearly, Durrio's recommendation was taken, as

pictures by Picasso were exhibited, though Picasso himself did not go to Paris until October (a trip mentioned in the

society column of the daily newspaper *El Liberal,* October 20, 1902).

In 1903, Charles Morice devoted three pages in *Le Mercure de France* to Durrio's jewelry exhibition. Spies quotes a

sentence he found in *Chroniques d'Art* by the poet Guillaume Apollinaire: "One contemplates the beautiful silver font by

Francisco Durrio, who knows how to manipulate human forms so that they become useful objects ..." (page 320).

In 1904, Durrio passed his Bateau Lavoir apartment on to Picasso and moved to number 3, *place* Constantin Pecqueur,

where he installed a large kiln. In Picasso's sketchbooks of this year there are drawings and caricatures of both Durrio and

his partner, Renée Peron.

It was on his fourth trip to Paris that Picasso took over the apartment Durrio had left him (considering Picasso the new

genius of art since Gauguin's departure). In her book *Picasso et ses amis* (Librairie Stock, Paris 1933 [American edition,

Picasso and His Friends, Appleton-Century-Crofts, New York 1965]), Fernande Olivier, Picasso's partner at that time,

testified to the assistance Durrio gave the young artist in those times of crisis. Similar praise for the kindness of the artist

from Bilbao is found in Noël Bureau's description in the introduction to the catalogue of Durrio's retrospective exhibition

in 1945 at the Salon d'Automne: exclusive in his enthusiasm, gentle or angered "aux humbles défenses ou poussant son

intransigeance, au caractère chatouilleux, mais le plus souvent désarmant de pureté, de jeunesse" (mildy deferential yet

prickly in his intransigence, volatile but most often than not disarming in his innocence and youthful qualities).

As regards Durrio's atelier, Pierre Cabanne (in *El siglo de Picasso,* Madrid 1982, volume I) described number 13, *rue*

Ravignan as "a strange building of stone, wood and glass, which people call 'Bateau-Lavoir,'" and Durrio's studio as

"particularly sinister, a foul den, boiling hot in summer and freezing cold in winter, as were all the squalid rooms of that rambling building which had only one floor on the *place* Ravignan, but which rose up behind, in vertiginous overlapping glassed-in galleries, on the vacant lots on the *rue* Orchampt … (page 119). Around the `Ship,' stalls, snack bars, and little gardens [were] crammed in together at the foot of buildings of every description. The hovel Pablo [Picasso] occupied after Paco Durrio … [had] a four-legged bed, a rush-bottomed chair, a few easels, an old trunk and a table as its only furniture. Washing facilities were a yellow pottery bowl on top of an iron stove, a towel and a lump of soap on the table, within hand's reach. There was, of course, no running water" (page 145).

Jean Paul Crespelle also wrote about these studios in *La vie quotidienne à Montmartre au temps de Picasso* (Hachette, Paris 1978): "Picasso moved to the Bateau-Lavoir at the end of February 1904, on his fourth trip to Paris. He already knew the strange house, since he had visited the studio of the ceramist Paco Durrio on his previous trips. Paco Durrio, who had lived in Montmartre for several years, had been a friend of Gauguin's and, thanks to the former, Picasso discovered the painting of the latter. Durrio felt deep admiration for the Hiva Oa recluse and owned some of his works, one being the portrait of Gauguin's mother. When Picasso arrived, Paco was about to leave the Bateau-Lavoir and therefore offered Picasso his studio. He had found premises in the *impasse* Girardon, on the banks of the Maquís, which were much better suited to his needs as a ceramist. Of all the Spaniards living in Paris, Paco Durrio was the one who helped Picasso most" (page 57). Crespelle was mistaken about the Basque sculptor's new studio, however, for he did not move to *impasse* Girardon until 1907.

Picasso's biographers tend to refer to three facts in the Paco Durrio'Picasso relationship:

—One is the night when, together with Jaume Sabartès, they sat up talking about sculpture and above all about Gauguin's

book *Noa Noa,* which had just been published, and about large Oceanic totems; this was in 1902. (Jaume Sabartès, *Picasso: Portraits & Souvenirs,* Paris 1946, page 90).

—Another is the fact that during the coldest days of 1904 Durrio secretly provided the painter with food: a bottle of wine, a tin of sardines, and a loaf of bread appeared daily—as if by magic—at the door of Picasso's studio. This story was told by Picasso's partner, Fernande Olivier.

—Finally, the picture Picasso gave "to [his] dear friend Paco Durrio": *La bella holandesa [Holandesa de la cofia]* (The Beautiful Dutch Girl, or Dutch Girl with Head-dress), painted in 1905 (oil, gouache, and plaster on cardboard, catalogued as number 1,134 by Josep Palau i Fabre in *Picasso vivo 1881 – 1907. Infancia y primera juventud de un demiurgo,* (Polígrafa, Barcelona 1965), and number XIII. 1. in Pierre Daix's book, *Picasso 1900 – 1906* (Blume, Barcelona 1987), and now in the Queensland Art Gallery in Brisbane), it is dated, signed, and dedicated at the upper left: "a mi querido amigo Paco Durrio Picasso 1905 Schoorl." Picasso almost certainly painted it in Holland during the summer of that year, when he was the guest of the Dutch writer, Tom Schilperoort, who was living in the town of Schoorl, near Alkmaar.

Another Picasso picture belonging to Durrio was *Muchacho portando un jarro* (Boy Carrying a Jug), 21 – 13 1/4 inches, now in the Hyde Museum, Glens Falls, New York. The jug the boy is holding in his hands, probably made by the artist from Bilbao, is very similar to a vase in the Sèvres Museum. Durrio sold the painting to the Düsseldorf dealer, Alfred Flechtheim, in 1912 (number 1,174 in Josep Palau i Fabre, *Picasso vivo 1881 – 1907,* and number XIII in Pierre Daix *Picasso 1900 – 1906,* cited above).

More important than this relationship of tenancy and nocturnal experiences is the fact that, in the spring of 1905, Picasso

modeled a bust of the writer Max Jacob in Paco Durrio's new studio in the *place* Constantin Pecqueur. It was the bust he later called *Cabeza de bufón* (Head of a Jester); the bronze version is now in the Musée Picasso in Paris. It was probably because of this, because of his technical help, that Picasso gave Durrio the *La bella holandesa* canvas on his return from his summer trip to Schoorl. In the Salon d'Automne of this year, Pierre Girieud presented his great canvas *Hommage à Gauguin* in which Durrio appears.

In 1906, Durrio visited Daniel Zuloaga in Segovia to help him with the ceramic pieces for his monument to the musician Juan Crisóstomo de Arriaga. On Durrio's return to Paris, Picasso modeled a clay bust of Fernande Olivier in his workshop (the bronze is in the Norton Simon Museum, Pasadena, California), and with help from Durrio made a ceramic bust of Josep Fontdevila, only 6 5/8 inches high (later also cast in bronze). Ambroise Vollard had a bronze edition made (see Christian Zervos, Vol. I, 380), which he dated incorrectly as 1905. This bust also appeared on page 13 (with two photographs of a bronze cast) of the catalogue *Private Views,* published by Achim Moeller (New York 1990). There are also some drawings by Picasso from this period which represent vases or sketches of ceramic vases, such as *Le vase bleu* (The Blue Vase) now in the S. Bollard Collection.

In 1907, Durrio moved to a little house with a garden—a small seventeenth-century farmhouse at number 4, *impasse* Girardon—and presented thirty-five ceramic pieces at the Salon d'Automne. Werner Spies (page 29) mentions another piece: "In Paco Durrio's studio yet another ceramic sculpture *Cabeza de hombre* (Man's Head) was made. Picasso used sketches from Gósol for it. As he himself has told us, in this piece, as in *Mujer peinándose*, he made use of drawings which he later transferred into three-dimensional form. Among the numerous sketches there was one which almost

certainly arose from a plastic conception (Zervos, Vol. VI, 765). These are almost the only cases we know of in which the relationship between the preliminary drawing and the modeled sculpture is unequivocal. Picasso confirmed that the drawing preceded the sculpture. He was categorical on this point." After Braque's and Picasso's cubist experiments, Durrio's friendship with Picasso cooled. In 1910, the poet Apollinaire wrote a review in which he praised Durrio highly.

According to John Richardson (*Life of Picasso,* Vol. I, Random House, New York 1991), it can be said (though there is no direct proof of this) that Picasso's first ceramics were important insofar as they reveal a link with the aesthetics of Paul Gauguin, "a link forged by Paco Durrio, the previous tenant of Picasso's Bateau-Lavoir studio" (page 456). This same author points to a piece which must have been made in Durrio's kiln (possibly number 110451 in the Museo Picasso in Barcelona), as well as to a pair of vases belonging to Picasso called *Los mormones* (The Mormons, page 459), and, in the inventory of Picasso's legacy, a couple of Durrio ceramics (page 520), which remain untraced. Spies, in a final note (No. 34, page 320), is even more specific: "Picasso, who appreciated his fellow countryman Paco Durrio's ceramics, owned two of his anthropomorphic vases: *Los mormones* (The Mormons). Kahnweiler granted Picasso's request and gave him a Paco Durrio vase. Picasso made the ceramic *Mujer peinándose* in Durrio's workshop."

Using the training he acquired with Fernand Chaplet's help, Gauguin fashioned earthenware and stoneware works, enameling, painting, and firing them with a very different approach from what was traditional in the plastic art of his time. This approach he passed on to Durrio, who in turn passed it on to Picasso. Gauguin himself wrote, in a letter to the dealer Ambrose Vollard dated August 25, 1902, "I was the first to attempt ceramic sculpture and I believe that, though it has been forgotten today, the world will thank me for it. I maintain with pride that nobody has done it before" (Bengt

Danielson, *Gauguin à Tahiti et aux îles Marquises,* Papeete 1975, page 302, number 105).

It was not only the sculptural role Gauguin gave to ceramics, but also the treatment of wood, or rather, the concept of sculpture with whatever materials, that Gauguin questioned in these pieces made with clay and fire. Thus, with respect to the wood *Busto de Meyer de Haan* (Bust of Meyer de Haan), Françoise Cachin pointed out: "This portrait reminds us what the modern sculpture of the first twenty-five years of the century owes to the simplifying, expressive work of Gauguin, as well as to the role of primitive sculpture (to whose appreciation by the artists of the turn of the century Gauguin had contributed). Let us consider Matisse's first pieces in wood or those by certain German expressionists like Schmidt-Rottluff. A piece such as Gauguin's, exhibited in 1919, could do no less than impress a whole generation of sculptors, in that avant-garde environment of Paris. Attention must likewise be drawn to the essential role of the sculptor Paco Durrio in the diffusion of the work of the legendary hero of Pouldu and Tahiti in the Bateau-Lavoir milieu and particularly in influencing the artist of the *Demoiselles d'Avignon*" (Grand Palais catalogue, Paris and Washington 1989, page 179).

The relationship between the genres, or specifically the *nonseparation* of artistic genres, was something common to the theory and practice of the two friends. While Durrio constantly mixed goldwork (which he wanted to be exhibited as sculpture) with ceramics or sculpture (consider the huge statue for the monument to the musician Arriaga, gilded by fire), Gauguin's ceramic work was intensely and inseparably associated with his painting. As Claire Frêches-Thory pointed out: "The Brittany sketchbooks are full of motifs to be used for vases, paintings and ceramic projects alike. Similarly some of these pieces appear in the artist's paintings. As Meret Bodelsen has brilliantly demonstrated, ceramic technique made Gauguin simplify his forms, leading on to cloisonné, before he developed a similar technique in painting. In short the

development of Gauguin's ceramic work belongs to his general stylistic evolution towards an increasingly complex symbolism. This can be seen in his last pieces *Venus negra* (Black Venus) and *Oviri*" (Grand Palais catalogue, page 87).

If Gauguin developed through contact with this technique, and if he transmitted to Durrio the validity of this same technique as a concept, then Durrio communicated this principle to the young Picasso, who shaped his first sculptural pieces in the studio of the artist from Bilbao. As John Richardson pointed out in his detailed biography of Picasso: "Then as now Gauguin's ceramics were underrated; Durrio was virtually alone in recognizing their importance and exploring similar techniques. Given the virtuosity of his huge stoneware pieces, as well as his expertise in glazes and enamels—an attribute he was to share with Picasso ..." Finally, he reached the conclusion that this work of Durrio's led to an important consequence: "The extent to which Durrio's techniques helped Picasso revolutionize the craft of ceramics in Vallauris forty years later has yet to be taken into account" (*Life of Picasso,* Vol. I, page 457).

The turn-of-the-century figure who was most insistent about the value of ceramics and the scope of clay and color committed to the kiln was Paco Durrio. It was he who preserved the flame of Gauguin's message and who would pass on that message to the hero of the next generation—whom he recognized as such on meeting him. In Richardson's words, the Basque Durrio "encouraged Picasso to follow Gauguin's example and try his hand at ceramic sculpture" (page 230); or in those of Claire Frêches-Thory: "Les récentes exhibitions consacrées au Primitivisme en 1982 et 1984 ont mis en évidence l'influence de la sculpture de Gauguin sur Picasso notamment par l'intermédiaire de son ami le sculpteur Paco Durrio ... (The recent exhibitions devoted to primitivism in 1982 and 1984 revealed the influence of Gauguin's sculpture on Picasso, mainly from their mutual friend, the sculptor Paco Durrio)" (page 364).

John Richardson wrote, "The encounter with Paul Gauguin's work in Paco Durrio's studio was positively confirmed as being in late autumn 1906, when the Salon d'Automne presented more than 200 of his works. For Picasso the experience was, beyond the shadow of a doubt, like proof of an auspicious syncretic flight from time, a flight he had himself prepared in the solitude of Gósol where, on his return, he finished the portrait of Gertrude Stein.

"Gauguin's *Retrato de la madre del artista* (Portrait of the Artist's Mother, 1898, Staatsgalerie, Stuttgart [which then belonged to Durrio]) and *Cabeza de mujer bretona* (Head of a Breton Woman, 1894, Private Collection, Paris) merely served as models. The simplified features and the accentuated plasticity in the expression of the portrait derived from Gauguin.

"In Paris in the winter of 1906 – 1907, Picasso produced another sculpture whose preparatory drawings were done in Gósol: *Cabeza de mujer* (Woman's Head). Made like a mask, it is the tangible plastic result of a transformation of a head that, though conceived of as a portrait, has undergone a simplifying stylization. It clearly illustrates Picasso's interest in the physiognomic abbreviation he had worked on in Gósol. The plastic conciseness of the medium and the reduction of the facial features to a few simple lines are also found in the works the artist later made in wood" (page 32).

Werner Spies also pointed out (note 38, page 321) the influence of at least three works by Gauguin owned by Durrio—the relief, *Cabeza de tahitiana* (Head of a Tahitian Woman), and the two paintings *Retrato de la madre del artista* (Portrait of the Artist's Mother) and *Cabeza de bretona* (Head of a Breton Woman)—in the portrait Picasso made of the American writer Gertrude Stein, as well as in a 1907 wood relief and woodprint *Busto de mujer* (Female Torso, Geiser catalogue, No. 212, Bern, Switzerland, 1979). This influence of the iconography and the technique of Paul Gauguin's aesthetic is also

apparent in Ernst Ludwig Kirchner's work, for example in his engraving for the poster for the Gauguin Exhibition at the Arnold Gallery in Dresden in 1910. *Oviri* would later be seen as a forerunner of the *Demoiselles d'Avignon* in the exhibition (organized by William Rubin, *Pioneering Cubism: Picasso, Braque* in New York and Basel, 1989) on the origins of cubism. The middleman, the conceptual *bridge,* between Gauguin and Picasso was, without any doubt, Paco Durrio.

Durrio was of help to Picasso not only with modeling and the technique of firing and its effect on pigments, but also—as Sabartès has pointed out—with his artistic vision, especially in a certain "multicultural" conception of statuary. In his turn, Durrio, influenced by Gauguin's views, was searching for some artistic way to combine Greek architectural balance with Iberian, Assyrian, or Egyptian models, that is, with primitive models in general, and not only African ones.

In 1939, Alfred Barr questioned the cliché of the influence of African art, especially that of the Ivory Coast and the French Congo, in the work of Picasso. Picasso had requested the publisher Christian Zervos to point out that he was indebted to the Hispanic reliefs of Osuna, which he had seen in the Louvre. This was mentioned by James Johnson Sweeney in his "Picasso and Iberian Sculpture" (*Art Bulletin,* New York, September 1941), two years after Barr's comments. Other authors have noticed the influence of Catalan Romanesque sculpture, and Josep Palau, that of the Virgin of Gósol in particular. The influence is, however, wider, more "multicultural," and is fundamentally due to the aesthetic interests of Durrio, and to his broad artistic vision. Gauguin's and Durrio's aesthetic categories go beyond a mere imitation of the primitive art of Tahiti, ancient Egypt, or the Iberian world. What was involved, probably due to the artists' contemplation and consideration of all the artistic phenomena filling the Museum of Man, was the founding of a *non-national, nameless aesthetic,* based in no specific anthropological region, an aesthetic in which all discourses were defended and complemented each other.

This was the lesson Picasso learned and developed.

The iconography in Picasso's ceramic pieces is very closely related to that seen in all of the artist's work, and includes the bullfights, portraits of friends, women, satyrs, and all the multiple references drawn from memory and from the history of art.

The variety of the themes Picasso used in his paintings and engravings is enormous. But it is the way he engraves pieces already made, the way he applies and outlines forms on a new background, and the way he makes use of the qualities of this material that makes his ceramic pieces stand out as an important aspect of his work.

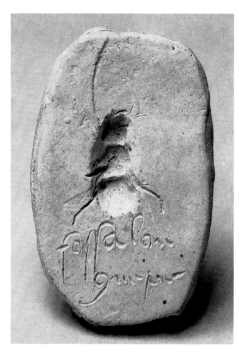

BERNARD PALISSY
Hymenoptera Insect Mold
ca. 1567
Unglazed ceramic
8 1/2 × 3 1/8 inches
NATIONAL RENAISSANCE MUSEUM, ÉCOUEN

This is the only representation of an insect in fired clay from the Palissy *atelier* (1510 – 1590) in Paris. Palissy himself called it his "Hymenoptera bee." Undoubtedly Picasso had seen the work of this artist in Paris; pieces like this were admired at the beginning of this century.
The writer Anatole France published an edition of Palissy's work in 1880. However, Palissy's first work *Receptes Veritables*, published in 1563, already signals his appreciation for the technique, and points out that he was capable of making molds of live insects (in his manuscript in the Bibliothèque Nationale, ms. Fr. Folio 129 [right]).
Bowls and plates like this—and like those Picasso would make later—that compete not with the great Italian ceramics, but with the most popular contemporary work, Palissy called *rustiques figurines*, or rustic ceramics.

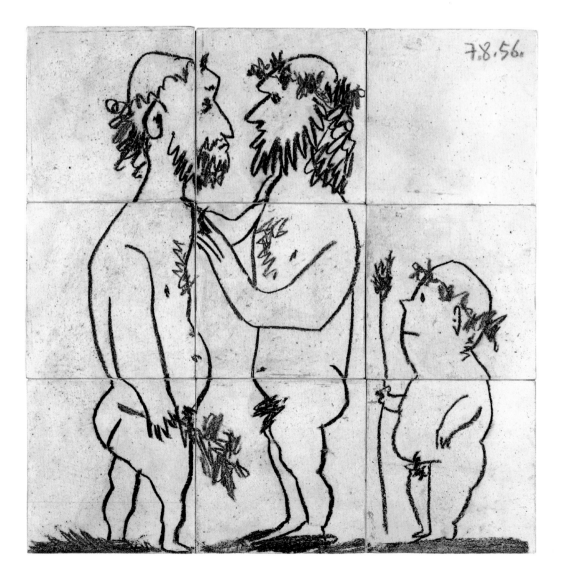

PABLO PICASSO
The Reunion
Nine enameled tiles
12 × 12 inches
1956

PABLO PICASSO
Fish Imprint
Terra cotta pulled from a mold
7 1/2 × 22 5/8 × 5/8 inches
Reproduced in Ermine Herscher,
À la table de Picasso, Paris 1996

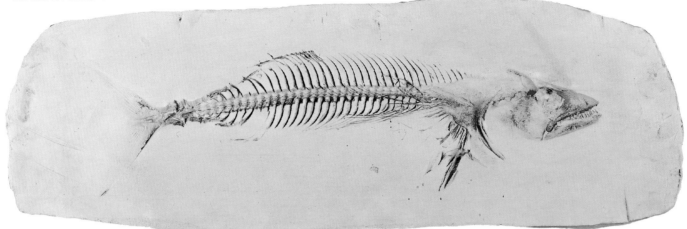

PABLO PICASSO
Bullfight
1957
Terra cotta pulled from a mold
3 3/4 × 11 3/4 × 3/8 inches

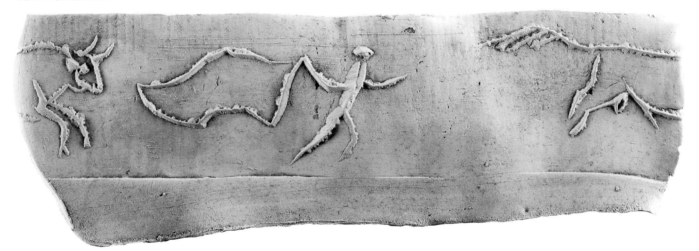

PABLO PICASSO
Plate with Stamps
1957
Terra cotta with stamped designs
4 3/4 × 14 1/2 × 5/8 inches

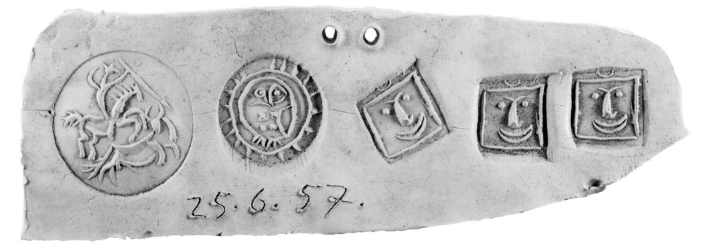

PABLO PICASSO
Portrait of Paul Éluard
ca. 1949
Painted faience
9 3/8 inches in diameter

PABLO PICASSO
Portrait of Jacqueline
1953
White faience, glazed and
engraved
14 7/8 × 12 1/2 inches

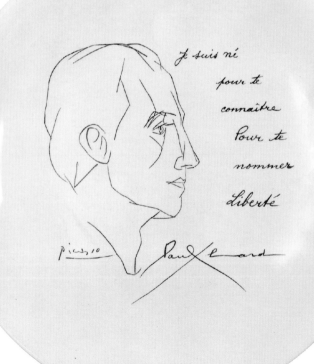

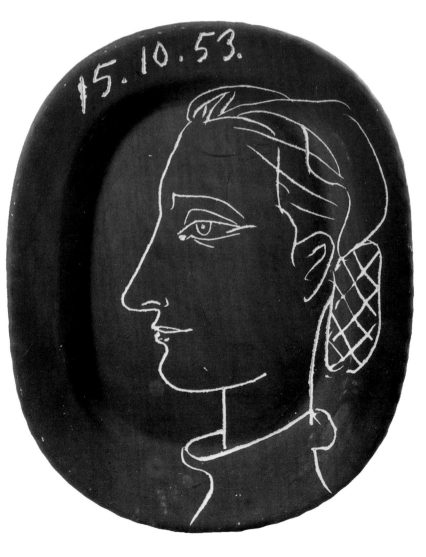

PABLO PICASSO
Breakfast on the Grass
1962
Ceramic ware printed with a
linoleum plate
20 × 24 1/8 inches

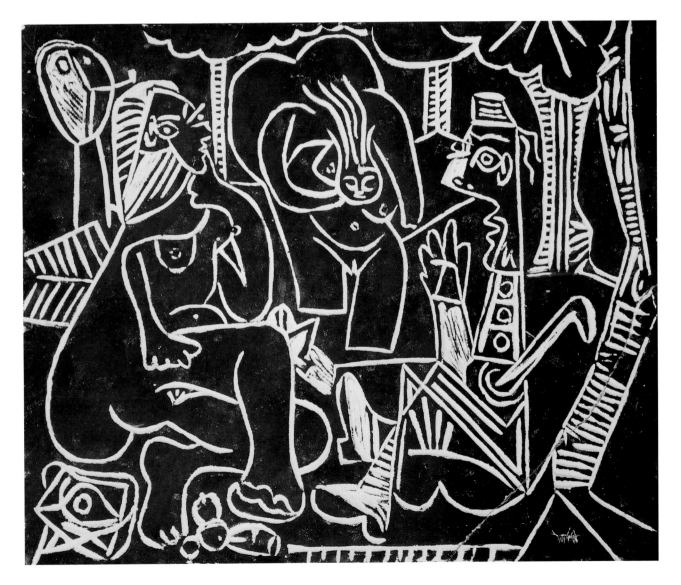

In his 1957 essay, Daniel-Henry Kahnweiler mentioned that in 1946 Picasso rented a house in Golfe-Juan from the engraver Louis Fort. The neighborhood known as Golfe-Juan belonged to Vallauris—a town with a long pottery and ceramic tradition, two kilometers from the coast. One day, Picasso visited Georges and Suzanne Ramie's Madoura workshop with a painter friend, and on this first visit made a small bull with fresh clay. Georges Ramié (*Céramique de Picasso*, Polígrafa) said that Picasso hand-modeled three pieces: a small head of a faun and two bulls. "Once finished they stood on the bench to dry out and await firing and their maker disappeared without a word; months passed—long enough to fire the abandoned pieces several times. We thought that attempt was just a whim which had enabled Picasso to fill in pleasantly a dog-day afternoon in an always cool pottery workshop" (page 12). But this was to be the beginning of a long friendship and collaboration with the Ramiés and the town of Vallauris—in whose main square Picasso's sculpture in bronze, *Hombre con cordero* (Man with a Lamb), stands today.

In Paris in 1945, Picasso had made a small clay statuette: *Mujer de pie* (Standing Woman, 5 1/2 inches high); later he made

a mold that he had cast in bronze in an edition of ten at the Valsuani Foundry. Werner Spies, in *Picasso: Das plastische Werk*

(mentioned above) wrote: "In the mid-1940s, Picasso began to model a series of figures. For his raw material he chose a

malleable white clay. The surface of these small works seemed to be made from lumps and the shapes recall the figures

of Tanagra. In another series of small sculptures, Picasso used clay as if it were flaky pastry. To create volume he divided

the clay into layers which he later stacked. At other times, he cut and pricked the clay with sharp instruments; in short, he

modeled it using technical means. Instead of using his hands, instead of mechanically stamping structures, Picasso made

use of a little set of tools with which he scratched the surface of the sculpture. This was not new. Since the Boisgeloup

period we can see how, time after time, he moved away from modeling—whether by a brief process thanks to which he

obtained a rich textural surface through the engraving of structural marks, or with the use of punches and blades which

allowed him to scratch the surface of the figures. Picasso experimented with these new techniques at a time when he was

also trying to break through the barriers of the medium in graphic art" (page 210). From this period comes a series of small

figures with the same spatial sense, and that therefore date from before his arrival in Vallauris. In these Picasso followed

Alberto Giacometti's sense of scale.

In his essay for the Beyeler catalogue, Pierre Daix explained that it was in February 1949 when he saw Picasso in the

Madoura pottery workshop for the first time. Daix, who was engrossed at that time with the Peace Conference and the

poster of the Dove designed by Picasso, was surprised to see how relaxed Picasso was, working in a place that was not

his own home and workshop.

However, Alain Ramié, in the introduction to his reference work, gives the date of Picasso's first visit to the Madoura

workshop as July 21, and points out that on this occasion Picasso did two works: "He thus readily ended the day, struggling

with the fresh clay and modeling two items which were left to be dried and fired. It was a year later when Picasso came

back and asked about these two pieces. Much to his delight, they were shown to him in excellent condition. He immediately asked to get back to work."

For Claude Picasso, however, the first works were others: "Les tout premières terres cuites realisées à Vallauris étaient de minuscules personnages—a proprement parler, la silhouette un peu obèses de ma mère—qui remontent a 1946. Il a fallu un an pour qu'il reprenne ses travaux a four a très haute temperature de Madoura qui appartenait a Suzanne et Georges Ramié." (All the very first terra cottas made in Vallauris were little figures, most were of a slightly rounded shape of my mother—the same shape goes back to 1946. He made them a year before he took them to fire at the high temperatures of Suzanne and Georges Ramié's Madoura workshop.)

The following summer, Picasso returned to Vallauris and found his three fired pieces, but he was not surprised by them, for he had been cooking up ideas in the fire of his mind during the winter. Ramié went on: "He no longer behaved like an amateur … he turned up laden with the sketches he had accumulated of all those promising meditations. When Picasso took up an issue, he immediately went beyond normal procedure. He had brought a cardboard box full of drawings, and these were laid out, commented on, discussed and admired. This time, it would seem, he was in earnest: here the great adventure began. From that moment on Picasso belonged to our workshop." The "moment" was to last over twenty years.

Picasso was to live in Golfe-Juan only a short time, but he remained nearby—at Cannes and then Mougins—and often visited the Madoura workshop. According to Daix, the Madoura workshop "was the one he liked most, the one he felt most relaxed in. Perhaps because it was there that he found the chance to carry on a technique which stretched back to the beginning of art and which had emerged in the Mediterranean tradition." Picasso was sixty-five years old and felt at home with ceramics. In human history, the production of ceramics meant and presupposed the move from nomadism to a sedentary lifestyle. Only by settling down, undisturbed, could man devote his time to clay. He would await the result of the

firing just as he awaited the time of harvest. Ceramics played a special role in the world of day-to-day living and the community, as it was the material employed for the creation of everyday utensils, as well as for objects of social importance. Now Picasso, who—according to his age—was retired, although with two new children, Claude and Paloma, devoted his time to the ancestral magic of the potter on the shores of the Mediterranean.

Renée Mautard-Uldry, in her article "La Renaissance de la Céramique à Vallauris" (*Cahiers de la Céramique et des Arts du Feu,* No. 3, 1956), pointed out: "In the Madoura workshop Picasso gladly learned the eleven different traditional methods of painting and firing clay and used them himself. He made sure he got to know all the techniques, whether with lead oxide or slip. He used traditional forms, but also created new and striking ones. Though he did not throw the clay, he decided on the colors, he transformed the pieces, modeled them, shaped them and even invented new methods like engraving, paraffin reserves, patina, marking reliefs, etc."

In his essay, signed in July 1971 (in the 1984 Madoura catalogue), Georges Ramié dated that first visit to their workshop at July 26, 1946. In the 1974 Polígrafa catalogue, it is given as July 21 (page 10). As Ramié noted: "It happened that, with the movement of populations due to the still recent war, a great many artists and craftsmen had converged there from all parts of France and even abroad, seeking asylum in the Provençal town, the existence of whose inhabitants had entirely depended for thousands of years on the clay of their soil and on the flames of the pines in their forests." The forests of the Mediterranean pine—Aleppo.

What is important is an assertion by Georges Ramié in his 1971 essay: "Picasso entered the workshop like a humble villager. Subsequently he penetrated our daily life, our family life and our friendship. However, all this feeling grew gently, without complications, as if this unforeseeable, warm, and so precious reality was completely natural; all aspects of his presence became as essential, familiar and necessary as a sweet, daily habit."

In his memoir *Querido Picasso: 35 obras y 14 documentos inéditos* (Destino, Barcelona 1997) the writer Josep Palau i Fabre pointed out: "In Vallauris, at the Madoura workshop naturally, Picasso—after greeting everyone very cordially—went to his

"corner," the place reserved for him under the image of Saint Claude (the ceramists' patron saint), where he had his four colors ready."

The inhabitants and potters of Vallauris knew what they owed to Picasso through the recognition of his work. Kahnweiler mentions an anecdote: When a film was being made of the town, the population gave the artist a standing ovation.

Picasso was not the only artist to work with ceramics in that part of France; Raoul Dufy had worked with the Catalan ceramist Llorens Artigas in Gallifa, and—also in the 1950s—Marc Chagall had worked in Vence. In the catalogue for an exhibition of his work at the Curt Valentin Gallery in New York (November 1952), the Russian painter wrote the following:
"These few pieces, these few samples of ceramics are a sort of foretaste: the result of my life in the south of France, where one feels so strongly the significance of this craft. The very earth on which I walk is so luminous. It looks at me tenderly as if it were calling me. I have wanted to use this earth like the old artisans, and to avoid accidental decoration by staying within the limits of ceramics, breathing into it the echo of an art which is near, and at the same time distant. […] Whether I am speaking of ceramics, of engraving, of sculpture or of painting, all my words are centered on the material, which, because of its very characteristics, is abstract, provided it maintains a certain aloofness. But even if this material were imbued with an excessive sensibility, would it not be better to devote oneself to this, rather than be lost in a world where automatism and insensitivity prevail?"

As Pierre Daix made very clear, the town of Vallauris and in particular Georges and Suzanne Ramié's Madoura workshop was one of the places Picasso regarded as home. "C'est ici que je suis chez moi" was Picasso's response. He felt at home, not only because of the sense of space in the workshop but also because of the "atmosphere," because of those phenomena coming from the sensation of déjà vu that allowed him to feel he was following a Mediterranean tradition linking him with the Greeks, Etruscans, and Iberians. As Picasso himself said: "Ils faisaient déjà ça ici il y a des millenaires …" (Ceramics have been made here for centuries).

It's important to note Picasso's mastery of the material, of this plastic element that accepts a form and will be adapted to the artist's thought. Plasticity is the ability of clay to acquire a determined form. Clay is considered plastic when it is easy to mold by hand or on the potter's wheel without pulling apart. It must contain a certain amount of water in order to allow the clay particles to slide against each other without losing contact with each other and causing the piece to crack.

The clay that is going to be self-glazed is not worked in the same way because it is not as plastic and manageable in the artist's hands and is difficult to throw on the wheel. It is not practical for big objects—but Picasso works with it not by molding, but by building with it; in other words, he sculpts with it. Later he delivers it to the fire.

Picasso not only plays with raw materials (clay, sand, quartz) but also with everyday materials—wires or a spool of thread, or the wooden *Knife* of 1914 and the wire figures of the 1930s which Werner Spies studied very well. Later Picasso built clay pieces that were no longer ceramics but objects sculptured in ceramic material. They are sculptures that include a montage of parts, similar to those he made with found objects. He rediscovered trash, pieces of dry clay or fired clay, pieces that were discarded by other potters, and transformed them into artwork in relief with his magic hands—not with a brush but with a stiletto.

PABLO PICASSO
Knife
1914
Painted wood
5 1/8 × 1 1/8 × 1/2 inches

PABLO PICASSO
Figure
Wire and wooden spool
12 1/2 × 3 3/8 × 2 1/4 inches
1931

PABLO PICASSO
Portion of a drawing of 1903
Christian Zervos Catalog, XII, 16
PICASSO MUSEUM, PARIS

In this pitcher, Picasso remembers the masks that Paco Durrio used so frequently in his sculpture, as for example, in Durrio's monument to Crisóstomo de Arriaga, the musician, as well as the bowls and pots for holy water.

PABLO PICASSO
Artist's Dining Room in Montoage
Drawing dated December 9, 1917
PICASSO MUSEUM, PARIS

In this representation of a dining room, where we see Picasso eating while in the company of two women and two dogs, we find on the left wall the same African mask from the Wode culture (today at the Picasso Museum in Paris) that Daniel-Henry Kahnweiler felt was enormously important to in Picasso's development of synthetic cubism. Several ceramic pieces can also be seen on the left.

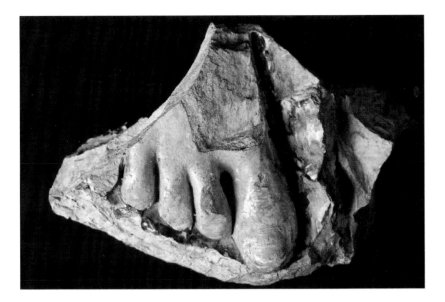

BERNARD PALISSY AND TALLER
Fragment of a Foot
ca. 1556–90
Ceramic with lead-based glaze
7 1/2 × 5 1/2 inches
LOUVRE MUSEUM, PARIS

This fragment of a foot is part of a statue made for an artificial grotto by the Bernard Palissy or his team of collaborators. It is exhibited at the Louvre Museum in Paris because of the quality of its glazes.

PABLO PICASSO
Left Hand
1937
Plaster
8 1/8 × 5 7/8 × 2 inches

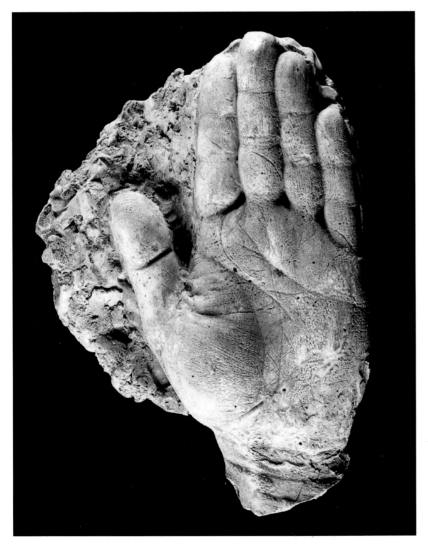

PABLO PICASSO
Left Hand
ca. 1939
Mold of plaster
7 5/8 × 4 × 1 7/8 inches

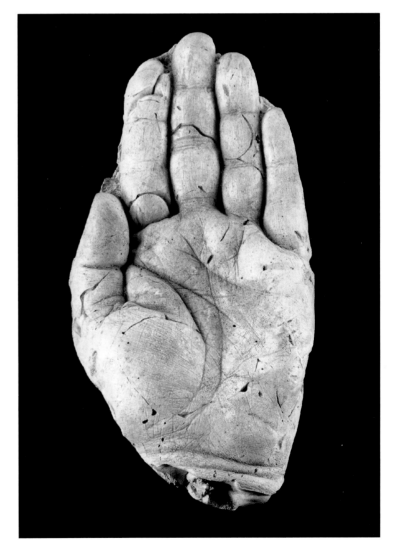

PABLO PICASSO
Eye
ca. 1947
Plaster mold and wire netting
3 3/8 × 2 3/8 × 1 5/8 inches

PABLO PICASSO
Eye
ca. 1947
Plaster mold
4 3/8 × 2 3/4 × 1 inches

PABLO PICASSO
Bird's Head
1950
Red terra cotta
1 × 3 3/8 × 1 5/8 inches

PABLO PICASSO
Fish
Prehistoric fired clay, excavated in Ibiza
7 7/8 inches
MUSEUM OF PREHISTORY, VALENCIA

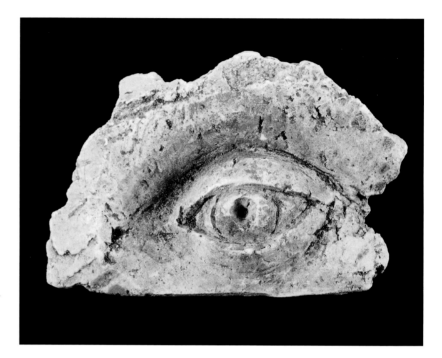

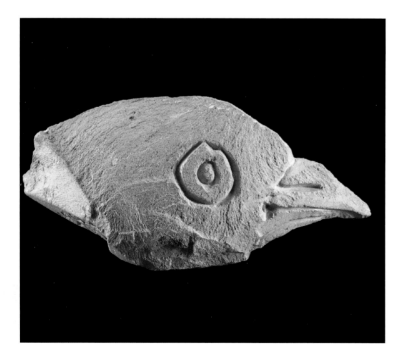

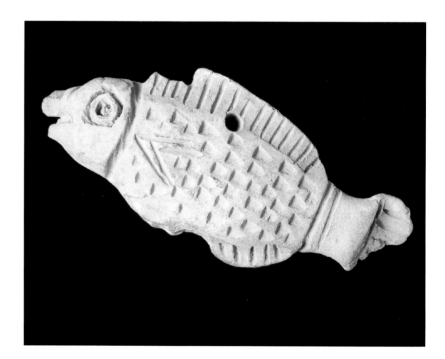

These are the first pieces Pablo Picasso created in Paris, done first in clay and then cast in bronze. The pieces already fired, like *Woman Combing Her Hair*, were probably made at Paco Durrio's workshop in Bilbao. Durrio was an intimate friend of Paul Gauguin, who designated him as the executor in charge of all his affairs when he left Paris definitively in 1895. In assisting the young artist from Spain, Durrio also transmitted to him some of Paul Gauguin's aesthetic conceptions.

PABLO PICASSO

Seated Woman
1902
Clay
5 3/4 × 3 3/8 × 4 1/2 inches

The Jester
1905
Original wax
16 × 14 1/2 × 8 5/8 inches

Head of Fernande
1906
Clay
13 3/4 × 9 3/8 × 9 3/4 inches

Woman Combing Her Hair
1906
Ceramic
16 1/2 × 10 1/8 × 12 1/8 inches

Alice Derain
1905
Clay
10 5/8 × 10 5/8 × 5 1/2 inches

ALL PIECES ARE FROM
THE PICASSO MUSEUM, PARIS

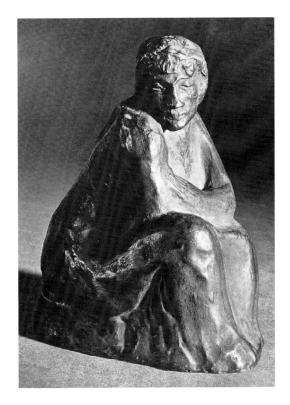
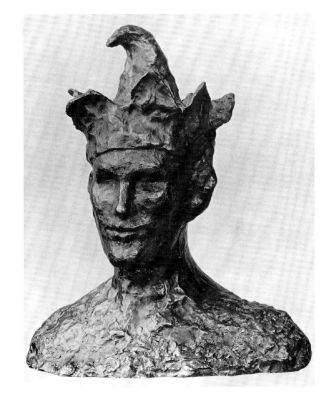
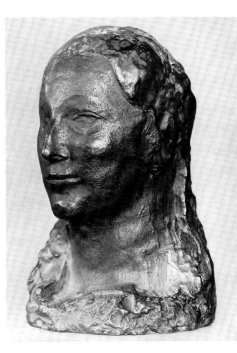
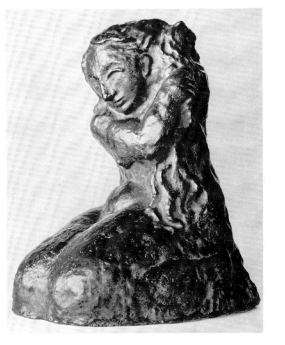
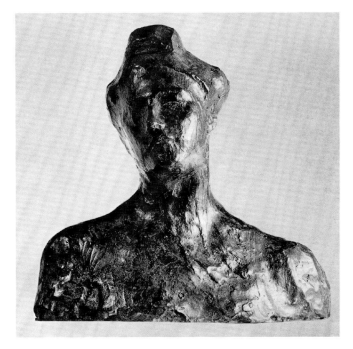

In his 1957 essay the gallery owner Kahnweiler asked "why Picasso began to work with ceramics? What fascinated

him about this, a technique to which he contributed so much? It is obvious that he never treated it as a decorative

art. Picasso never `adorned' finished items, but used them to create other kinds of objects." The answer is, he used

them as a support for new plastic experiences.

Kahnweiler concluded: "To characterize Picasso's ceramics briefly, and clearly differentiate them from work by others

in this style, I would like to point out that Picasso was not a painter whose collaboration had been requested by a

ceramist but an artist who was fascinated by ceramics and began this task in the only suitable place for it—a pottery

workshop. In Picasso's *oeuvre,* ceramics occupy an especially important place."

Daix also pointed out how, on a visit to Picasso in 1952, he came to realize that for the artist "ceramics was not a means of relaxation but the beginning of a new path in his art, similar in importance to the *papiers collés* path he had taken with Braque. In this new medium of expression, Picasso saw the most wonderful possibilities, without having to worry about rules or heeding the advice of traditional potters."

Picasso was the god who reincorporated the value of everyday beauty into the Vallauris potteries, and who raised the ruins and the magic of the clay to make them supports for the magic of his signs. It is the sensation Albert Camus described in *Noces à Tipasa* (1939): "The passing of the years has made his mother's house return to ruins. Finally today its past abandons them, and now nothing distracts them from the deep force that reintegrates them into the center of things that fall. … Here the gods serve as a bed or milestone for the sequence of the days." With Picasso working there, the town of Vallauris once more became a city inhabited by gods, and the gods spoke in the sun and in the fragrance of the plants.

Picasso encountered the material and the light of the native land—a material that originated in antiquity, that contained the remoteness of centuries yet aspired to a modern feeling, that responded to the fresh touch of other hands. Just as the Spanish poet José Ángel Valente describes how the flamenco singer's voice emerges—"The voice of the flamenco singer rises to his throat from what immeasurable distance? His couplet draws on age-old themes"— so Picasso's imagery drew on an iconography that is immersed in the warm, pleasant waters of the Aegean and the eastern shores of the *mare nostrum*.

In Vallauris, Picasso learnt the millenia-old techniques of humanity so that he could leave his imprint on the clay and turn it into a monument, into that immutable *terre cuite* (baked earth) he continually spoke of. Here Picasso learnt the mysteries of the clays, the coloring power of the mineral pigments when fired, and also how to distinguish, just like

Prometheus, between the different kinds of fire. The mystery of firing and the waiting for the pieces to come out of the kiln did more than serve as a source of amusement. Picasso was always asking questions. He learned the effects of high and low temperatures, what oxidation and reduction were, and which was the best wood for maintaining the temperature; although this was the 1940s, the kilns were almost the same as those the Romans had used.

A new type of kiln, an electric one, was to soothe Picasso's impatience to see the results of his experiments. The following is Georges Ramié's account of the new kiln: "Firing by means of oxidizing flames was used until January 21, 1953. Before this date all the pieces were fired this way; then one of the first postwar electric ceramic kilns was installed. For a long time it alternated with the wood-fuel kiln until the latter was abandoned in favor of the newcomer. It was certainly technically very different, both in the thermal rate and in the chemical nature of the glazes treated ..." (Polígrafa catalogue, page 70).

The advantages of the electric kiln for a restless spirit like Picasso's were obvious: ease and speed. In Ramié's words, "Another advantage was that it had a smaller chamber which allowed more frequent firings and therefore shortened that impatient period of waiting for results. The research process was therefore easier, as any loss of interest due to an overlong break in attention was avoided" (Polígrafa catalogue, page 77). Picasso experimented not only with the process of firing, but also with the customary use of the material being fired. Ramié said that he was attracted by "the untiring search for old, broken, raw and fired shards, found by chance in the waste bins. He liked to change their nature by bestowing a new interpretation on them or by modifying their destiny through adding or subtracting attributes" (page 79). Spies states: "In 1948, [Picasso] moved to a little house known as `La Galloise' and set up his workshop in *rue* Fournas. Nearby there was a rubbish dump where he found pieces of ceramic and bits of metal which he would use in his 1950s assemblages" (page 211).

Picasso produced sculpture out of clay and clay remains, and also turned ceramics into a support for his painting. Instead of canvas, he began to use clay—even industrial paving and wall tiles. Here, once more, are the words of his potter Ramié: "With the tiles before him, Picasso carried on along the road of his imagination at the same rhythm and almost with the same brushes. Out of this surprising way of overlapping techniques arose ceramics treated like oil paintings, paintings that took advantage of the characteristics of the ceramic medium, and added them to their own qualities" (page 233).

For Picasso, painting clay—above all if it was to be fired at a high temperature—was like painting in fresco: the tensions which arise are similar. Clay, with its rather dusty surface, absorbs the mass of color or enamel very quickly; it does not allow repetition and even less any alterations in the strokes. Work on clay—as with silverpoint or fresco—allows no hesitation; the hand must be firm and sure. Picasso used paintbrushes that were thick but also hard enough to hold a sufficient amount of color. Furthermore, there is the difficulty of the color; the range of tones applied is not the range that will eventually appear. Metal oxides capable of resisting high temperature and of "expressing themselves" are very few. The painter, helped by the age-old wisdom of the potter's tradition, tried out combinations to obtain given results. The artist thus experimented with "the possibilities," and awaited the results from the firing.

That sureness in the way of making strokes was mentioned by Josep Palau i Fabre in *Querido Picasso* in an account of a visit he made with Picasso to the Madoura workshop in February 1969: "Picasso asked them to bring him one or two vases of the same shape. For almost a half hour he worked very intently on one of them until it was finished. I observed his calm, sure way of working. Each touch was the right one. Before making each brushstroke he would look at the vase carefully and touch it with the paintbrush as if each stroke were predetermined, as if he only had to

execute what was already there, what *he had already seen there*. In the space of an hour he had painted three or four more vases" (page 116).

It was on this visit that Picasso told Palau that he always had the four colors ready for him in the workshop, since four basic colors were applied to ceramics. Picasso liked cobalt blue—for him it played a special role. In Italian it is called *zaffera,* a distortion of *al-safra,* the Persian term for cobalt—the mineral, its oxide and salt. Picasso used it to make black and accentuated it with *bianchetto* to obtain light areas on the modeled figures, sometimes placing white on white.

The British artist and thinker, Bernard Leach (1887 – 1979) wrote in his *A Potter's Portfolio* (Lund Humphries, London 1951): "Aesthetically, a pot may be analyzed for its abstract content or as a humanistic expression; subjectively or objectively for its relationships of pure form, or for its manner or handwriting and suggestion of source of emotional content. It may be coolly intellectual, or warmly emotional, or any combination of such opposite tendencies. Whatever school it belongs to, however, the shape and pattern must, I believe, conform to inner principles of growth which can be felt even if they cannot be easily fathomed by intellectual analysis. Every movement hangs like frozen music in delicate but precise tension." Though Leach was referring more to the action of the potter modeling a pitcher, its void, its rim, the rhythm of its volume, with his wet hands, I believe that these words on hand creation are also relevant to Picasso when he transformed the meaning of the pitchers with a paintbrush and his hands. That vibration of sensitivity can be detected in many of Picasso's brushstrokes on that thrown and dried earthenware which was awaiting the action of the demiurge to be transformed into an object with another meaning.

In ceramics Picasso sought the path that respected both the cultivated and the popular; with the magic of his hand

he sought a new way of depicting his images. He wished to provide a new visual horizon. In 1772—after thirty-six years in Naples—when Lord William Hamilton (1730 – 1803) donated his Greek vases to the British Museum, he did so not only to widen the historical study of Greek culture but mainly to widen the visual horizon of the British potters of his time. Picasso had no intention of industrializing his "poterie"; rather, he wished to widen the real horizon of ceramics as a support for artistic creation. Spies sums up all this work this way: "Picasso's ceramics can be classified into two groups. The first comprises works in which the ceramic material is a vehicle for paint: plates, dishes and vessels. In this kind of ceramic work, the artist is interested, on the one hand, in the color quality of the glazed paint, its luminous values and its immutability and, on the other, in experimenting with drawing and color on rough surfaces, as his comments to Laurens reveal. However, in the context of his plastic work as a whole, the group of pieces in which the artist created his own forms is much more important. Most of these works derived from utilitarian ceramics, which means that here, also, Picasso used ready-made forms which he modified on the wheel or with his hand" (page 211).

The methods of production—or rather of reproduction—of Picasso's work were known to Jules Agard and the Ramié family better than anyone else. The success of mass production, of industrial production, is borne out by the flourishing businesses of the producers of Wedgewood, Limoges, and others. Picasso neither committed himself completely to industrial production, nor to the meditative line fostered by Bernard Leach. After he had settled in St. Ives in Cornwall in 1920, Leach identified with the oriental world and its ideals of sensitivity (expressed in his *A Potter's Book* in 1940) and was to be the prophet of a craft conceived of as spiritual reflection, a road that so many present-day artists have taken. But Picasso did not move in that direction either.

Picasso produced countless unique pieces in ceramic, both functional ones and sculpture, but also made editions of

his work in clay. In the words of Alain Ramié, author of the *catalogue raisonné* of Picasso's ceramic editions: "It was essential to apply to ceramics the method already used in graphic art, but for this new application, the basis of reproduction in engraving had to be constructed on different principles. This particular difficulty was resolved by adopting two methods with different techniques:

1. Making a true replica of an original by repeating volumes and decoration exactly.

2. Transferring an image engraved on a hardened plaster matrix onto a sheet of damp clay."

Thus, apart from Picasso's unique pieces, we must also consider those originating from these two methods, regarded as "Picasso's ceramic editions." They are all authenticated with a monogram and with an edition number.

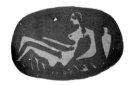

The art of ceramics, or the use of clay to create objects of art and for everyday use, is lost in the depths of time. We see this tradition emerging, within the frame of Picasso's eagerness. In his sixties, Picasso often worked with ceramics, attracted not only by the possibilities the materials had to offer, but because he was able to mold them to his imagination. Some of the ceramics were glazed, painted, or engraved; others were transformed in their uses by the artist's magic power. Some of the pieces are numbered editions signed by Picasso, while others—most of them—are unique. Also, we find some pieces that are not simply decorated, but rather are sculptures. These small, hand-molded figurines acquired all their strong expression with only four incisions, incisions that when observed from the back provide a sense of space and give the figure its position.

In 1956, the gallery owner and scholar Daniel-Henry Kahnweiler published a conversation between the sculptor Henry Laurens (1884 – 1954) and Picasso. This conversation happened on July 8, 1948, at Laurens's gallery at *rue d'Astorg* in Paris. Picasso said to Laurens, a friend from the cubism period and three years younger, "You should try ceramics! It is exiting! I have done a head. You can look at it from all angles, and it is flat. Surely, it is the painting that makes it flat. It has been painted. I have made it flat from all sides. What do you expect or want from a painting? Depth and all the possible space! You need to make a sculpture that is flat to the spectator, from all possible angles. I have tried other things; I have painted over a curved surface and I have painted balls. It's emotional. You make a bottle with it, it escapes from you, and you contort it around the bottle." Three years later Picasso bought a Laurens fired-clay piece from Kahnweiler titled *Femme en Chemise*, to transform it using Chinese ink. Claude Picasso has this to say about the fact that his father would convert the Laurens sculpture to represent a naked woman: "Working with ink on the majority of the flat surfaces in the Laurens, he made it his sculpture, obliterating Laurens."

PABLO PICASSO
Standing Woman
1945
CATALOGUE NO. 1

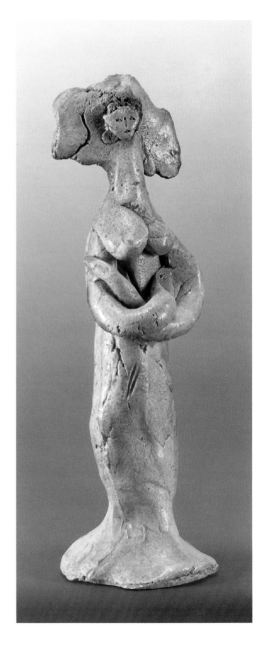

PABLO PICASSO
Standing Woman
1945
Varnished plaster
8 1/8 inches high

Mother Goddess
Terra cotta from Serreta
7 7/8 × 11 3/4 × 3 3/8 inches
ARCHEOLOGICAL MUSEUM, ALCOY

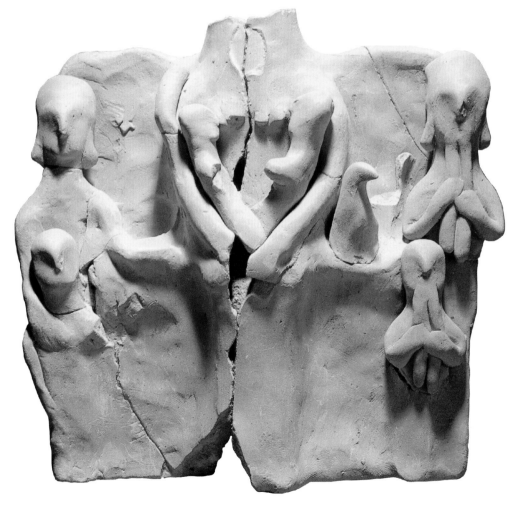

PABLO PICASSO
Woman Standing
1945
Varnished plaster
3 1/8 × 1 5/8 × 1 7/8 inches

PABLO PICASSO
Woman with Her Arms Raised
Boisgeloup 1932
Painted plaster
11 3/4 × 5 7/8 × 5 7/8 inches
A single lost-wax casting was done in
bronze by Valsuani

Standing Woman
1951–53
Terra cotta
11 1/2 × 3 3/4 × 2 3/4 inches
The sculpture, titled **Woman in Chemise**,
was made by Henri Laurens in 1921;
Picasso painted it with Chinese inks
between 1951 and 1953.

PABLO PICASSO
Woman Standing
1945
Colored plaster
8 × 3 1/2 × 3 inches

PABLO PICASSO
Woman Standing
1945
Colored terra cotta
10 3/8 × 3 1/8 × 2 3/4 inches

PABLO PICASSO
Woman Standing
1945
Varnished plaster
5 3/4 × 1 5/8 × 1 5/8 inches

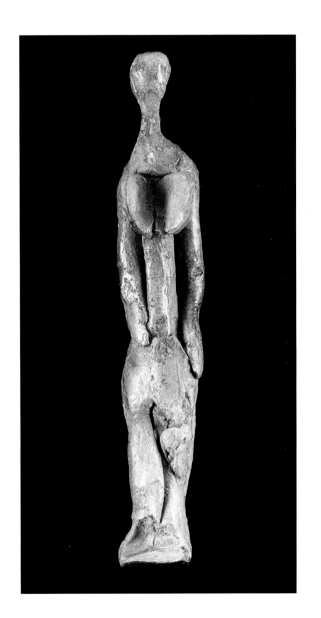

Picasso continued to make use, on the one hand, of his typical iconography—though he was influenced by Mediterranean popular traditions rather than by sophisticated French ceramics—that is, of the abstract style of geometrical or animal combinations, with a fauna and flora taken directly from his painting and sculpture. On the other hand, in the more narrative pieces, in those with motifs in relief or with a great mixture of pigments, his style did not follow the formalism and ornamental complexity of European porcelain, but had the sense of fun of popular earthenware. Four such motifs may be seen in the depiction of such popular figures as courtiers, satyrs, soldiers, and knights; there is a roughness in the expression which only an able hand like Picasso's could allow.

Consider in this respect the uninhibited iconography of the Montelupo ceramics produced in Tuscany in the 1630s, with its plates bearing harquebusiers on their own or attacking fortresses. It is the style the Italians call "*a compendiario*"—succinct—in which, with a reduced palette, the intention was not to cover the whole ceramic piece—plate, dish, or whatever to turn it into an item telling a story—but to underglaze it with an image establishing a less dominant relationship; the plate is a plate and the artist simply enlivens it, without extravagantly covering it *all over*. In his use of outline and color, Picasso preferred to use this sober style; it was vivacious without resorting to minutia or falling into the perfectionism of designs made with the use of transfers.

The themes are faces, birds, still lifes, flowers, typical Bacchanalia and pastoral scenes, bulls, women, the Arcadian world, and the Spanish court. As Georges Ramié wrote: "A noteworthy collection was formed of large round plates—called 'Spanish plates'—which were the logical extension of the tradition. They display, in fact, that typical, profoundly creative spirit that enlivens day-to-day Spanish existence. Their shape, springing from a slight bulging in the center, after a gently rounded depression, continues into a wide, slightly convex handle, which gives the piece an undulating look of very fluent elegance. This form was conceived in memory of a vessel used long ago in Spain. Some examples are still to be found in collections of the triumphal ceramic period in which those famous Moorish reflections shone. Whatever the case, this type of conception goes back to a completely original Mozarabic source and the inspiration it reflects derives form a specifically Iberian character" (page 174). Compare these with the plates painted with colored fish (7 inches) discovered in Numancia (today in the Museo Provincial in Soria) that Luis Pericot studied in his *Cerámica Ibérica* (Polígrafa, Barcelona 1979). Werner Spies also clearly placed this interest at the time of Picasso's arrival in Paris: "Picasso's encounter with Iberian sculpture—which interested him as the Spaniard he was— happened at a time when he was also studying Gauguin's work. In Paco Durrio's workshop he had seen Gauguin's

paintings, ceramics, carvings and wood engravings. Paco Durrio had been a friend of Gauguin's and owned a large number of his works. In 1903, Picasso was given a copy of *Nao-Nao* by Durrio. As a sculptor Durrio was influenced by Gauguin. What is really important is that at Durrio's side Picasso was able to obtain inside information on the Gauguin myth, on his flight from European civilization, and on the archetypal character of the imagery and the customs of primitive peoples" (page 29).

More accurate and broader in its analysis of references is Claude Picasso's essay. He considered the various experiences in Picasso's life which led him to ceramics: that first contact with Durrio's enthusiasm; the 1919 trip to Naples; the illustrated Greek books of the 1920s; the visits to the Antibes municipal museum—the Château Grimaldi—on the invitation of its director, Dor de la Souchère, who was also a teacher of Greek at the Institute of Cannes; and his wife, Françoise Gilot. He said: "It is often thought, not without condescension, that the artistic expression of Picasso changed each time a new person entered his life. It has to be admitted without reserve that my mother, Françoise Gilot, was an extremely authoritarian person (exactly the opposite of Marie-Therese Walter, Dora Maar and Jacqueline Rogue, for as much as I can remember)... My mother possessed the deep certainty of those patrician figurines from Tanagra that my father had recreated in his own unmistakable style. At the same time that she is fully aware of being firmly anchored in reality, with both feet on the ground, her eyes are profoundly anchored in the infinite spaces of truth, like those so well described in the subject of the painting *La Femme fleur.*"

At times Picasso worked on the shapes of the vases, turning them into human forms, into faces like the ancient Greek *oinochoes* (wine pitchers) signed by Charinos (in the Antikensammlung in Berlin). The Greek potters created those vessels with female heads with very detailed adornments and cosmetics. Some authors (like H. Schuhhardt) believe that they were vases used by sacred prostitutes. The *oinochoes* lend themselves to this head form because

of their large handle, which rises above the rim rather like a hat; these handles helped Picasso to form surprise elements. Picasso also reinterpreted the "archaic smile," giving his figures a sense of amusement and innocent enthusiasm. But in no way did he abandon in this type of decoration his great sense of volume, that sculptural sense with which he approached all his constructions, and which deep down was what he wanted to communicate to Henri Laurens in the anecdote recounted by Kahnweiler and retold by Claude Picasso in his essay. Using a paintbrush, Picasso could flatten the volume or give planes the sense of relief.

We can see this perfectly in that brick, that fragment of building brick, beautifully metamorphosed by Picasso (Catalogue no. 49). If we compare the three 1952 pitchers (Catalogue nos. 24, 25, and 26), we can see how he transformed them simply through color and underglazes. They are identical in form, but Picasso's treatment is different: he painted two, three, or six masks, and, above all, changed the patches of enamel and enlivened the third with outlines engraved in the clay.

The sense of composition ancient Greek vases show—the weight of the figures enlivening the volumes of the amphoras, the mastery with which a figure organizes the space, the force of the decorative borders that at once emphasize the edge of the plate or dish and frame the central scene—can be detected in the circular dishes Picasso devoted to bulls (Catalogue nos. 45 and 46), and especially in that 1969 piece, which, like a Greek vase, depicts a very elegant female head (Catalogue no. 61). It is without doubt a portrait of Jacqueline Roque, whose eye, eyebrow, and ear were produced by making a reserve in the black enamel. The edges of this plate have a geometrical border with little discs, very much along the lines of the Archaic Greek style.

Picasso placed the figures and their gestures not only in accordance with the space available for representation,

but also in a harmonious balance between the color of the image and that of the base of the vessel, sometimes experimenting—as he did in engraving—with paraffin reserves to allow the original texture of the material to show through.

The bull theme was the preferred motif for plates, and later for the dishes whose oval shape enabled Picasso to play with the space in which he mixed the colors of the bullring, the bull, the bullfighter, and the tiers of seated spectators. Picasso used the oval shape of the dishes as an area within which the scenic perspective was adapted to the ellipse, as if the dish were a cinemascope screen. The uninhibited styles of Tuscan Montelupo ceramics can also be seen— and might have been seen by Picasso—in the tiling in the Saint Clare cloister in Naples, designed by the architect Domencio Vaccaro, and executed by the ceramicist brothers Giuseppe and Donato Massa between 1741 and 1742. Displaying idyllic comedy scenes, they are full of the *opera buffa* humor with which Picasso depicted his satyrs or caricatured his friends and himself. The *ABC* critic, Adolfo Castaño, wrote (December 19, 1997): "The general characteristic of the ceramics and pottery objects exhibited here—vessels, birds, plates, and figures—is a certain respect for traditional forms. Picasso accepted the contours and the function of vases and plates and raised their status, making them his through the way he decorated them and this, of course, made them unique. He humanized his surfaces by drawing faces, eyes, and women on them or animalized them with birds (owls) and fauns, marking the remaining space with emblematic signs that, in a Picassian fashion, covered their spareness."

In his *Querido Picasso* (Destino, Barcelona 1997, page 87) Josep Palau i Fabre recalled Picasso's interest in a La Canonja terra-cotta moneybox he had been given by the Catalan writer and which he transformed into a small sculpture. Consider, in *Mujer con piernas cruzadas* (Woman with Her Legs Crossed, 1950, Catalogue no. 13), the simplicity of the movements, the soft layer of white forming the towel, the flowing waves of the hair. In 3 1/8 inches

of clay, Picasso achieved a monumental image, beautiful in all its aspects. It can be compared with an alabaster image from the Yemen from the first century A.D. which depicts a woman with very wavy hair seated on a curule seat (see page 28). Her head and legs are shown in profile, her upper body in three-quarter-face. In one hand she is holding a small vase with two handles, in the other, a statuette of a gazelle. Her feet are resting on a very faintly engraved stool. Opposite her is a smaller male figure standing on a stool. He is armed to the teeth and has a lance in his right hand, a bow in his left, a sheathed dagger at his waist, and a quiver on his back. Both figures are wearing pleated clothing. Between them, in the upper area, there is a dedication with a moon in the last quarter and a Venus medallion, and at head height a cubic incense table on a kind of cross, an essential object in the cult.

This kind of agile "writing" which is not monumental, this kind of rapid yet also detailed drawing of the figures is what Picasso also displayed in many of his narrative images. They seem like quick graffiti images, yet Picasso records many details.

The art of ceramics—the use of fired clay to create both everyday utensils and art objects—goes back to the dawn of time. In the Mediterranean area alone, the various civilizations that have inhabited the shores have used the potter's wheel to produce an endless variety of beautiful pieces.

It was from within the framework of this tradition that the work of Pablo Picasso emerged. The lovers of his genius will be fascinated by this exhibition of pieces whose everyday shapes have been transformed by the artist's magic touch. When he was over sixty, Picasso tackled ceramics again and again, attracted by the possibilities the material offered him, and by the responsiveness with which it adapted to his imagination. His achievement recalls those words in the *Wisdom of Solomon:* "For the potter, tempering soft earth, fashions every vessel with much labor for

our service; of the same clay he makes both vessels that serve for clean uses, and likewise also all such as serve to the contrary: but what is the use of either sort, the potter himself is the judge."

Some ceramics are enameled or painted, others incised or engraved, and the purpose of still others has been transformed through the magic power of the artist. Some pieces belong to a series, numbered and signed by Picasso; most are unique. Then there are the pieces which are not merely decoration, but sculptures in their own right. Consider those small 1950 figures (Catalogue nos. 12 and 14), *Mujer de pie* (Standing Woman) in red clay and *El Músico* (The Musician) in white. Modeled with the hands, they take on all their expressive force through four incisions which, if observed from behind, are what give the sense of space and position of the figure. As we turn *Hombre sentado* (Seated Man, 1952, Catalogue no. 22), the face changes from being rather chimpanzee-like to that of a thoughtful villager with a big nose.

Picasso's ceramics speak through everyday objects over which the artist's hand and paintbrush are inclined (sculpting it, painting it, or engraving it—metamorphosing it). The language of man, of his myths and his history, is baked into them and captured. They possess—or rather acquire—the artist's deep vitality, humor, and irony, which encloses them in the telluric mystery of matter consecrated to fire.

When you compare this series of plates and bowls with a still life (a set of flatware and an apple), we can substantiate Picasso's technical resources. The representation of a fork and a knife is not only achieved with color, as in the first example, but also with the glaze and the incisions in the plate, or only with an incision as in the third example. Picasso worked with diverse technical resources, one time by only using one color (fig. 3), another time by taking advantage of different tones— in other words, by manipulating the amount of metal oxides (Figure 1), or leaving portions of the clay unglazed (Figure 2).

In Figure 4, the fish silhouettes continue up to the plate's inside border, whose shallow depth makes it appear flat. On the back he uses an opposite technique to create the volume of a turtle with the plate's belly. Javier Valenzuela said that the term "still life" when applied to Picasso's work is "especially appropriate ... The skulls, guitars, bottles, candles, newspaper sheets, and other objects that the artist from Malaga painted on are so alive they talk back to you, they summon the spectator both with contagious humor and depressing paternalism." Here in these flatware pieces, he expresses it with their schematic apples and rhythmic peels.

The other examples with the same one-color linear style, two plates measuring less than two and a half inches in depth (Figures 6 and 7), help illustrate Picasso's use—or abolition—of borders. In the solar disk, the border is obvious because of a diverting ray from the solar face. In the piece with the owl, Picasso's lines, rather than defining the interior border merge with the strength of the image.

Figure 1
PABLO PICASSO
Still Life with Apple
Glazed ceramic
13 inches in diameter

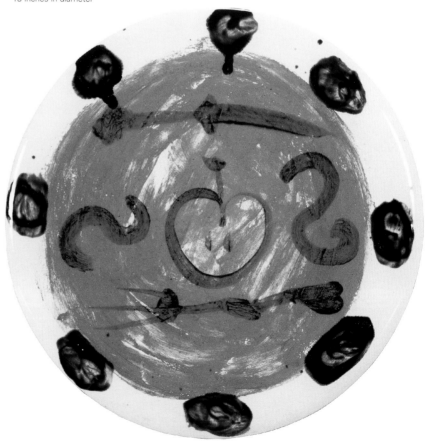

Figure 2
PABLO PICASSO
Still Life with Apples
Painted and partially glazed
ceramic
13 3/4 inches in diameter

Figure 3
PABLO PICASSO
Still life with Apple
Painted and incised ceramic
12 3/4 inches in diameter

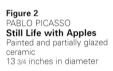

Figure 6
PABLO PICASSO
Solar Disk
Painted and incised
ceramic
16 5/8 inches in diameter

Figure 7
PABLO PICASSO
Owl
Painted and incised ceramic
17 5/8 inches in diameter
Dated on the back: 2.4.57

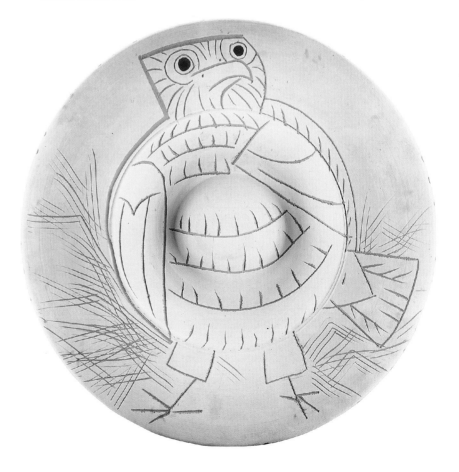

BERNARD PALISSY (Attributed)
Oval Bowl with Animals
ca. 1570
Glazed ceramic
19 1/8 × 14 1/2 inches
NATIONAL CERAMIC MUSEUM, SÈVRES

In this work, Palissy (or the artist who copied him) created a bowl with drawings of fish, crustaceans, mollusks, and reptiles. It shows good harmony in its color and excellent craftsmanship in the use of oxides and in its firing. Without a doubt Picasso brings back Palissy's still-life iconography, both in its color and in its sculptural relief. However, with his well-known facility, he abandons Palissy's harmonic sense of arrangement, instead organizing the composition in his characteristically more informal and amusing manner.

Figure 4
PABLO PICASSO
Still Life with Fish
1957
Painted ceramic
17 1/8 inches in diameter

Reverse of adjacent piece
Dated: 17.4.57

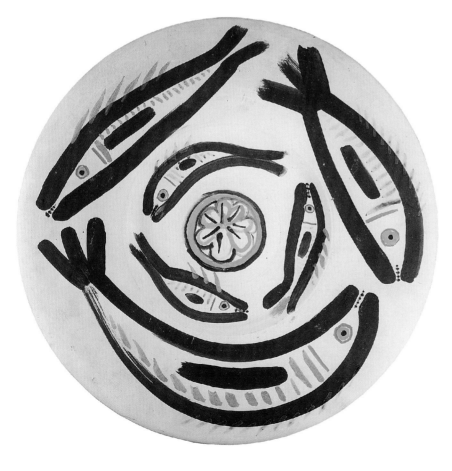

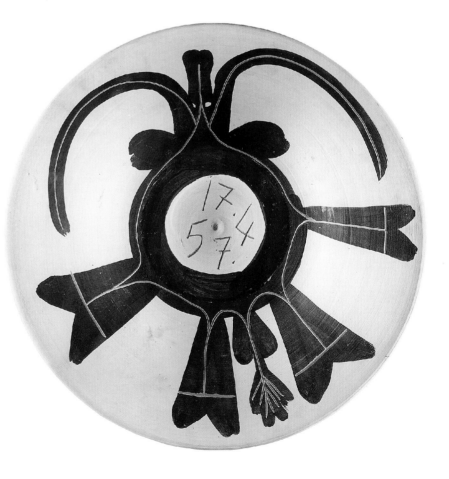

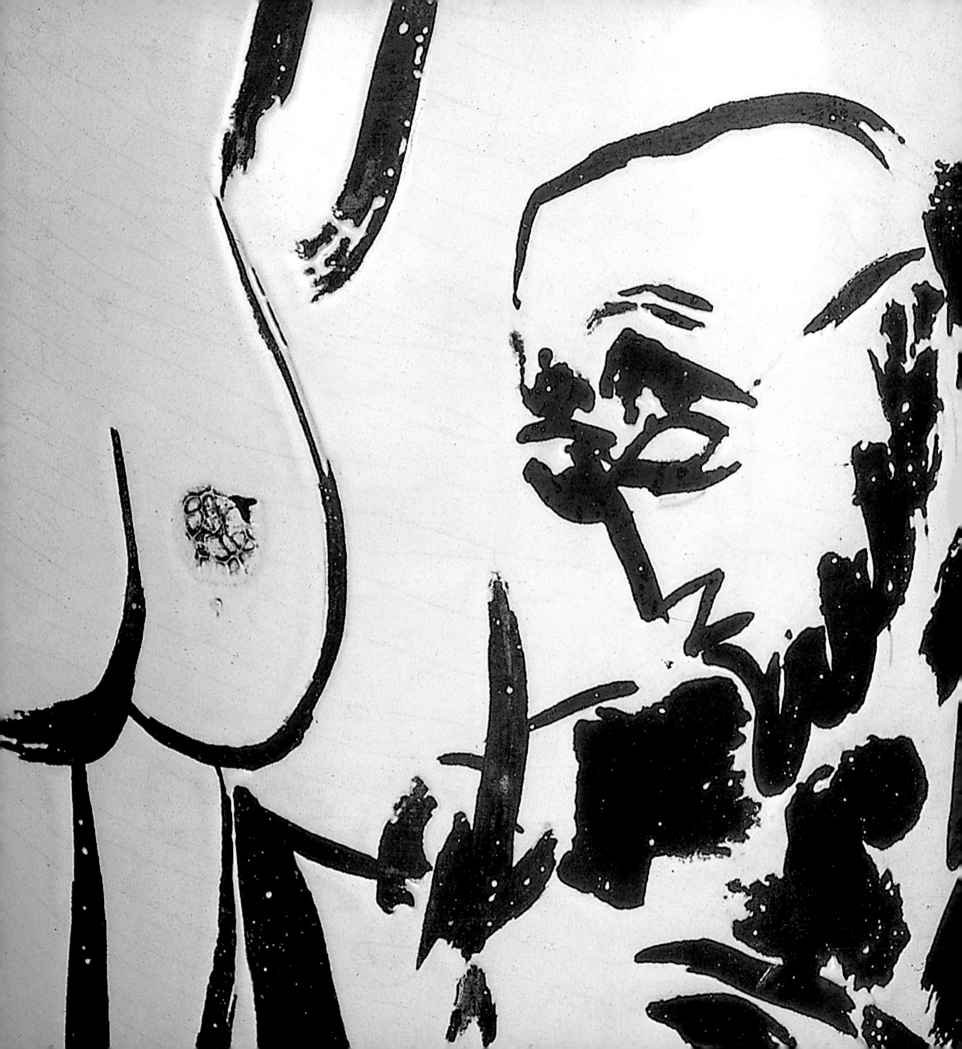

PICASSO'S CERAMICS
PERSPECTIVES OF SEVEN ARTISTS

© Jesús Uriarte

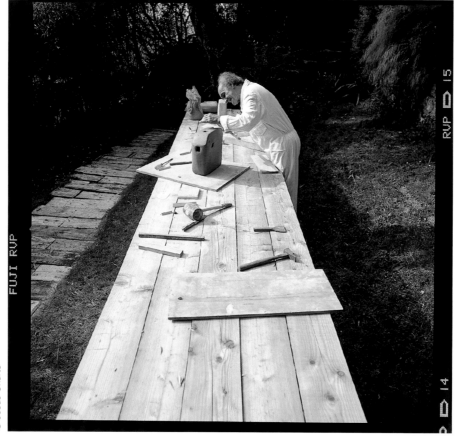

PICASSO FUE UNA FUERZA
DE LA NATURALEZA, CON
UNA NATURALEZA QUE NO
SIEMPRE SUPO CONTROLAR
SU FUERZA.

Picasso was nature's
force, with a nature
whose force he could
not always control.

Eduardo Chillida
San Sebastián, January 1998

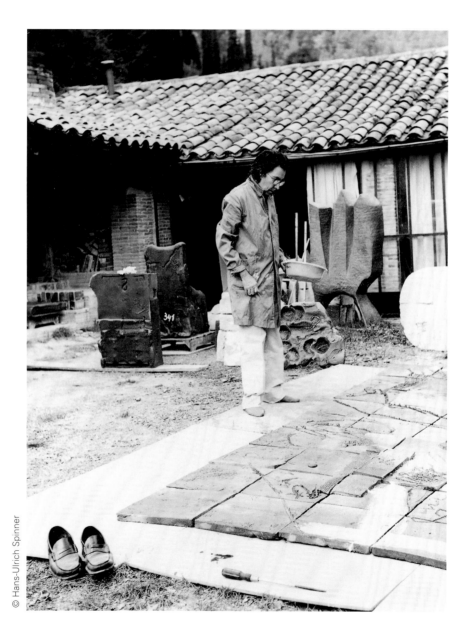

© Hans-Ulrich Spinner

Picasso's ceramics are a beautiful example of what you can do with everyday

images and with the most common materials. His ceramics are on a level with

many of his primary works—his famous 1912 or 1913 cubist drawings, his

brilliant 1926 *Guitarra* made with only a bit of rag and four strings, and in so many

of his paintings done with newspaper strips . . . , and also, it is evident, in the

most ordinary and popular fired-clay pieces. This places Picasso in the best moral

and aesthetic tradition, one that stimulates us to make all things and all

human actions beautiful, to consider that the best artwork is life itself,

and to realize that, within each of our specific

Antoni Tàpies

professions, we all could and should be artists. Barcelona, January 1998

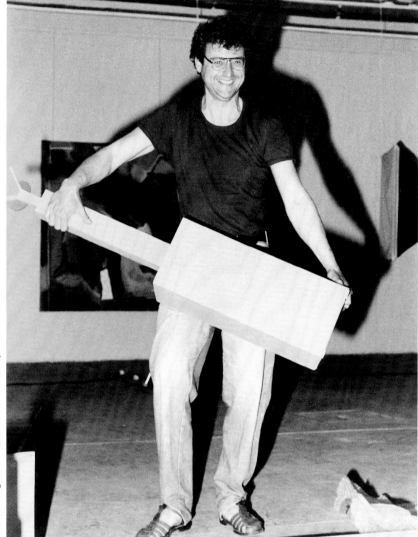

Foto: J. Pingarron · © Galería Fernando Vijande

Picasso's ceramic work brings together the essential primitive, ancestral aspects of creative activity, and enriches them with the patina of history, thus incorporating diverse eras, from archaic to contemporary. I would like to highlight two qualities of Picasso's ceramics. From one side, we don't find him a strict professional of this technique, which demands an exhausting and orthodox process. But from the other side, the fact that he does not know the technical part permits him to display a fresh and direct approach, distinct from the academic styles that might be present in his pictorial artwork.

As a creative procedure, ceramic art has its own autonomy; it often escapes the intentions of the artist. In ceramics, therefore, there are casual and accidental elements that are surprising. However, its true virtues are permanent; they originate with the material itself, which is profoundly attached to the earth and its origins. Picasso feels it that way and that is the way he expresses it.

Miquel Navarro
Valencia, December 1997

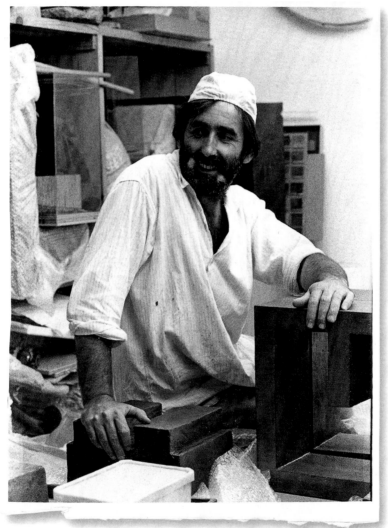

© Maite Oñederra

Among its many achievements, Picasso's ceramic work implies a revision of most of the processes that the medium has to offer. In his intense search for the medium's possibilities, his enormous production made him plunge into the adventure of someone younger, someone who seeks the imprint of his own creative language, even though he began his work when his career was completely established, with sixty years' experience behind him. This factor differentiates him from many other artists—painters, sculptors, designers—who came to ceramics to find variations in their artwork as a way to overcome the exhaustion of the creative language burdening them.

As he establishes himself for several years in a ceramic shop at Vallauris, Picasso assumes the difficulties, the lack of understanding, and the jokes that the presence of a famous artist commands at a place with a ceramic production tradition. There he examines, observes and utilizes the available resources, as he takes advantage of the artisanry of production in the workshop, applying enamels, englobes, and oxides over floor tiles, plaques, bricks, or wheel-thrown pieces that he alters, deforms, joins, composes, engraves, scrapes, and prints . . . creating a universe of relationships between color and form that, until that moment, was never suspected.

His contribution is a radical change in the concept of ceramics. As he had done in earlier years with other materials in the field of sculpture, Picasso broke with the medium's previous uses to give us a glimpse of a magnificent array of possibilities. Here he restates the medium's capacity for expression, liberating it from procedures that had constricted it for centuries. As he follows the historical transformation of ceramics through several cultures, Picasso's attitude dignifies the presence of the ceramic language in modern sculpture and makes it stand out as the standard to be used in understanding the sense and evolution of the art of his time.

Angel Garraza
Mungia, December 1997

Certainly, the city of Vallauris benefited and it still continues to benefit from Picasso's stay. And I suspect

that the reverse is also true. Picasso's ceramics—excluding those that support his paintings (such as the

bullfight scenes)—are, in my opinion, plates and vessels decorated by a genius.

In the curious and playful handling of the clay were born unique pieces with a immense power of attraction

and some charm. However, much of this attractiveness was destroyed when they were produced and

distributed as a series, for purely commercial reasons.

Without a doubt, we would find Picasso's ceramics completely different today if—perhaps through his

friend Miró's intercession—the artist could have found his way to Llorens Artigas's workshop.

Nevertheless, this is one ceramist's biased opinion, one

who mourns the fact that he never worked with Picasso.

Hans-Ulrich Spinner
Grasse, January 1998

It was Picasso's adventures in pottery that some artisans from Vallauris rejected, leaving Suzanne and Georges Ramié free to receive the magician at the their workshop. You can imagine Picasso entering the workshop and finding Jules Agard, the potter, working on a series of bottles. Animated and with interest, the magician transforms the bottles into pigeons! Bravo! Applause! This is better than a rabbit jumping out of a hat! If you judge him historically, it was worth it. But at the time, the trick was not a triumph. Try to arrange a production like this in similar circumstances. The situation would have to be acrobatic in nature.

For a little history, we could tell short stories, for example the one of a group of Hindus that arrived at the Madoura workshop. At that moment Picasso was alone and the visitors asked if they could see the owner. He answers, no, because he is too busy and the owner is not there that day, but he shows them the workshop, he explains the work and takes them to the door without introducing himself.

Let's leave the little history, there would be too much to tell. Let him speak: "In ceramics, the artist can demonstrate his creativity and the force of his inventiveness as in a painting, but with the safety of the spontaneous qualities of a concrete result, which is born specifically and materially from his hands." That's how he underscores the originality of his work from the earth, placing his expression directly in the center of the work. Thus, he leaves the debate about the "ceramics of a painter or the ceramics of a sculptor."

In talking about him, we have heard the expression verve (inspiration). It is interesting to use a word that refers to words, for in artwork like this it as if the word were indispensable in defining all mediums of expression. However, he treated words like materials. Are we referring to his origins and the magic spell of the Spanish speech? Nevertheless, not all Spaniards handle the paradox like Picasso did.

It would be more accurate to talk about techniques, those found in Provence at the time. We are in 1946: glazes, enamels for earthenware, painted motifs with brush, with the work thrown, modeled, assembled, and stamped for molding. Talking about this brief sampler of techniques brings to mind many images. The pigeons, modeled of wheel-thrown bottles, the clay not yet set, the squatting woman, the hawk at Grimaldi's museum. The engravings—all the motifs engraved in plaster—the bullfights, the red land, the square face in a round plate, and many more. Earth-engraved plaques . . . Can we talk about the decoration of these pieces? Also, the montages where form and motif unite to define the purpose of the work: the owl, *la tarasca,* the pitcher with a bull with *banderillas* . . . but let's not do an inventory. To conclude, may we send a friendly salute to the Madoura workshop team around Monsieur Alain Ramié at the time when Picasso's pieces were definitely unrestrained in their adventure.

Michel Anasse
Vallauris, January, 1998

Picasso was interested in ceramics very early, possibly in Barcelona, before he went to Paris. It was in Paris in 1921 where he met Llorens Artigas and they became friends. The interest that he had in ceramics at that moment did not leave him unresponsive. At the time, there were many artists who used clay as a medium of expression: Rouault, Gauguin, Dufy, Renoir, and a long list of others.

In the 1920s, Artigas worked in Pablo Gargallo's workshop at La Rue Blomet, the same that Joan Miró later occupied. Later, in the 1930s, Picasso told Artigas of his interest in working in ceramics together, and showed him twenty pieces he had done. Artigas looks at them, speechless. Picasso interrogates with his penetrating eyes and, confronted with Artigas's silence, he says "Galeries Lafayette" [a fashionable Paris department store]. The ceramist agreed, and Picasso broke all of them. This anecdote confirms the severity of the demands that Picasso placed on his work.

They decided to make a two-by-three meter mural that Artigas was preparing in his Charenton Le Pont workshop at the outskirts of Paris. But this panel was never realized; it was later decorated by Raoul Dufy. This frustrated collaboration between Picasso and Artigas was Picasso's first obvious attempt to make ceramics.

It is well-known that the painter had an interest in and desire to use different forms of expression—sculpture, engravings, lithography . . . so it is not difficult to conceive that ceramics would interest and intrigue him: a world of fire and surprises, with a staying power that had a compelling attraction for the young Picasso. Picasso's ingenuity, his marvelous imagination, and his personal pictorial world would be the foundation for his new work at Vallauris, an old town of ceramists in the south of France, a town whose name, "Valley of Gold," comes from the metallic reflections of their artisanry. Picasso would contribute to the rebirth of this potter's town, since all his world of pigeons, fauns, bulls, and fishes will come alive in the ceramists' Madoura workshop, at Vallauris by the Mediterranean—the same Mediterranean where, in Greece, centuries before Jesus, you could already see the collaboration between painter and artisan. This collaboration is essential in Greek ceramics, as it is with Picasso's work, or the joint Miró-Artigas work, and the great pre-Columbian, Persian, and Far Eastern work. The ceramist is the artist, omitting the decorations and making the quality of glazes themselves the protagonists, valuing the ceramic piece itself.

We are following the steps of the Greeks, the Mediterranean cultures, the Etruscans, and the Phoenicians—the Mediterranean that is the cradle and fountain of our history. Picasso understands and utilizes the sources of classicism, which he brings to modernism with the genius

of his drawings. Picasso understands that you should not burden ceramics with detail—because the richness of the glazes is, in most instances, better. This makes him adapt the drawing to the form, to a whole world of forms that Picasso, amused, transforms to create a new language, a language full of dreams and magic. Also in old Greece the painter—like Picasso—uses ceramics to support magnificent drawings, real lessons in knowing how to do things, masterpieces of drawing that talk about everyday life, about its struggles, about love, music, and about the gods. The freedom of expression Picasso showed in these works arrives with the knowledge and the opportunity his collaborators at Madoura and Ramié offered him, by putting their knowledge within reach for the established painter, establishing a complicity in their work, making a place favorable to creation without any obstacles. And with respect for the discipline of the craft—the only law that should be respected: doing things right, knowing the requirements and the technical demands of what you *can* do and what you should *not* do.

Bulls and bullfighters, owls, women, fish and birds, pigeons and flowers, centaurs and satyrs, this is the world that will populate these ceramics, which Picasso, with outstanding ability, with enthusiasm and perseverance, created throughout the decade of the 1960s. The abundance of his ceramic work is due to his enormous creative power, but also to the help of his collaborators at Vallauris.

I met Picasso in 1961. Joan Miró introduced me, and we visited his home and workshop at Californie in Cannes. The great friendship that Picasso constantly demonstrated to Joan Miró did not lack the rivalry that always exists between two great painters. Miró's first ceramics preceded Picasso's ceramics, as the first Miró-Artigas collaboration took place after the war, in Barcelona in 1945. During the 1950s and 1960s, Picasso worked in ceramics with intensity. I remember a day when Miró came to visit at Gallifa with a Picasso plate under his arm. He showed it to us—it was a the arena of a bullfight, with *toreros*. The plate was magnificent. Miró asks my father for his opinion, and watching Llorens Artigas's face, Miró said: Can we do it better? Of course! Artigas answered. Of this encounter with Picasso's plate a three-month period of intense work between Artigas and Miró was born: "TERRES DE GRAND FEU." The work was exhibited in Paris, New York, and later at Niza, at the Matarosso Gallery. Picasso came to the opening. This friendly rivalry, based on mutual respect, provided in part the energy needed to create these artworks. We could say that Picasso's ceramic work is *earth and drawing,* while Miró's is *earth and fire.*

We have talked about the influence that Greek ceramics had on Picasso's ceramics, but we also find another one, technical in nature: the use of low-temperature glazes (less than 1,000° C.) of Arabic origin, which are characteristic of all the Mediterranean area. These are lead

glazes with strong colors, intense blacks, cobalt blues, and copper greens, with manganese, iron, and a world of mineral oxides, colors that they will reveal through the glass of the glaze, as well as the white englobes applied over red clay, all techniques used for many years in traditional pottery of the Mediterranean people.

Possibly the idea of making numbered editions of many of these works comes from the custom the artist employed for engraved prints and lithography, since it is not common for ceramics to be numbered.

We should be grateful to Picasso's talent, to his creativity and capacity for work, for creating these works that today open the path for new generations, and fill us with admiration and happiness. These works have been realized with great respect to the ceramic craft, and with respect to its techniques and the discipline. Let's rejoice, for as these works keep the freshness of their spontaneous realization, they show us a part of Picasso's work which is of great interest, while with the passage of time they also enter into classicism, and find their source in the ceramics from "Ceramikos," the potters' district of Athens, bringing together ancient Greece, cradle of our culture, and Picasso's masterpieces for our admiration.

J. Gardy Artigas
Gallifa, November 1997

1

CATALOGUE OF THE EXHIBITION

8

1. Standing Woman

1945
5 1/2 × 1 7/8 × 1 3/4
Fired clay, modeled

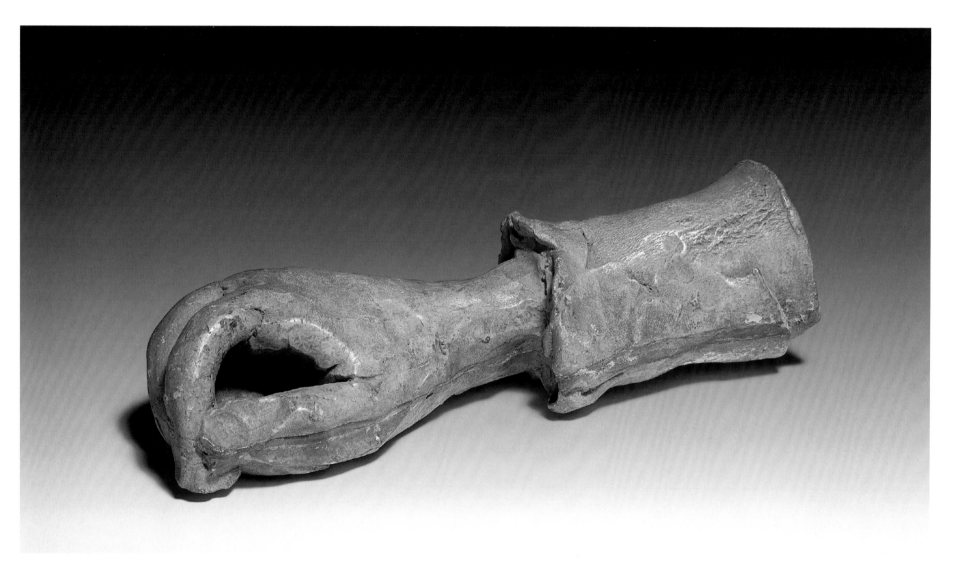

2. Hand with Sleeve
1947
2 3/4 × 9 1/2 × 3 3/4
Varnished plaster

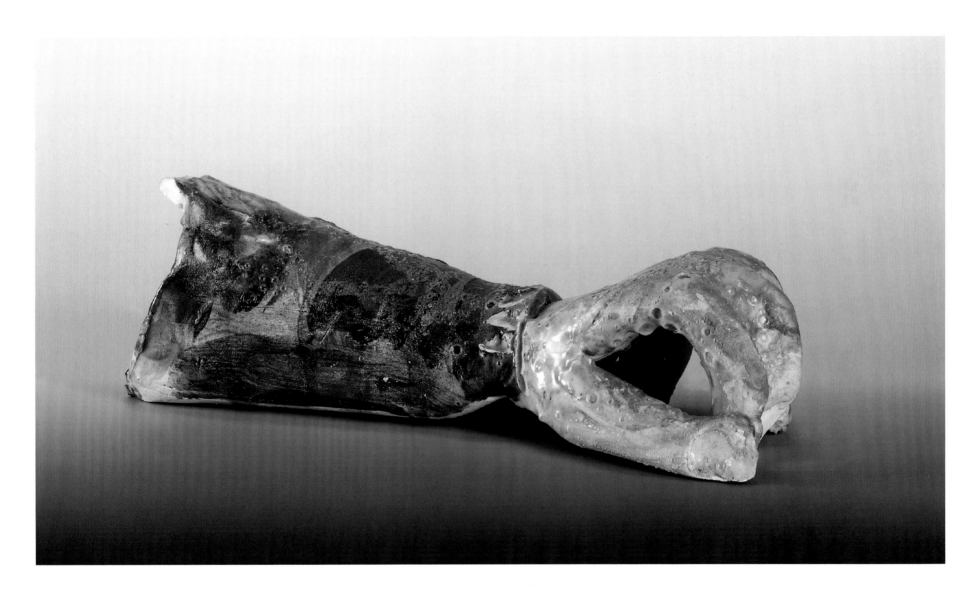

3. Hand

1947
3 × 9 1/2 × 3 1/2
Fired white clay, painted
and glazed
Unique piece

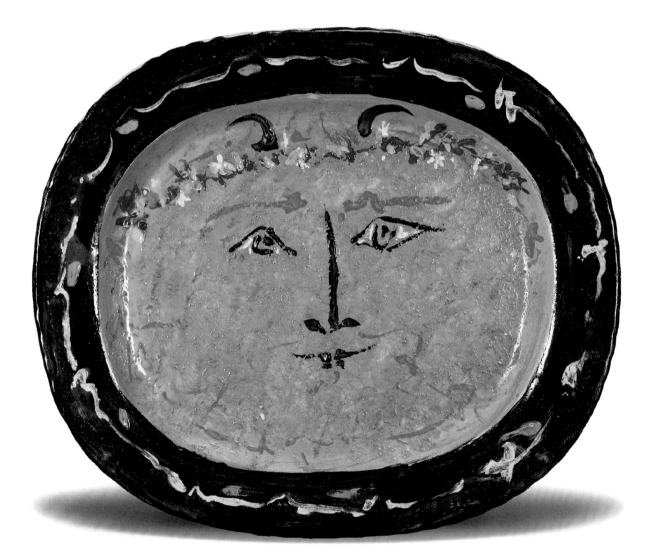

4. Long Plate (Head of a Faun)
1947
14 7/8 × 12 1/2 × 1 7/8
Fired clay, painted and partially
glazed

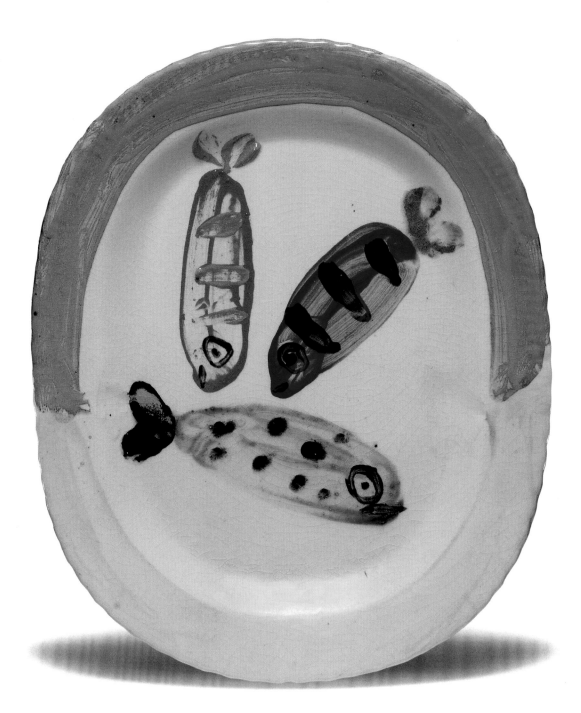

5. Long Plate "Fish" (Three Fish)
ca. 1947
14 3/4 × 12 1/4 × 1 3/4
Fired clay, painted and glazed

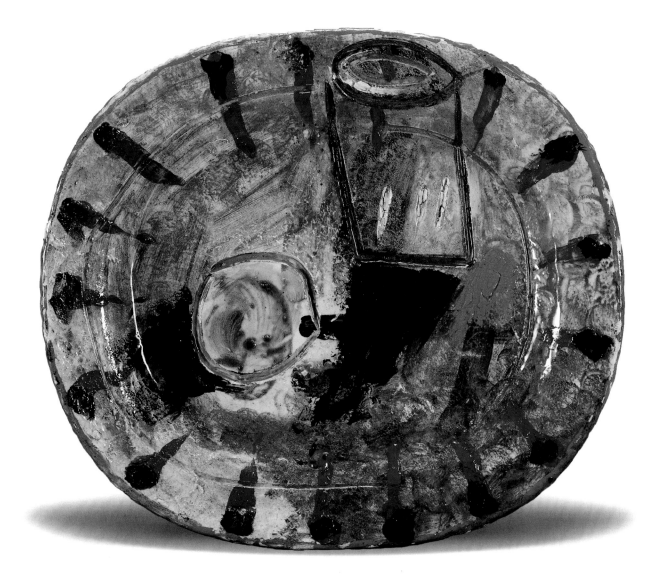

6. Long Plate (Still Life with a Glass)
1947
14 7/8 × 12 3/4 × 1 7/8
Fired clay, painted and glazed

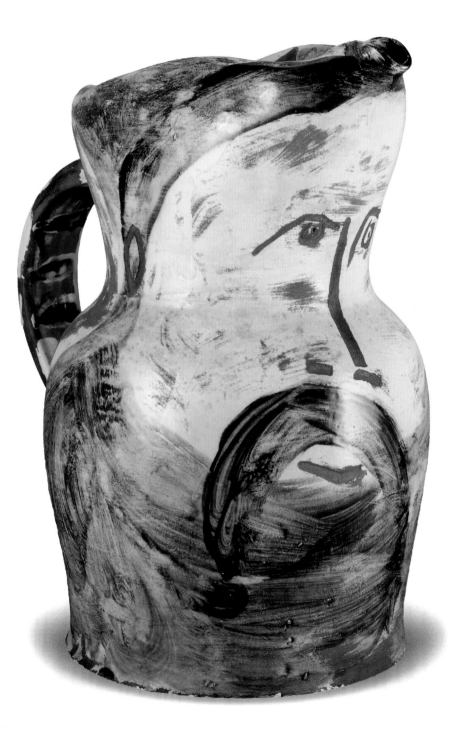

**7. Jar with Pointed Spout
(Lunar Face)**

1948
12 3/8 × 12 1/2 × 8 5/8
Fired clay, painted and glazed,
with incisions

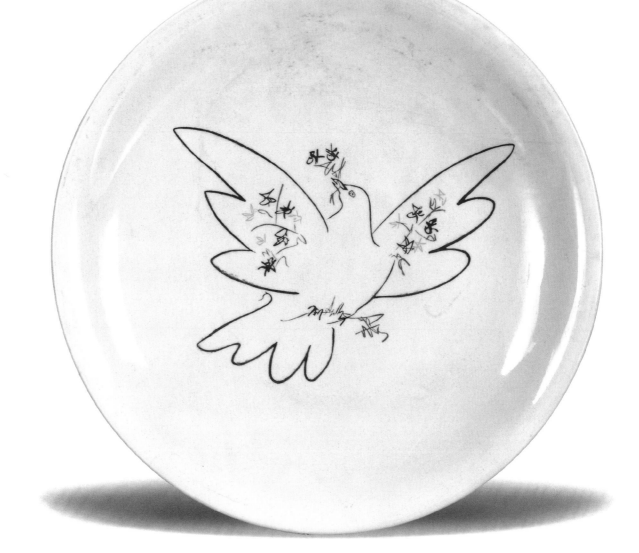

8. Plate (Dove of Peace)
ca. 1949
9 3/8 diameter
Porcelain, with blue, green,
red, and yellow outlines
over white background

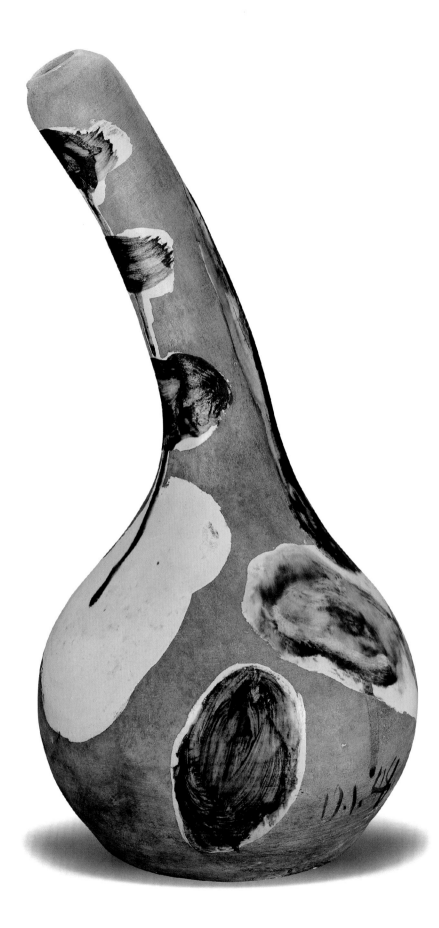

**9. Vase with Slanted Neck
(Oval-shaped Decoration)**

1948
7 7/8 diameter × 15 5/8
Fired clay, with enameled white,
green, and maroon strokes over a
gray painted background

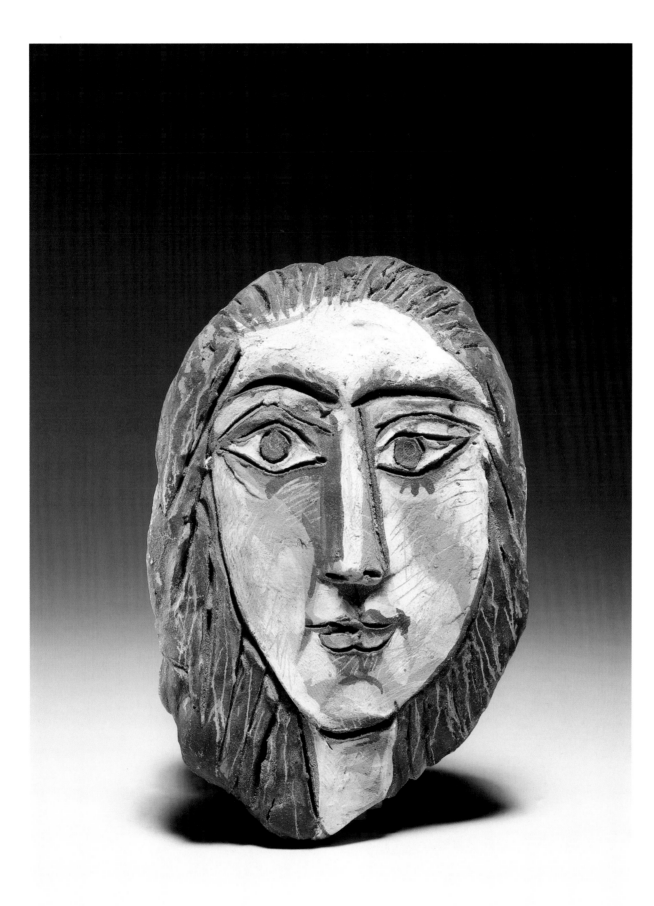

10. Head of a Woman
1950
4 3/4 × 3 1/4 × 7/8
Fired clay, modeled and
painted, with incisions

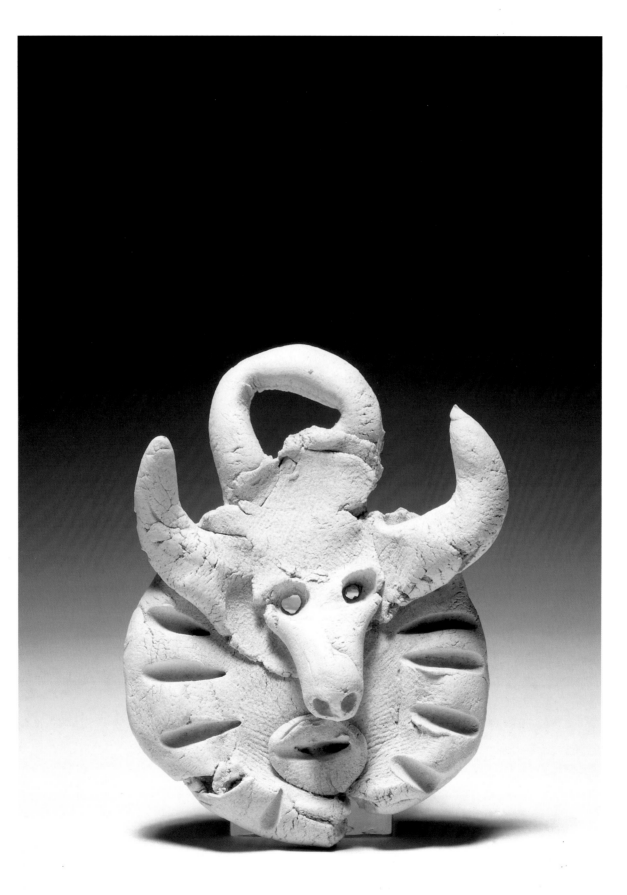

11. Head of a Faun
1950
3 × 2 3/8 × 3/4
Fired white clay, modeled,
with incisions

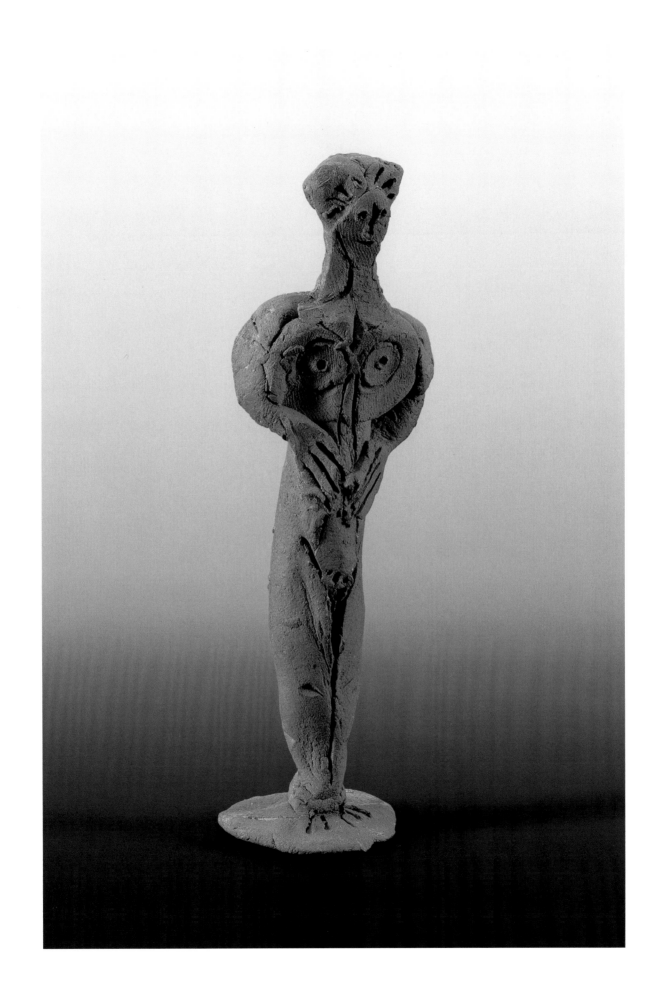

12. Standing Woman
1950
5 × 1 3/8 × 1 1/4
Modeled red clay with
incisions

**13. Seated Woman
with Crossed Legs**

1950
3 3/8 × 2 7/8 × 1 3/4
Fired ocher clay partially
painted in white

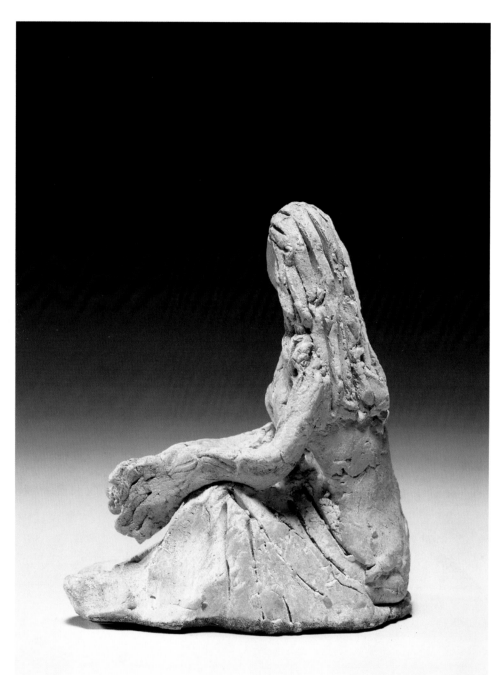

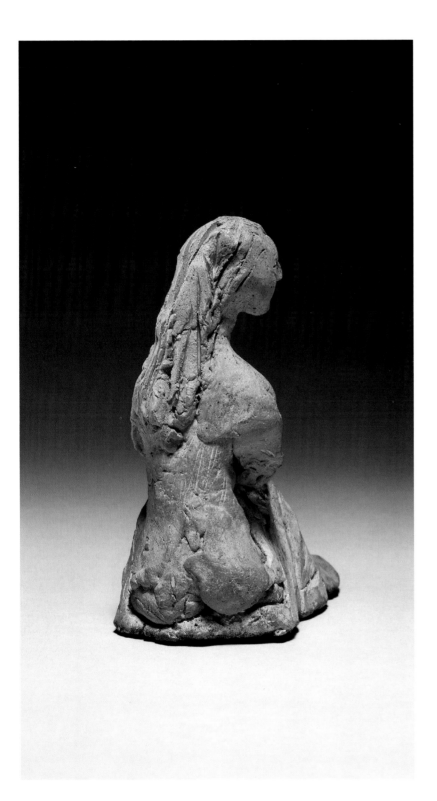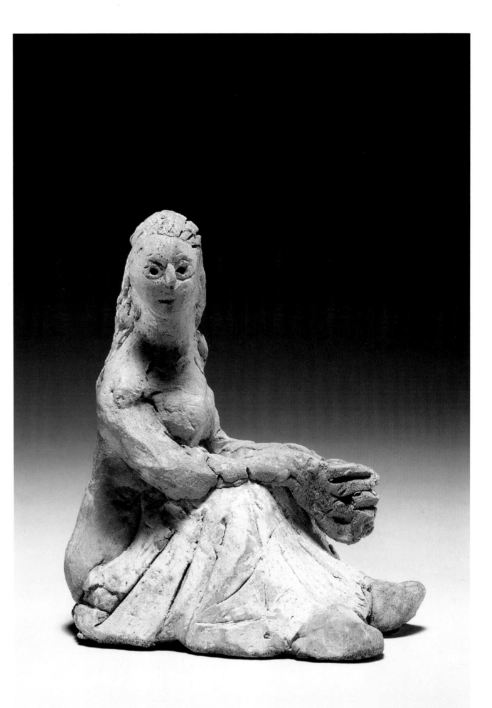

14. Standing Musician
1950
5 1/4 × 2 1/8 × 1 3/4
Fired white clay,
modeled, with incisions

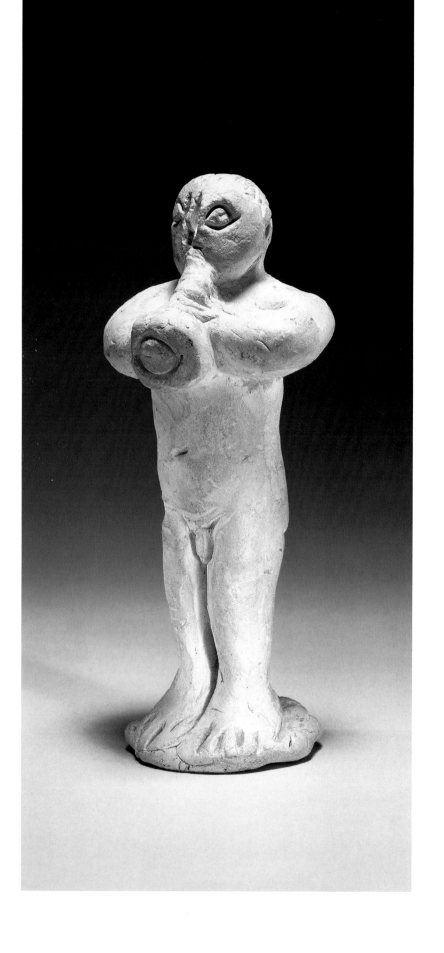

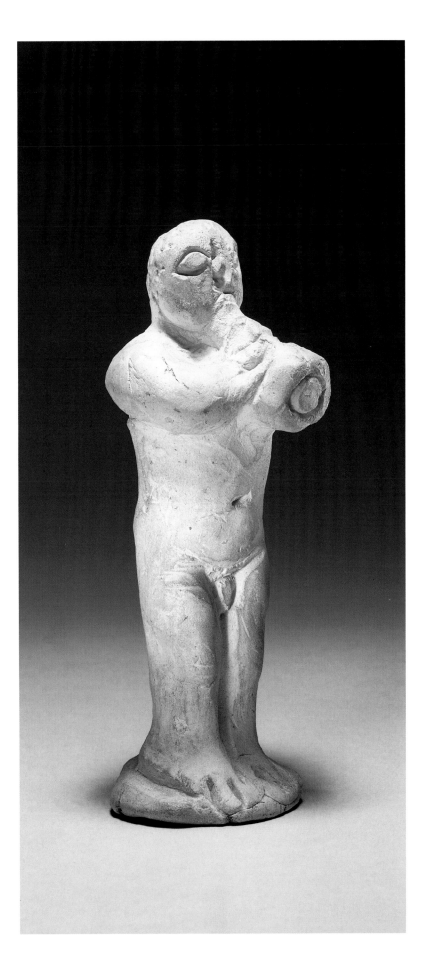

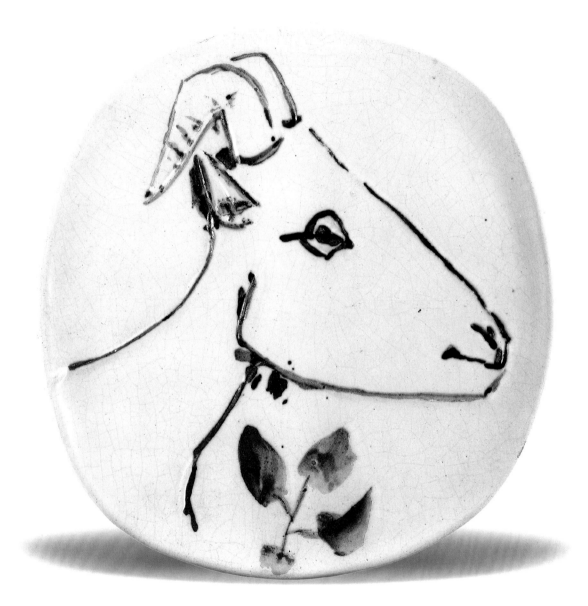

**15. Plate (Profile of Goat's
Head with Foliage)**

1950
10 1/4 diameter × 7/8
Fired clay, painted green-brown
over white glazed background

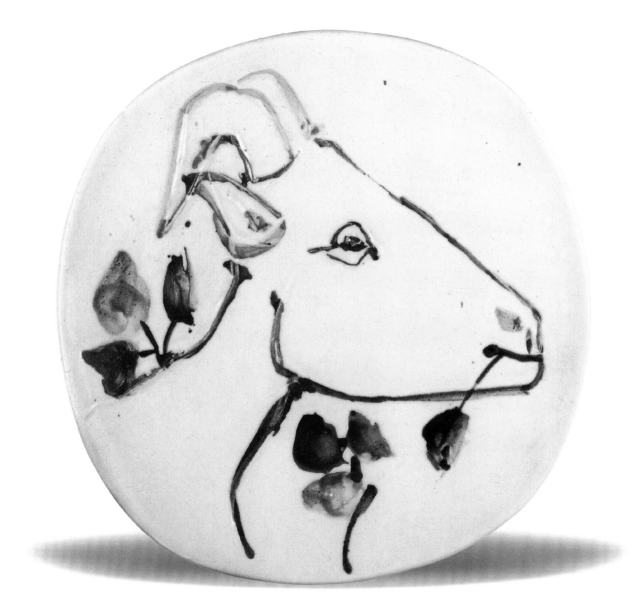

**16. Plate (Profile of Goat's
Head with Foliage)**

1950
10 3/8 diameter × 7/8
Fired clay, painted green-brown
over white glazed background

17. Pot (Frieze of Women)
1950
7 5/8 × 10 1/4 × 9 3/4
Fired clay, painted

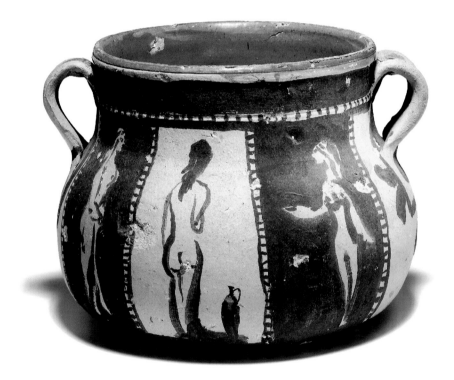

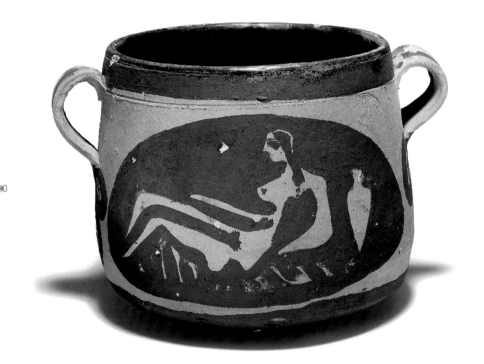

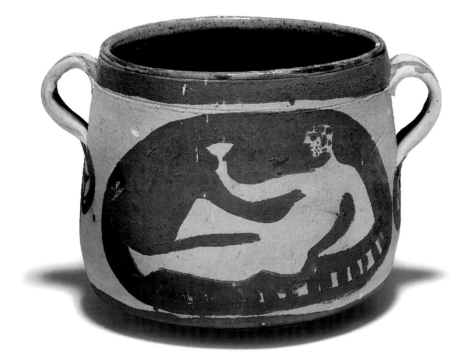

18. Pot (Reclining Man and Woman)
1950
7 1/4 × 10 1/4 × 8 5/8
Fired clay, painted

**19. Pot with Two
Handles (Celebrants and
Procession Carrying a
Dove)**

1950
6 7/8 × 10 3/4 × 8 5/8
Fired clay, glazed interior

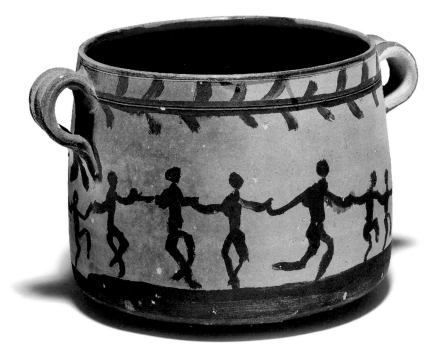

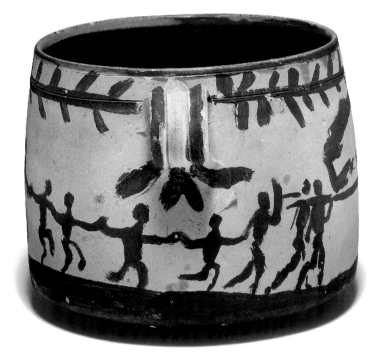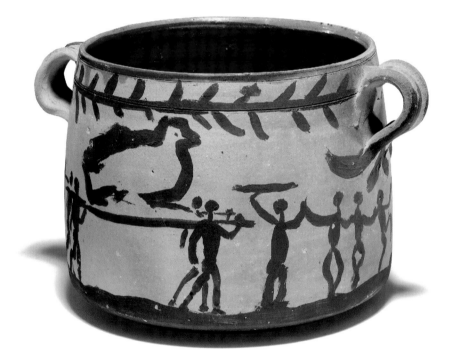

**21. Pendant
(Standing
Woman)**

1951
3 7/8 × 1 1/4 × 1/2
Fired white clay,
modeled, with
incisions

4

**20. Round Plate (Knight in
Armor and Woman)**

1951
8 5/8 diameter × 1 1/4
Fired clay, painted and glazed

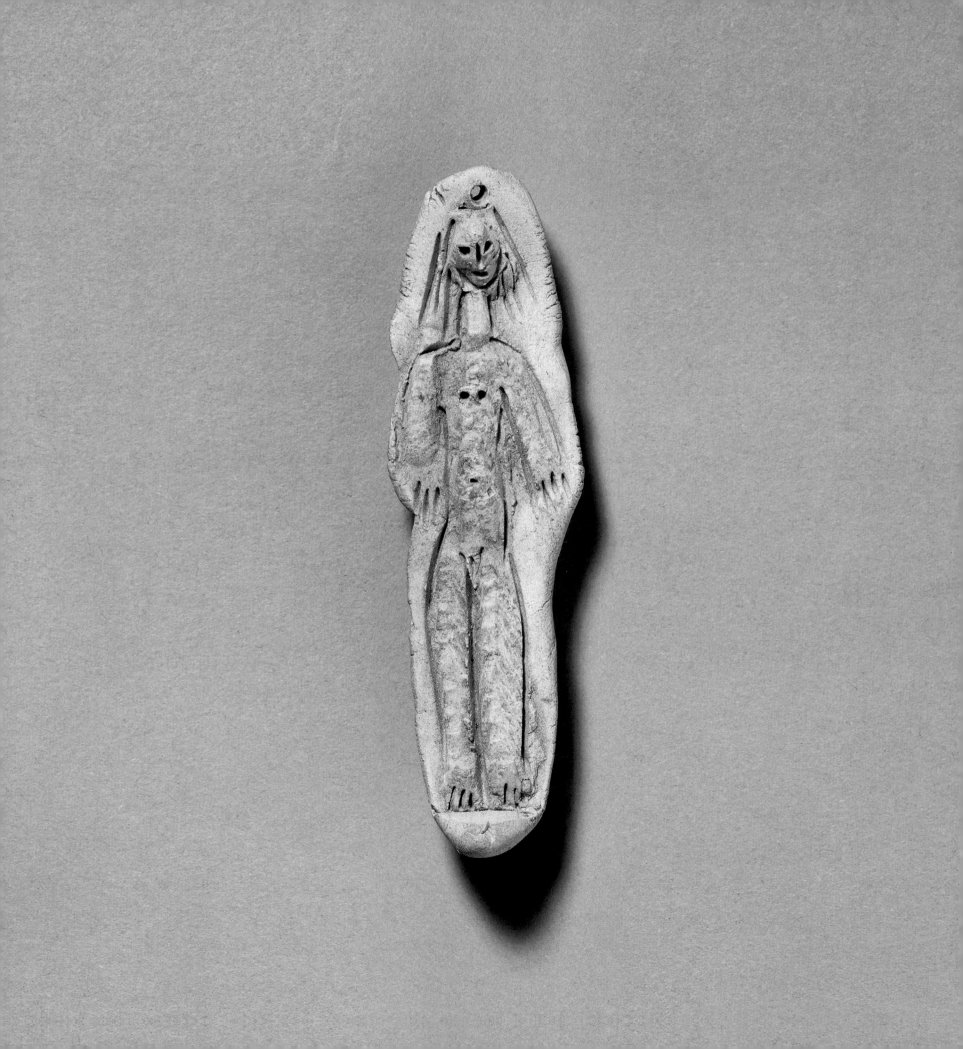

22. Seated Old Man

1952
2 × 1 3/4 × 2 1/2
Fired white clay,
modeled

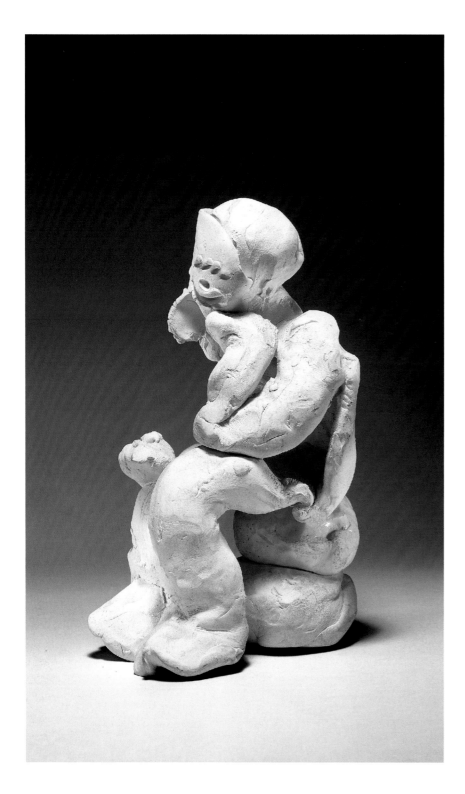

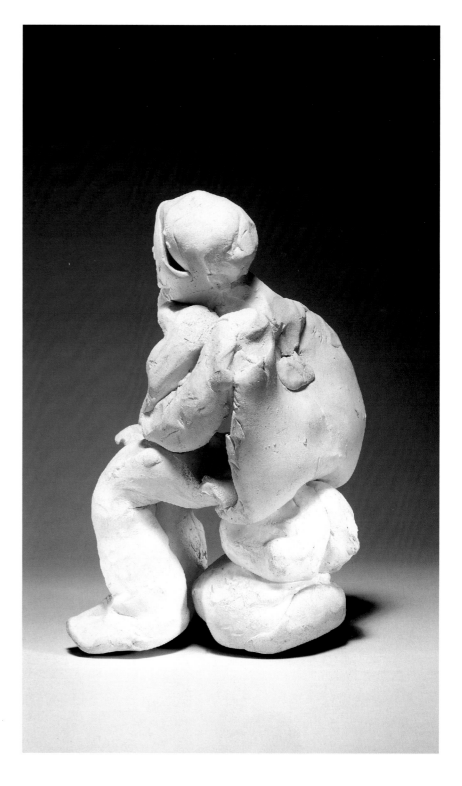

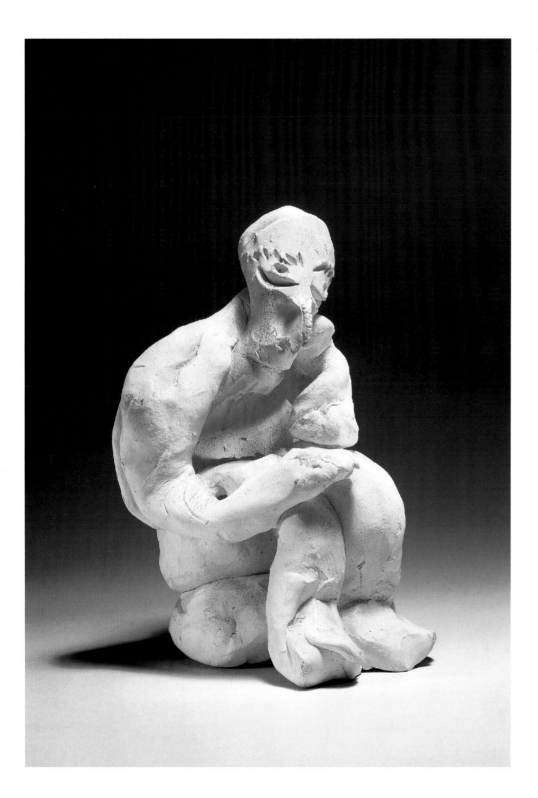

23. Seated Man
ca. 1952
7 7/8 × 4 1/8 × 4 3/4
Fired white clay,
modeled

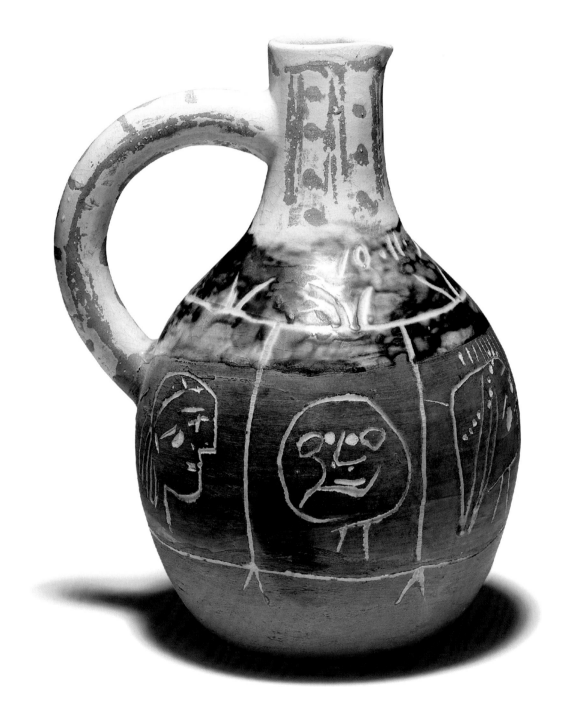

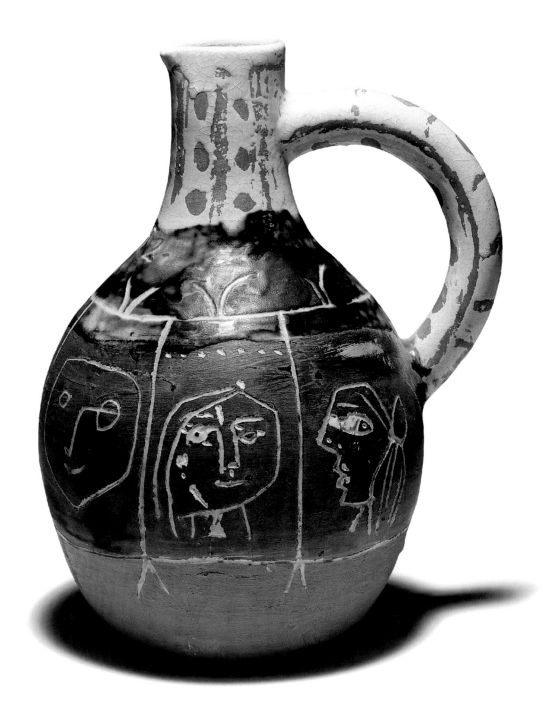

24. Round Pitcher (Six Masks Inside Squares)

1952
11 × 8 7/8 × 7 1/4
Fired clay, painted, with engraved drawings, and partially glazed

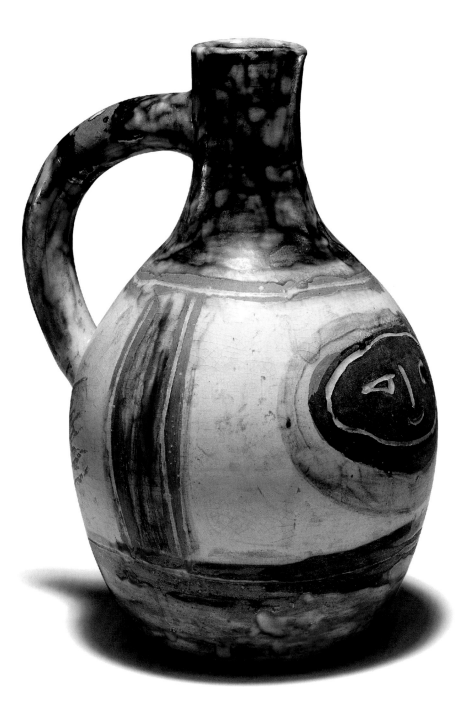

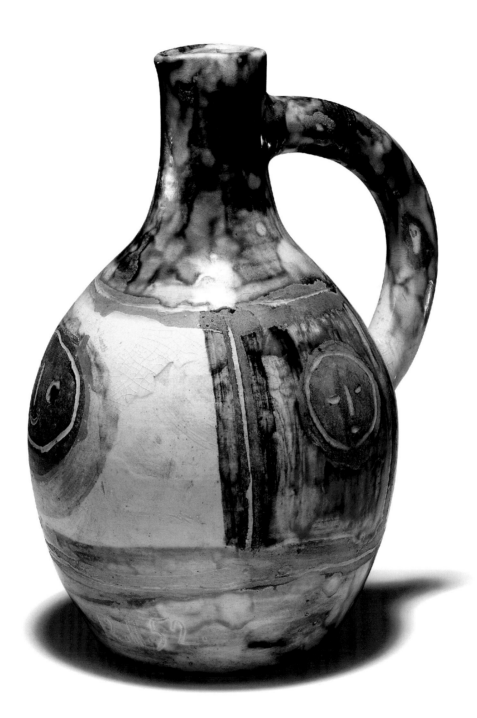

25. Round Pitcher (Two Masks in Sections)
1952
11 3/4 × 8 5/8 × 7 1/4
Fired white clay, painted and partially glazed

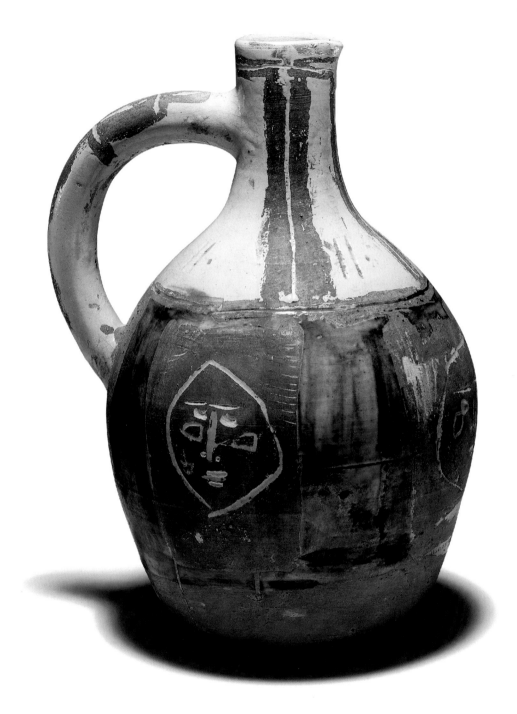

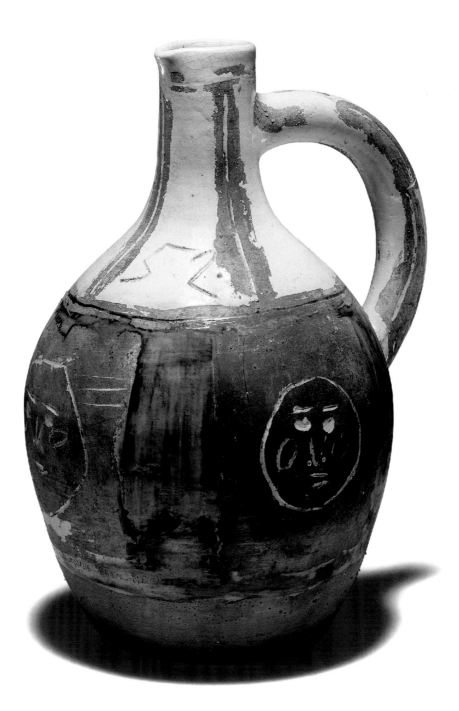

26. Round Pitcher (Three Masks in Sections)
1952
11 1/2 × 8 1/4 × 7 1/4
Fired clay, painted, with engraved drawings, and partially glazed

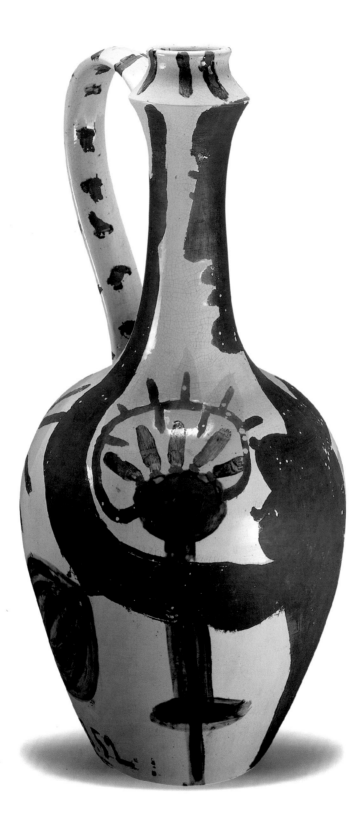

27. Large Jar (Woman with Sunflowers)
1952
24 1/2 × 15 5/8 × 11 3/4
Fired clay, painted and partially glazed

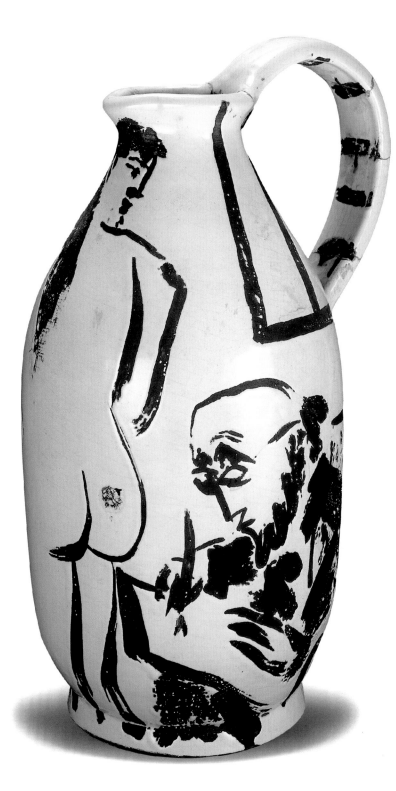

31. Two-color Jar (The Painter and His Model)
1954
14 7/8 × 9 3/8 × 7 1/4
Fired clay, gray traces over a white glazed background

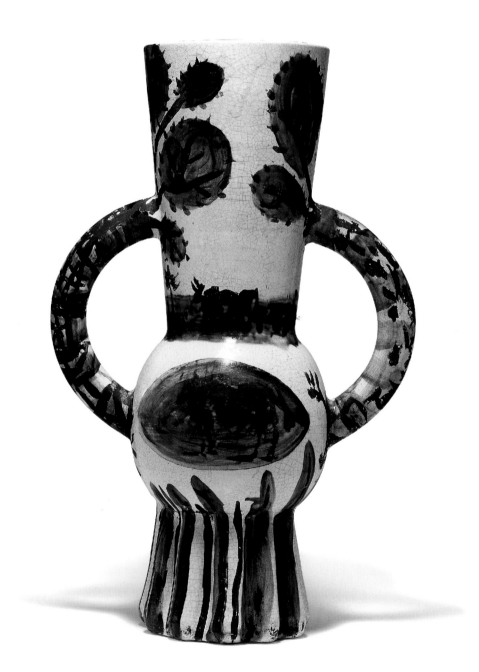

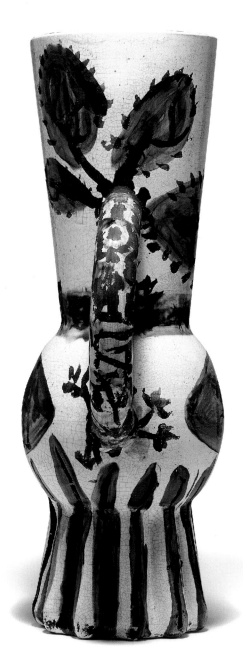

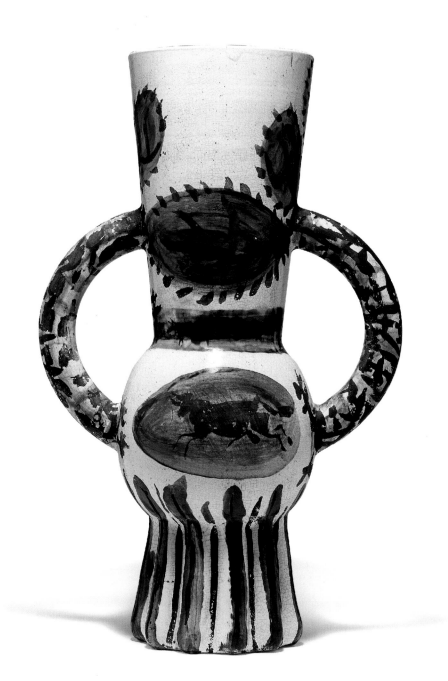

**28. Large Jar with Two
Handles (Flowers and Two
Oval Areas with Bulls)**

1952
28 3/4 × 18 × 10
Fired clay, painted and
glazed

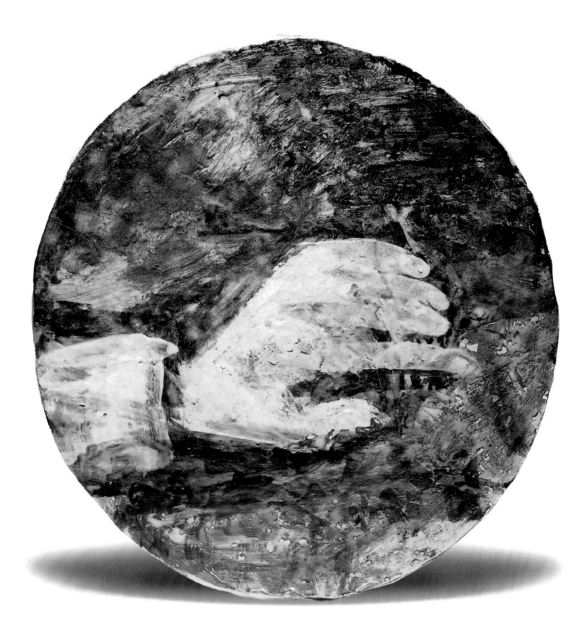

30. Round Plaque (Hand)

ca. 1953
11 7/8 × 11 1/2
Fired white clay, with traces
of pink, yellow and blue
glaze over green and blue
background

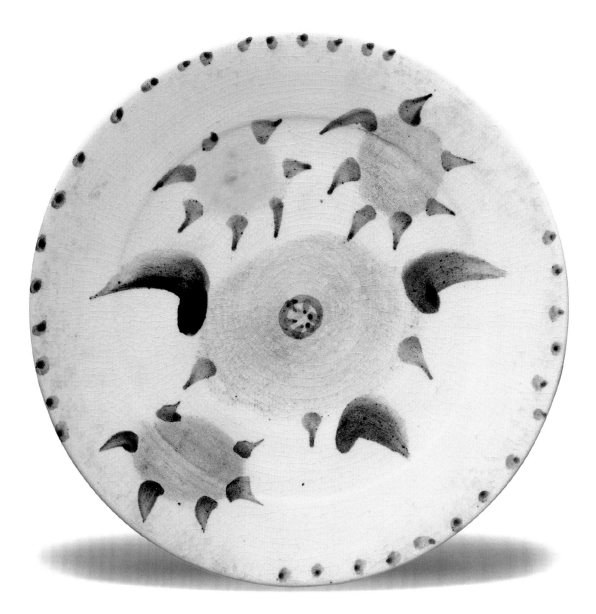

29. White Plate
1953
8 7/8 diameter × 7/8
Fired clay with white
glazed background

32. Pitcher (Nun and Faun)

ca. 1954
8 5/8 × 9
Fired clay, painted and glazed

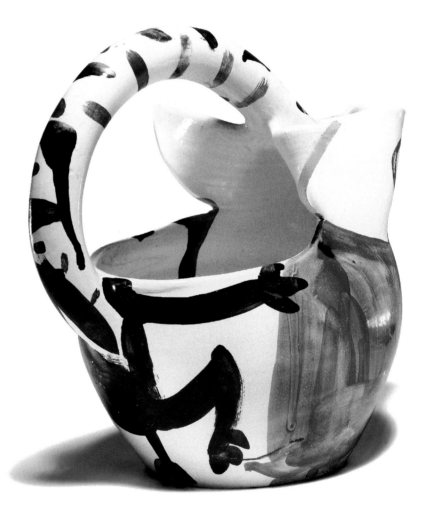

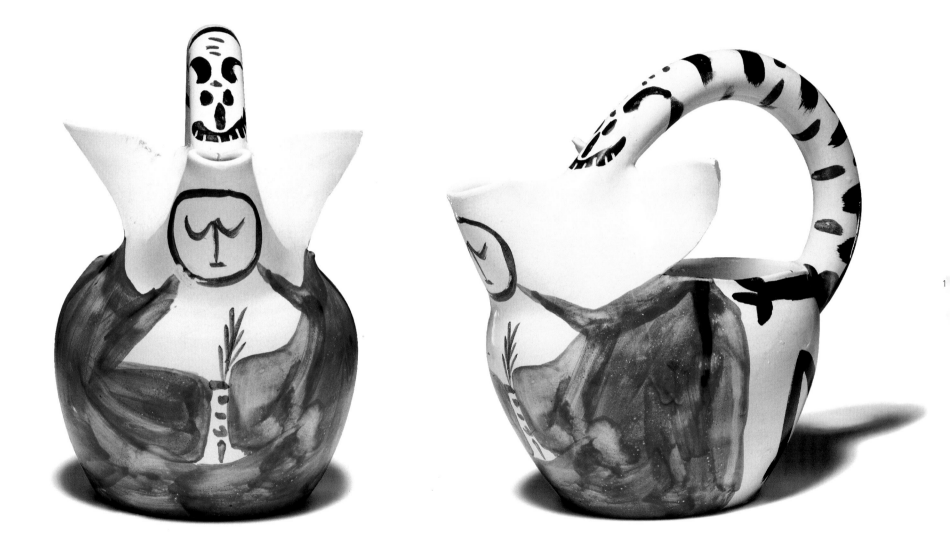

64

33. Pitcher (Arabesque Design)

ca. 1954
10 3/8 × 7 7/8 × 5 7/8
Fired clay, painted and glazed

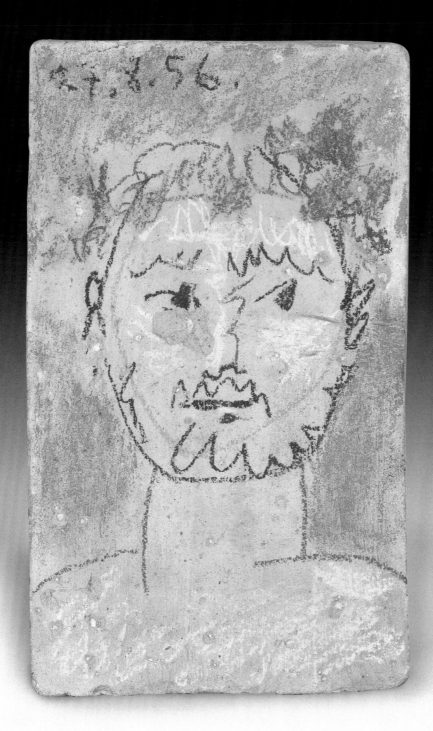

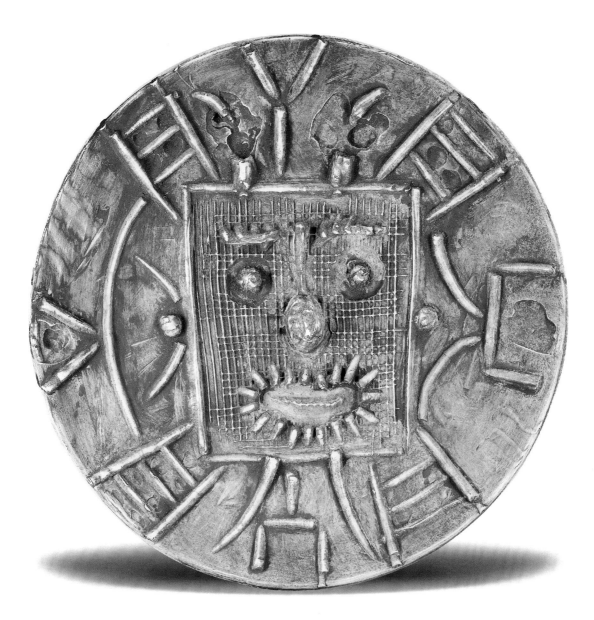

**35. Large Round Plate
(Square Face Mask in
relief)**

1956
16 7/8 diameter × 1 3/8
Fired white clay, painted
gray

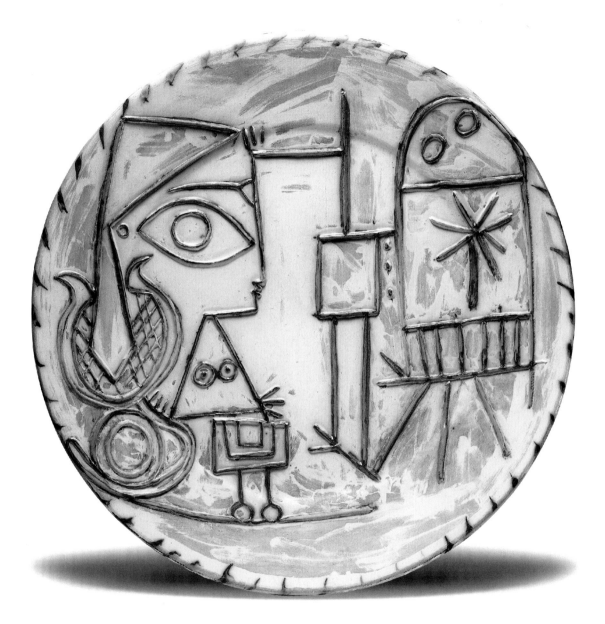

**36. Large Round Plate
(Portrait of a Woman
in the Studio in relief)**

1956
16 5/8 diameter
Fired clay, relief lines
tinted green, over a
white glazed background
painted in gray

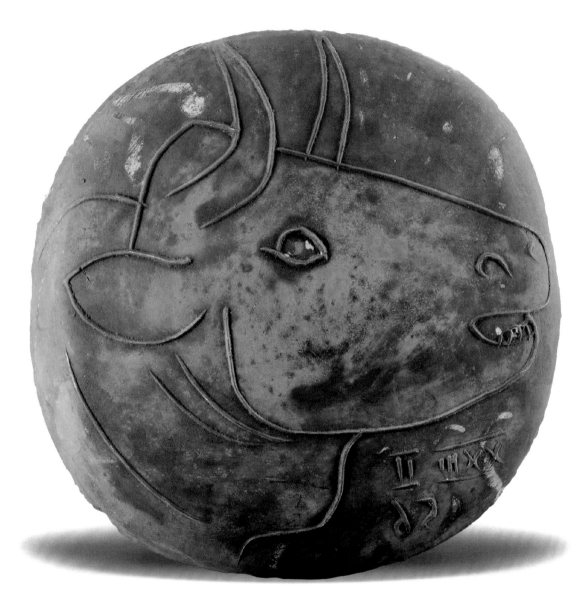

37. Mural Plaque (Head of a Bull in relief)

1956
10 1/2 diameter × 1 3/8
Fired clay painted in gray

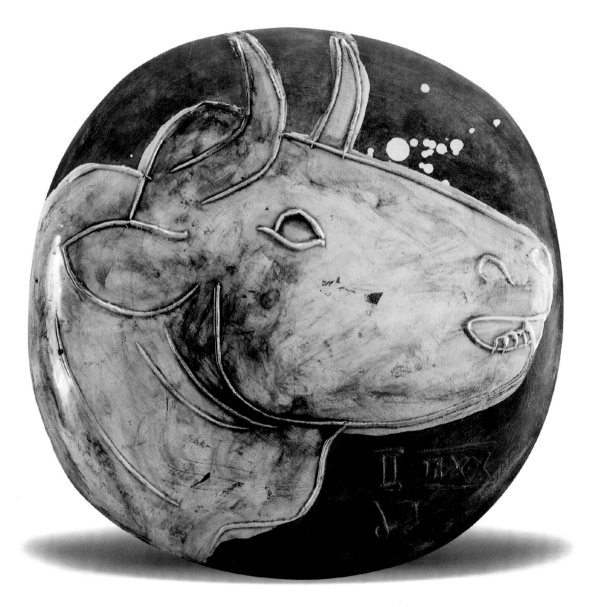

**38. Mural Plaque (Head
of a Bull in relief)**

1956
10 1/2 diameter × 1 3/8
Fired clay, traces of
white glaze over a
painted gray background

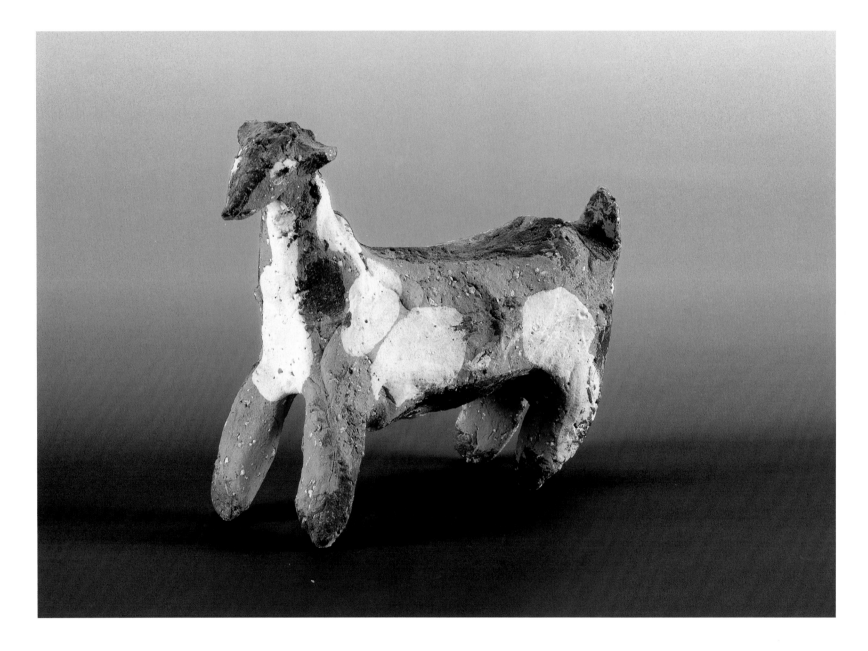

39. Goat
1957
2 5/8 × 3 1/8 × 1 1/8
Fired red clay, modeled
and painted

40. Plaque (Bullfight)
1957
12 3/8 × 6 × 5/8
Fired clay, modeled,
stamped, and painted

**41. Large Oval Plate
(Bullfight and
Spectators)**

1957
11 3/8 × 25 3/4 × 1 5/8
Fired clay, painted and
glazed

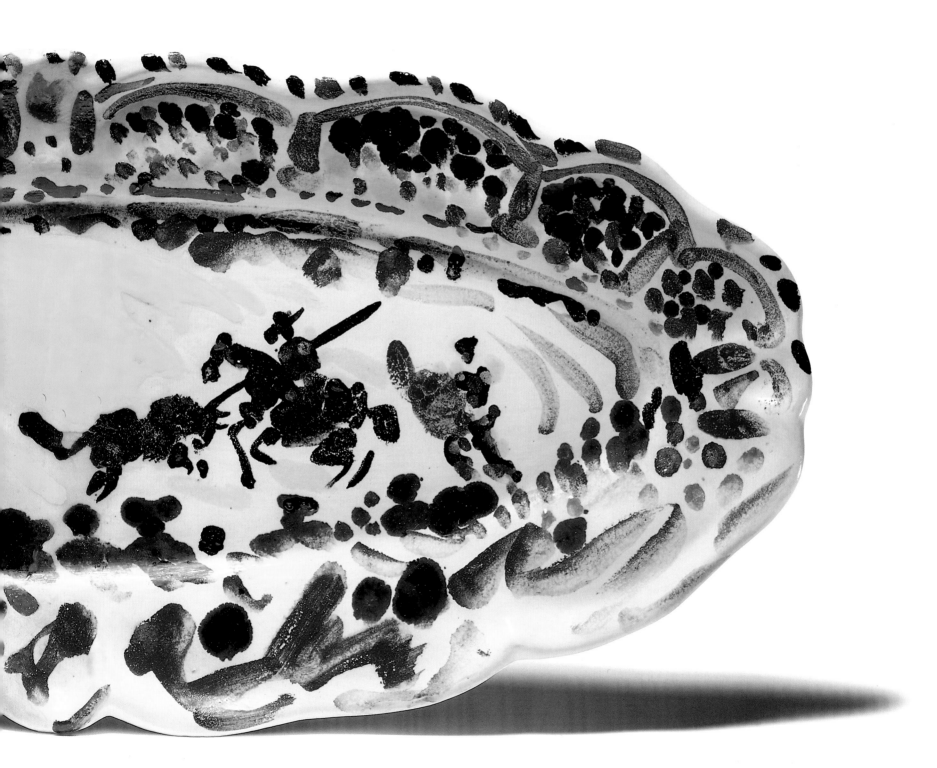

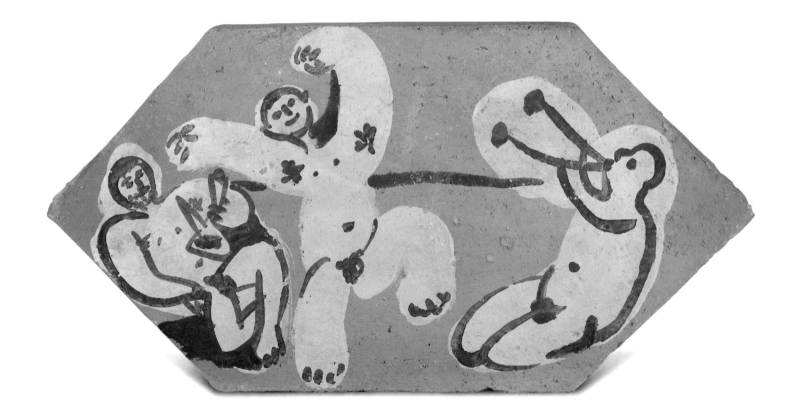

42. Tile (Musicians and Dancers)

1957
7 7/8 × 15 3/8 × 1 3/4
Fired clay, painted

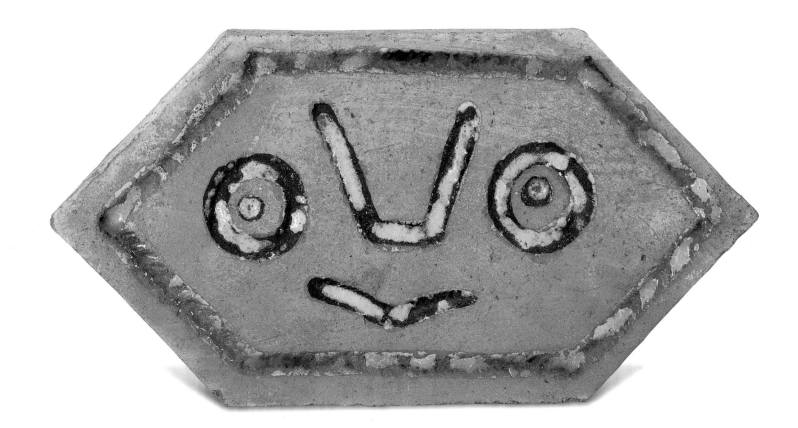

43. Tile (Face)
ca. 1957
7 7/8 × 15 1/4 × 1 3/4
Fired clay, with incisions,
partially glazed

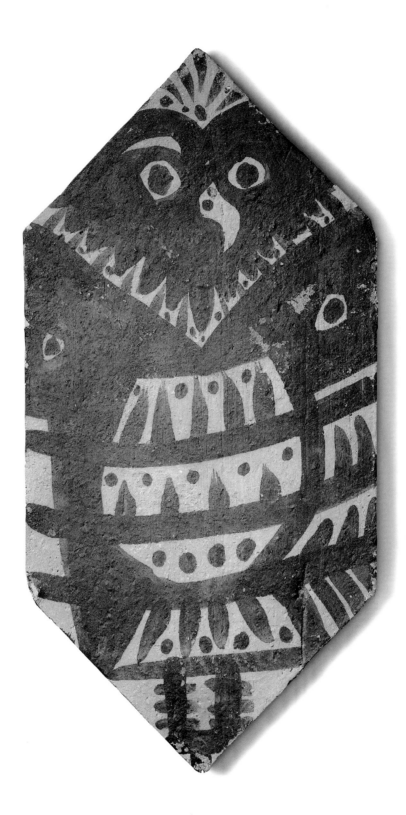

44. Tile (Owl)
ca. 1957
15 1/4 × 7 5/8 × 1 5/8
Fired clay, painted front
and back

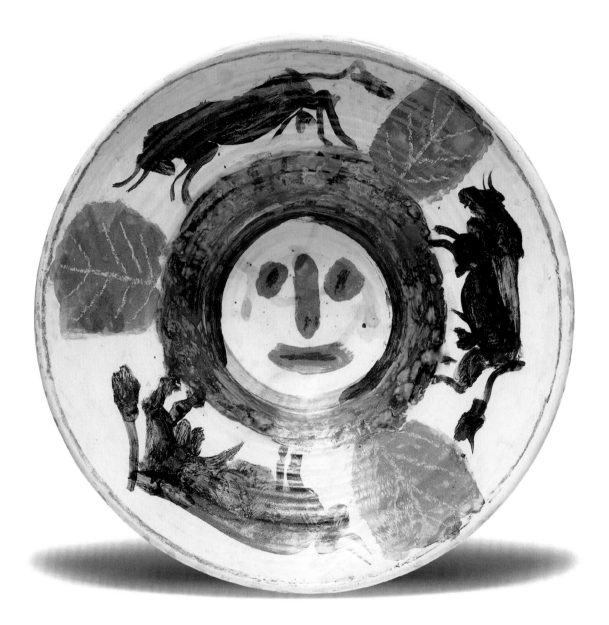

45. Large Dish (Three Bulls and One Face in the interior)

1957
17 1/4 diameter × 4 7/8
Fired clay with green,
black, and blue-gray glaze
on white background

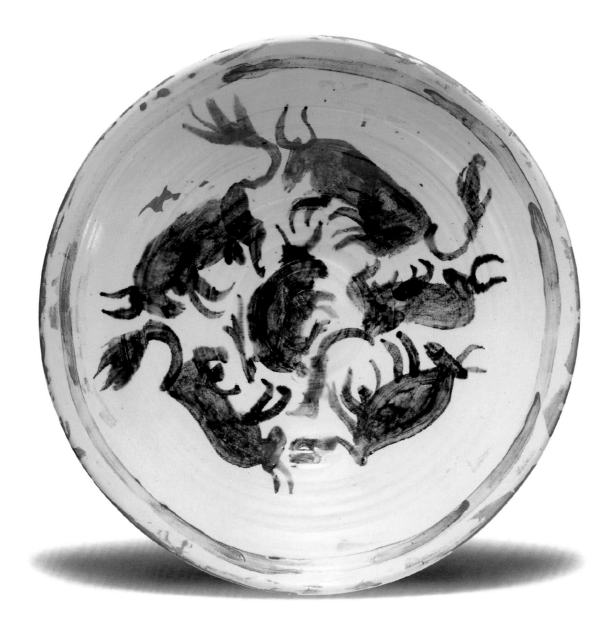

46. Large Dish (Bulls in the interior)

1958
18 diameter × 4 3/4
Fired clay, painted and glazed over a white background

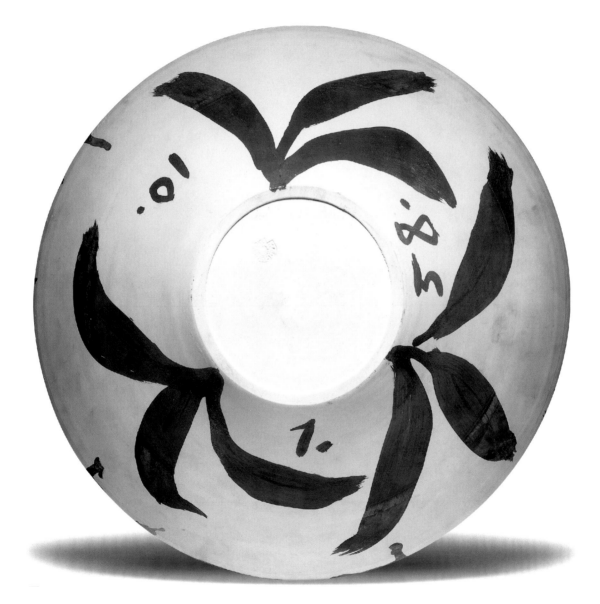

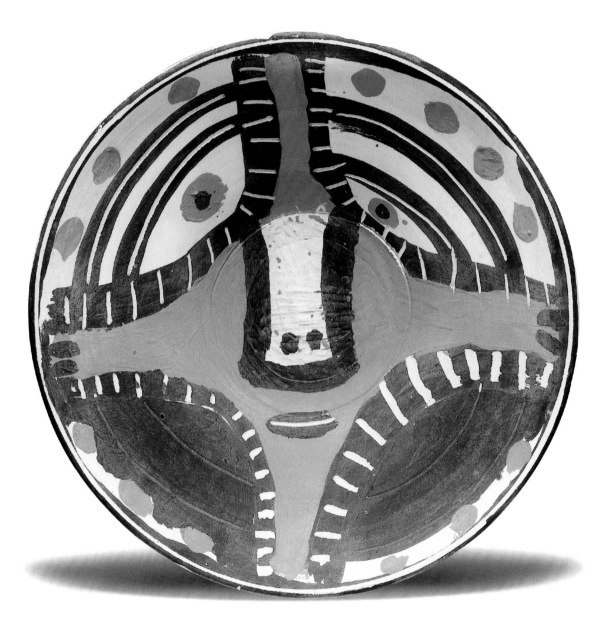

**47. Large Dish (Head in
four sections in the
interior, three branches on
the exterior)**

1958
16 5/8 diameter × 5
Fired clay, painted black and
dark gray, with incising, over
a white background (interior),
painted black features
(exterior)

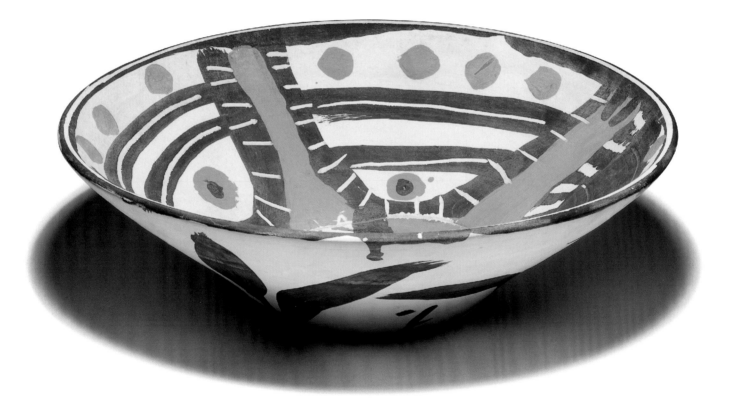

47. Large Dish

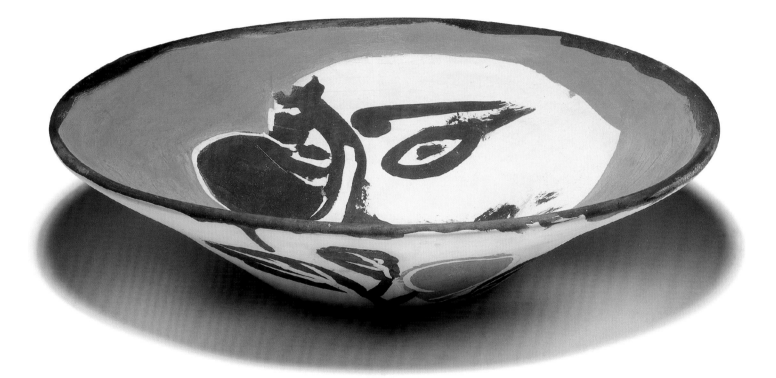

**48. Large Bowl
(Self-portrait)**

1958
17 diameter × 4 1/4
Fired white clay,
painted in ocher and
gray, unglazed

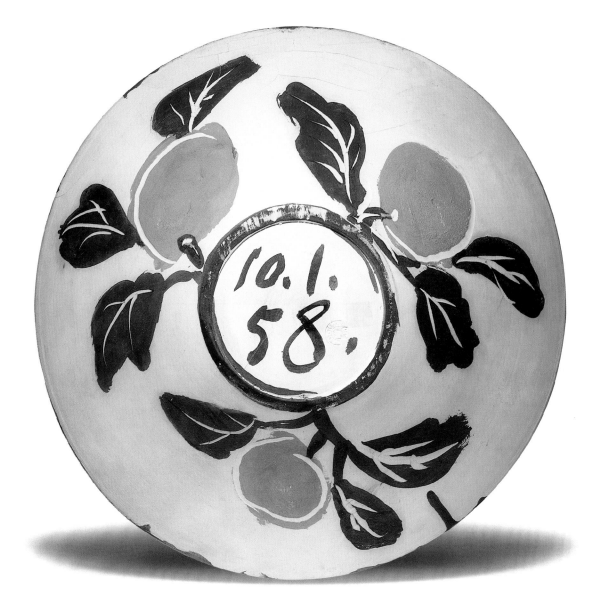

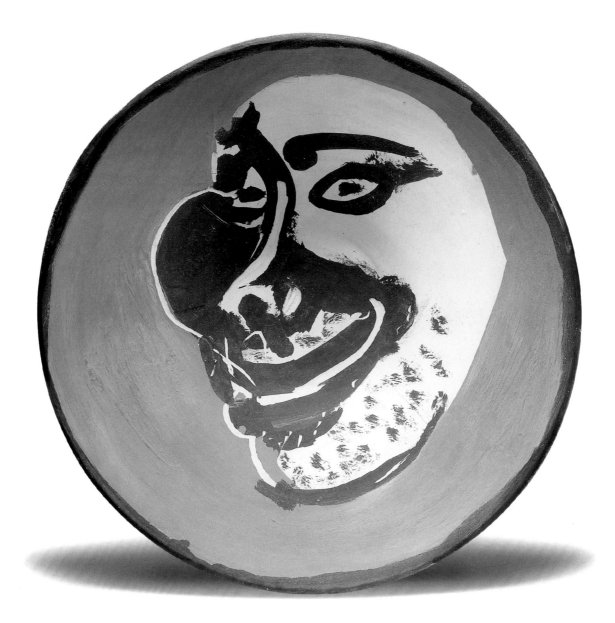

**48. Large Bowl
(Self-portrait)**

1958
17 diameter × 4 1/4
Fired white clay, painted
in ocher and gray,
unglazed

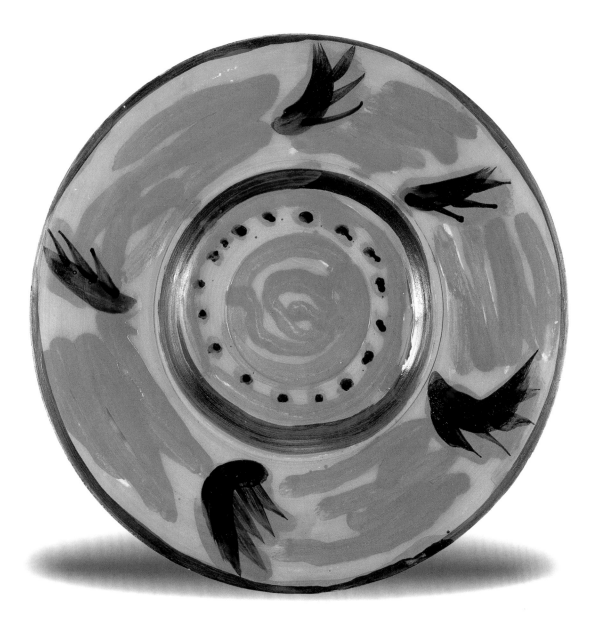

49. Large Round Plate (Informal decoration)
1959
15 1/4 diameter × 2
Fired clay, traces of black paint and glaze, ocher
on the bottom, geometric frieze in black glaze
on back

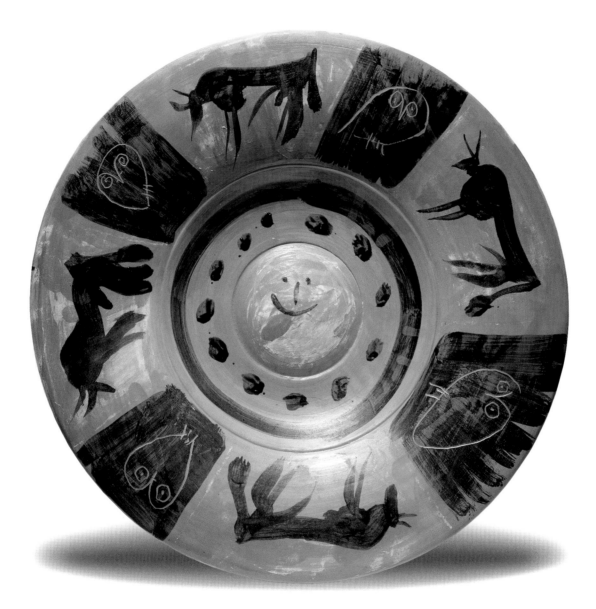

50. Large Round Plate (Frieze with four bulls and four owls interspersed)
1959
16 1/2 diameter × 2 5/8
Fired clay, painted and glazed

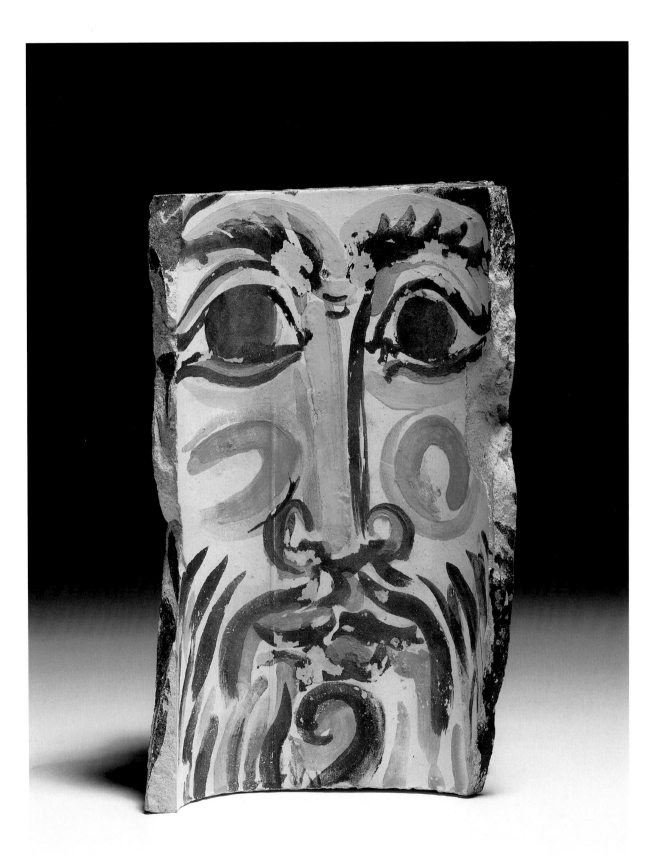

**51. Face of a Man
with Beard**
1962
8 5/8 × 5 3/8 × 3 1/4
Painted brick fragment

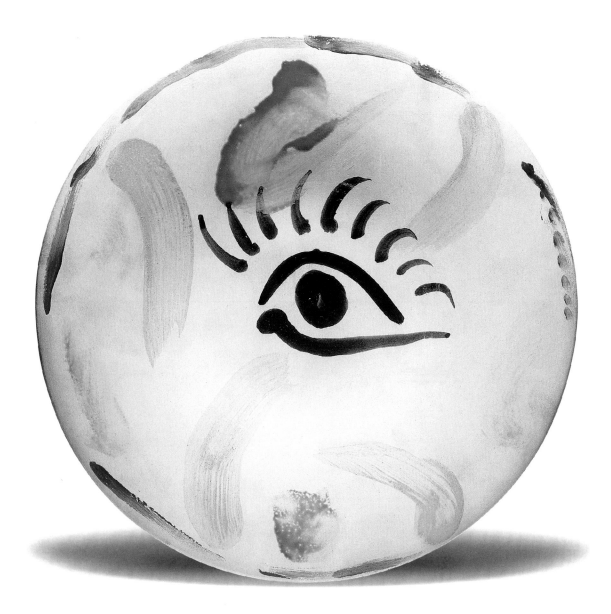

52. Round Plate (Face)

1963
9 1/4 diameter
Fired clay, painted and
glazed

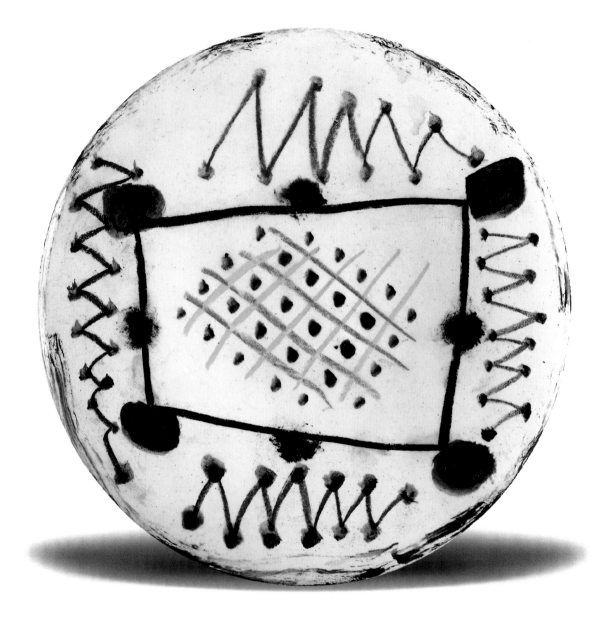

**53. Round Plate
(Informal design)**

1963
9 1/4 diameter
Fired clay, painted and
glazed

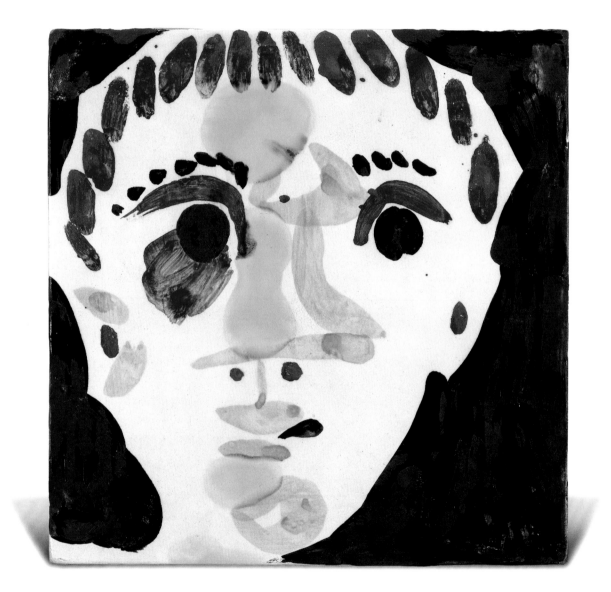

54. Floor Tile (Face)
1965
10 1/8 × 10 1/8 × 7/8
Fired clay, painted and
glazed

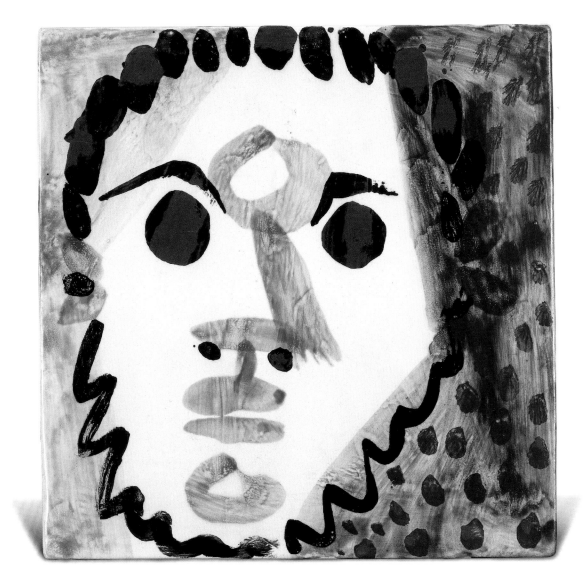

**55. Floor Tile
(Face of a Man)**

1965
10 1/8 × 10 1/8 × 7/8
Fired clay, painted and
glazed

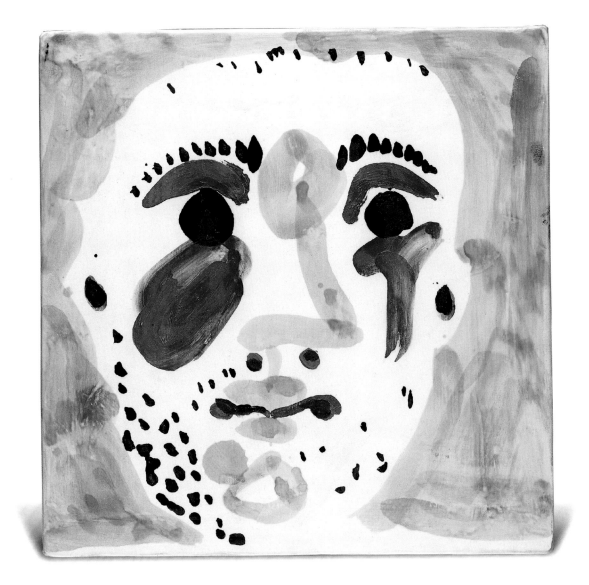

**56. Floor Tile
(Face of a Man)**

1965
10 1/8 × 10 1/8 × 7/8
Fired clay, painted and
glazed

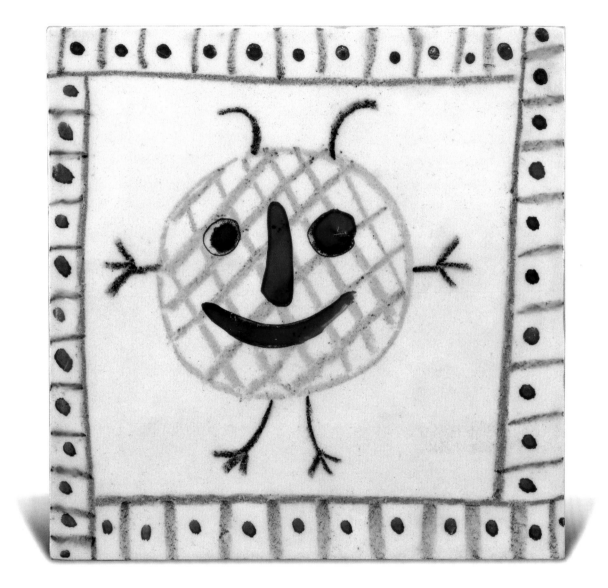

57. Floor Tile (Faun)

ca. 1968
6 × 6
Fired clay, painted and
glazed

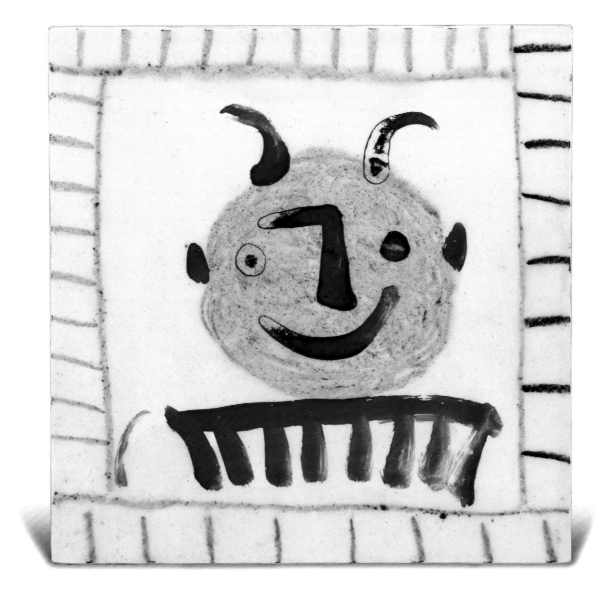

**58. Floor Tile (Head
of a Faun)**

ca. 1968
5 7/8 × 5 7/8
Fired clay, painted and
glazed

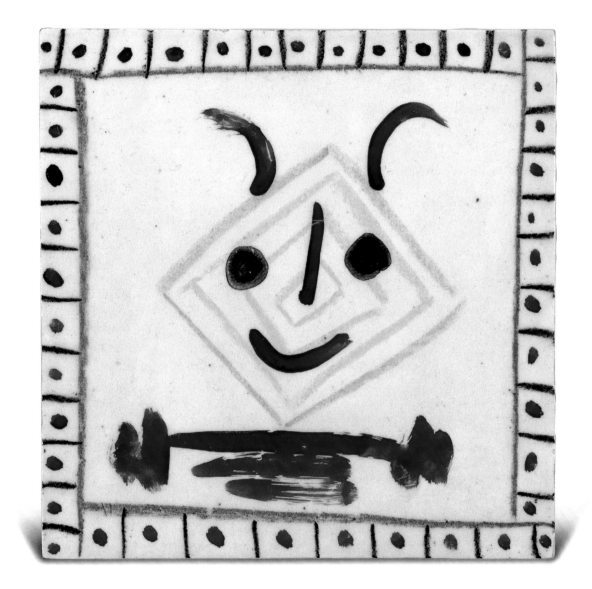

59. Floor Tile (Bust of a Faun)

ca. 1968
5 7/8 × 5 7/8
Fired clay, painted and glazed

60. Floor Tile (Bust of a Faun)
ca. 1968
5 7/8 × 5 7/8
Fired clay, painted and glazed

61. Floor Tile (Bust of a Faun)
ca. 1968
5 7/8 × 5 7/8
Fired clay, painted and glazed

62. Floor Tile (Faun)

ca. 1968
5 7/8 × 5 7/8
Fired clay, painted and
glazed

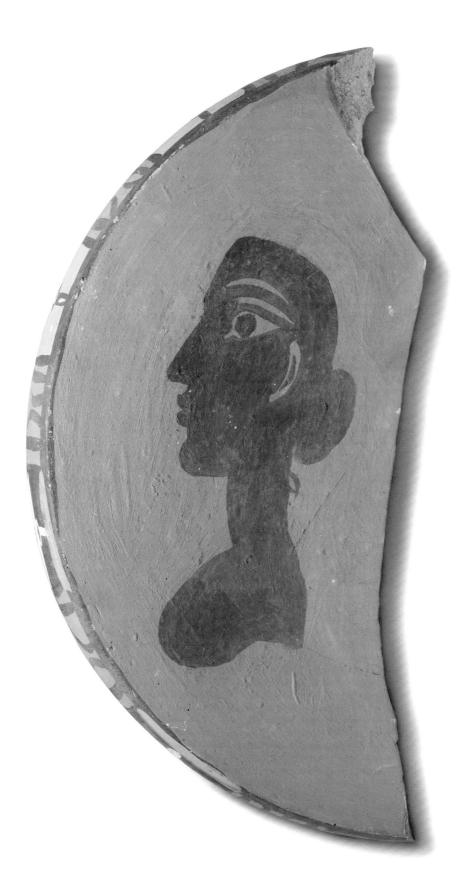

63. Fragment (Bust of a Woman)

1969
10 5/8 × 5 1/8 × 2 1/4
Vessel fragment made of fired and painted clay

CHECKLIST

All measurements are in inches; height precedes width precedes depth. All works of art are from the collection of Marina Picasso.

1. Standing Woman
1945
5 1/2 × 1 7/8 × 1 3/4
Fired clay, modeled

Bibliography
Werner Spies, *Picasso: Das Plastiche Werk,* Ed. Verlag Gerd Hatje, Berlin-Düsseldorf, 1983–1984, no. 329 Ia., p. 386; p. 346 (reproduction in bronze)

Notes
Extant:
- one fired-clay piece (S. 329 Ia)
- one plaster mold (S. 329 Ib)
- eleven pieces in bronze, one not numbered and ten pieces numbered 1/10 to 10/10, Fundición Valsuani (S. 329 II)

2. Hand with Sleeve
1947
2 3/4 × 9 1/2 × 3 3/4
Varnished plaster

Bibliography
Werner Spies, *Picasso: Das Plastiche Werk,* Ed. Gerd Hatje, Berlin-Düsseldorf, 1983–1984, no. 338, p. 386; p. 346 (reproduction in bronze)

Notes
Extant:
- one piece in plaster (Spies Ia)
- one plaster mold (Spies Ib)
- eleven pieces in bronze, one not numbered and ten numbered 1/10 to 10/10 (Fundición Valsuani 1948–1954)

3. Hand
1947
3 × 9 1/2 × 3 1/2
Fired white clay, painted and glazed
Unique piece

The difference from the previous hand is that here the fingers are not closed, thus leaving an open space

4. Long Plate (Head of a Faun)
1947
14 7/8 × 12 1/2 × 1 7/8
Fired clay, painted and partially glazed

Date painted on the back "15.10.47" and a stamp "MADOURA PLEIN FEU"
Painted number "1.273"
Unique piece

5. Long Plate "Fish" (Three Fish)
ca. 1947
14 3/4 × 12 1/4 × 1 3/4
Fired clay, painted and glazed

Exhibitions
Museum Het Kruithuis, Hertogenbosch, *Picasso Keramiek,* June 22–August 11, 1985, reproduced p. 177.

6. Long Plate (Still Life with a Glass)
1947
14 7/8 × 12 3/4 × 1 7/8
Fired clay, painted and glazed

Date painted on the back "28.10.47 VII"
Painted number "1.276"
Unique piece

7. Jar with Pointed Spout (Lunar Face)
1948
12 3/8 × 12 1/2 × 8 5/8
Fired clay, painted and glazed, with incisions

Date in the neck's interior "31.1.48" (covered)
Number painted under the base "2.5"
Unique piece

Exhibitions
Museum Het Kruithuis, Hertogenbosch, *Picasso Keramiek,* June 22–August 11, 1985, reproduced p. 193.

8. Plate (Dove of Peace)
ca. 1949
9 3/8 diameter
Porcelain, with blue, green, red, and yellow outlines over white background

Signed on the back "Picasso" and stamped "SALINS FRANCE"

9. Vase with Slanted Neck (Oval-shaped Decoration)
1948
7 7/8 diameter × 15 5/8
Fired clay, with enameled white, green, and maroon strokes over a gray painted background

Dated on the side "19.1.48 II"
Painted number at the base "2.29"
Unique piece

Exhibitions
Exposition Pablo Picasso: Marina Picasso Collection, organized by Association of Art Museums Yomiuri Shimbun Sha, Japan, November 18, 1986–October 18, 1987, no. CC-7, reproduced p. 63.

10. Head of a Woman
1950
4 3/4 × 3 1/4 × 7/8
Fired clay, modeled and painted, with incisions

Engraved in the back on red clay with a knife: "Vallauris 22 Juillet/50"

11. Head of a Faun
1950
3 × 2 3/8 × 3/4
Fired white clay, modeled, with incisions

Bibliography
Werner Spies, *Picasso: Das Plastiche Werk,* Ed. Gerd Hatje, Berlin-Düsseldorf, 1983–1984, no. 377 I, p. 389; p. 349 (reproduction in bronze)

Notes
Extant:
- one piece in fired white clay
- two pieces in bronze; one not numbered and one with the number 2/2 (Fundición Godard)

12. Standing Woman
1950
5 × 1 3/8 × 1 1/4
Modeled red clay with incisions

Dated under the vase: "Vallauris 20.7.50"

Bibliography
Werner Spies, *Picasso: Das Plastiche Werk,* Ed. Gerd Hatje, Berlin-Düsseldorf, 1983–1984, no. 389 I, p. 389; p. 350 (reproduction in bronze)

Notes
Extant:
- one piece in fired red clay (Spies 389 I)
- two pieces in bronze, one not numbered and one with the number 2/2 and dated under the base "Vallauris 20.7.50"; Fundición Godard (Spies 389 II)

13. Seated Woman with Crossed Legs
1950
3 3/8 × 2 7/8 × 1 3/4
Fired ocher clay partially painted in white

Date engraved under the base "Vallauris juin 50"

Bibliography
Werner Spies, *Picasso: Das Plastiche Werk,* Ed. Gerd Hatje, Berlin-Düsseldorf, 1983–1984, no. 386 I, p. 350 (reproduction in bronze)

Notes
Extant:
- one piece in fired ocher clay
- two pieces in bronze, one not numbered and one numbered 2/2 and dated under the base "Vallauris juin 50"; (Fundición Godard)

14. Standing Musician
1950
5 1/4 × 2 1/8 × 1 3/4
Fired white clay, modeled, with incisions

Date engraved under the base "Vallauris/juin/50"

Bibliography
Werner Spies, *Picasso: Das Plastiche Werk,* Ed. Gerd Hatje, Berlin-Düsseldorf, 1983–1984, no. 429 I; p. 391; p. 354 (reproduction in bronze)

Notes
Extant:
- one piece in fired white clay
- two pieces in bronze, one not numbered and one numbered 2/2 and dated under the base "Vallauris (juin) 50"

15. Plate (Profile of Goat's Head with Foliage)
1950
10 1/4 diameter × 7/8
Fired clay, painted green-brown over white glazed background

Stamped on the back "MADOURA PLEIN FEU" and "EMPREINTE ORIGINALE DE PICASSO"
Unique piece

16. Plate (Profile of Goat's Head with Foliage)
1950
10 3/8 diameter × 7/8
Fired clay, painted green-brown over white glazed background

Stamped on the back "MADOURA PLEIN FEU" and "EMPREINTE ORIGINALE DE PICASSO"
Unique piece

17. Pot (Frieze of Women)
1950
7 5/8 × 10 1/4 × 9 3/4
Fired clay, painted

Stamped "VALLAURIS AM" on the side (not easily readable)
Date and number painted on the base "Vallauris 11.8.50 II"
Unique piece

18. Pot (Reclining Man and Woman)
1950
7 1/4 × 10 1/4 × 8 5/8
Fired clay, painted

Stamped "Société Stella n° 12 Vallauris Alpes Maritimes"
Dated and numbered under the base "10.8.50 I Vallauris"
Unique piece

19. Pot with Two Handles (Celebrants and Procession Carrying a Dove)
1950
6 7/8 × 10 3/4 × 8 5/8
Fired clay, glazed interior

Date painted under the base "Vallauris 11.8.50 I"
Unique piece

Exhibitions
Exposition Pablo Picasso: Marina Picasso Collection, organized by Association of Art Museums Yomiuri Shimbun Sha, Japan, November 18, 1986–October 18, 1987, no. CM-7, p. 133; reproduced p. 74.

20. Round Plate (Knight in Armor and Woman)
1951
8 5/8 diameter × 1 1/4
Fired clay, painted and glazed

Date on the back "2.3.51" with a painted border
Unique piece

21. Pendant (Standing Woman)
1951
3 7/8 × 1 1/4 × 1/2
Fired white clay, modeled, with incisions

Bibliography
Werner Spies, *Picasso: Das Plastiche Werk,* Ed. Gerd Hatje, Berlin-Düsseldorf, 1983–1984, no. 384 I; p. 389; p. 354 (reproduction in bronze)

Notes
Extant:
- one piece in fired white clay
- two pieces in bronze, one not numbered and one numbered 2/2 (Fundición Godard)

22. Seated Old Man
1952
2 × 1 3/4 × 2 1/2
Fired white clay, modeled

Bibliography
Werner Spies, *Picasso: Das Plastiche Werk,* Ed. Gerd Hatje, Berlin-Düsseldorf, 1983–1984, no. 459 I; p. 393; p. 354 (reproduction in bronze)

Notes
Extant:
- one piece in fired white clay
- two pieces in bronze, one not numbered and one with the number 2/2 (Fundición Godard)

23. Seated Man
ca. 1952
7 7/8 × 4 1/8 × 4 3/4
Fired white clay, modeled

Unique piece

24. Round Pitcher (Six Masks Inside Squares)
1952
11 × 8 7/8 × 7 1/4

Fired clay, painted, with engraved drawings, and partially glazed

Dated on the neck "10.11.52" and stamped under the base "MADOURA PLEIN FEU"
Unique piece

Exhibitions
Museum Het Kruithuis, Hertogenbosch, *Picasso Keramiek,* June 22–August 11, 1985, reproduced p. 183.

25. Round Pitcher (Two Masks in Sections)
1952
11 3/4 × 8 5/8 × 7 1/4
Fired white clay, painted and partially glazed

Stamped under the base "MADOURA PLEIN FEU"
Date engraved "12.11.52"
Unique piece

26. Round Pitcher (Three Masks in Sections)
1952
11 1/2 × 8 1/4 × 7 1/4
Fired clay, painted, with engraved drawings, and partially glazed

Date engraved on the lower part of the neck "11.11.52"
Stamped under the base "MADOURA PLEIN FEU"
Unique piece

Exhibitions
Museum Het Kruithuis, Hertogenbosch, *Picasso Keramiek,* June 22–August 11, 1985, reproduced p. 205.

27. Large Jar (Woman with Sunflowers)
1952
24 1/2 × 15 5/8 × 11 3/4
Fired clay, painted and partially glazed

Dated at the base "1.8.52"
Stamped under the base "MADOURA PLEIN FEU"
Unique piece

28. Large Jar with Two Handles (Flowers and Two Oval Areas with Bulls)
1952
28 3/4 × 18 × 10
Fired clay, painted and glazed

Date engraved inside the neck "23.7.52"
Unique piece

Exhibitions
Center for Fine Arts, Miami, *Picasso at Work at Home: Selections from Marina Picasso's Collection,* November 19, 1985–March 9, 1986, no. 112, reproduced

p. 116. *Exposition Pablo Picasso: Marina Picasso Collection,* organized by Association of Art Museums Yomiuri Shimbun Sha, Japan, November 18, 1986–October 18, 1987, no. CC-11, reproduced p. 67.

29. White Plate
1953
8 7/8 diameter × 7/8
Fired clay with white glazed background

Partial imprint of a stamp "MADOURA PLEIN FEU"
Dated on the back "6.3.53"
Unique piece

30. Round Plaque (Hand)
ca. 1953
11 7/8 × 11 1/2
Fired white clay, with traces of pink, yellow and blue glaze over green and blue background

Unique piece

31. Two-color Jar (The Painter and His Model)
1954
14 7/8 × 9 3/8 × 7 1/4
Fired clay, gray traces over a white glazed background

Dated on the handle "5.1.54"
Stamped under the base "MADOURA PLEIN FEU"
Unique piece

32. Pitcher (Nun and Faun)
ca. 1954
8 5/8 × 9
Fired clay, painted and glazed

Stamped under the base "MADOURA PLEIN FEU"
Tag number "2.167"
Unique piece

Exhibitions
Center for Fine Arts, Miami, *Picasso at Work at Home: Selections from Marina Picasso's Collection,* November 19, 1985–March 9, 1986, no. 149, reproduced p. 155. *Exposition Pablo Picasso: Marina Picasso Collection,* organized by Association of Art Museums Yomiuri Shimbun Sha, Japan, November 18, 1986–October 18, 1987, no. CC-12, reproduced p. 68.

33. Pitcher (Arabesque Design)
ca. 1954
10 3/8 × 7 7/8 × 5 7/8
Fired clay, painted and glazed

Stamped "MADOURA PLEIN FEU"
Unique piece

34. Plaque (Bust of a Man)
1956
9 5/8 × 5 7/8 × 7/8
Fired clay touched with grease pencils

Dated on the front "27.8.56"
Unique piece

35. Large Round Plate (Square Face Mask in relief)
1956
16 7/8 diameter × 1 3/8
Fired white clay, painted gray

Stamped on the back "MADOURA PLEIN FEU" and "EMPREINTE ORIGINALE DE PICASSO", "EDITION PICASSO"
Engraved "C/20"
Unique piece

* Shown only in Spain

36. Large Round Plate (Portrait of a Woman in the Studio in relief)
1956
16 5/8 diameter
Fired clay, relief lines tinted green, over a white glazed background painted in gray

Stamped on the back "MADOURA PLEIN FEU" and "EMPREINTE ORIGINALE DE PICASSO"
Unique piece

Exhibitions
Center for Fine Arts, Miami, *Picasso at Work at Home: Selections from Marina Picasso's Collection,* November 19, 1985–March 9, 1986, no. 120, reproduced p. 124.

37. Mural Plaque (Head of a Bull in relief)
1956
10 1/2 diameter × 1 3/8
Fired clay painted in gray

Dated on the back (backwards in relief): "XXIII.II.56"
Stamped "MADOURA PLEIN FEU" and "EMPREINTE ORIGINALE DE PICASSO"

38. Mural Plaque (Head of a Bull in relief)
1956
10 1/2 diameter × 1 3/8
Fired clay, traces of white glaze over a painted gray background

Dated on the back (backwards): "XXIII.II.56"
Unique piece

39. Goat
1957
2 5/8 × 3 1/8 × 1 1/8

Fired red clay, modeled and painted
Unique piece

40. Plaque (Bullfight)
1957
12 3/8 × 6 × 5/8
Fired clay, modeled, stamped, and painted

Engraved on the back "25.6.57"
Unique piece

41. Large Oval Plate (Bullfight and Spectators)
1957
11 3/8 × 25 3/4 × 1 5/8
Fired clay, painted and glazed

Dated on the back "24.6.57" and stamped "MADOURA PLEIN FEU"
Unique piece

42. Tile (Musicians and Dancers)
1957
7 7/8 × 15 3/8 × 1 3/4
Fired clay, painted

Signed and dated on the back "6.3.57 IV/Picasso"
Unique piece

Exhibitions
Museum Het Kruithuis, Hertogenbosch, *Picasso Keramiek,* June 22–August 11, 1985, reproduced p. 225.

43. Tile (Face)
ca. 1957
7 7/8 × 15 1/4 × 1 3/4
Fired clay, with incisions, partially glazed

Unique piece

44. Tile (Owl)
ca. 1957
15 1/4 × 7 5/8 × 1 5/8
Fired clay, painted front and back

Unique piece

Exhibitions
Exposition Pablo Picasso: Marina Picasso Collection, organized by Association of Art Museums Yomiuri Shimbun Sha, Japan, November 18, 1986–October 18, 1987, no. CM-17; reproduced p. 77.

45. Large Dish (Three Bulls and One Face in the interior)
1957
17 1/4 diameter × 4 7/8
Fired clay with green, black, and blue-gray glaze on white background

Dated on the back "12.12.57" and

stamped "MADOURA PLEIN FEU"
Number on the tag "0.113"
Unique piece

Exhibitions
Museum Het Kruithuis, Hertogenbosch,
Picasso Keramiek, June 22–August 11,
1985, reproduced pp. 210–211.

46. Large Dish (Bulls in the interior)
1958
18 diameter × 4 3/4
Fired clay, painted and glazed over a
white background

Dated on the back "26.1.58"
Stamped "MADOURA PLEIN FEU"
Number on the tag "no. 146"
Unique piece

Exhibitions
Museum Het Kruithuis, Hertogenbosch,
Picasso Keramiek, June 22–August 11,
1985, reproduced pp. 212–213.

47. Large Dish (Head in four sections in the interior, three branches on the exterior)
1958
16 5/8 diameter × 5
Fired clay, painted black and dark gray,
with incising, over a white background
(interior), painted black features (exterior)

Dated on the back "1.10.58"
Stamped "MADOURA PLEIN FEU"
Unique piece

48. Large Bowl (Self-portrait)
1958
17 diameter × 4 1/4
Fired white clay, painted in ocher and
gray, unglazed

Plant decorations painted on the back and
dated with incisions "10.1.58"
Stamped on the back "MADOURA PLEIN
FEU"
Unique piece

49. Large Round Plate (Informal decoration)
1959
15 1/4 diameter × 2
Fired clay, traces of black paint and
glaze, ocher on the bottom, geometric
frieze in black glaze on back

Stamped "MADOURA PLEIN FEU"
Date painted on the back "27.12.59"
Unique piece

** Shown only in Tacoma

50. Large Round Plate (Frieze with four bulls and four owls interspersed)
1959

16 1/2 diameter × 2 5/8
Fired clay, painted and glazed

Stamped "MADOURA PLEIN FEU"
Date painted on the back "27.12.59"
Unique piece

** Shown only in Tacoma

51. Face of a Man with Beard
1962
8 5/8 × 5 3/8 × 3 1/4
Painted brick fragment

Dated twice on the edge and the inside
of the brick "17.7.62"
Unique piece

* Shown only in Spain

52. Round Plate (Face)
1963
9 1/4 diameter
Fired clay, painted and glazed

Date given on the back: 1963
Unique piece

53. Round Plate (Informal design)
1963
9 1/4 diameter
Fired clay, painted and glazed

Date painted on the back "30.5.63"
Number engraved on the back "IV"
Unique piece

54. Floor Tile (Face)
1965
10 1/8 × 10 1/8 × 7/8
Fired clay, painted and glazed

On the back in squares
24	6
6	5
Unique piece

55. Floor Tile (Face of a Man)
1965
10 1/8 × 10 1/8 × 7/8
Fired clay, painted and glazed

On the back in squares
24	6
	65

In the empty square there is a face,
painted with brushstrokes.
Unique piece.

56. Floor Tile (Face of a Man)
1965
10 1/8 × 10 1/8 × 7/8
Fired clay, painted and glazed

On the back in squares
24	6
65	
Unique piece.

57. Floor Tile (Faun)
ca. 1968
6 × 6
Fired clay, painted and glazed

Unique piece

58. Floor Tile (Head of a Faun)
ca. 1968
5 7/8 × 5 7/8
Fired clay, painted and glazed

Unique piece

59. Floor Tile (Bust of a Faun)
ca. 1968
5 7/8 × 5 7/8
Fired clay, painted and glazed

Unique piece

60. Floor Tile (Bust of a Faun)
ca. 1968
5 7/8 × 5 7/8
Fired clay, painted and glazed

Floor tile with raised squares on the back
"PROCERAM/FRANCE"

Unique piece

61. Floor Tile (Bust of a Faun)
ca. 1968
5 7/8 × 5 7/8
Fired clay, painted and glazed

Unique piece

62. Floor Tile (Faun)
ca. 1968
5 7/8 × 5 7/8
Fired clay, painted and glazed

Unique piece

63. Fragment (Bust of a Woman)
1969
10 5/8 × 5 1/8 × 2 1/4
Vessel fragment made of fired and
painted clay

Unique piece

GLOSSARY

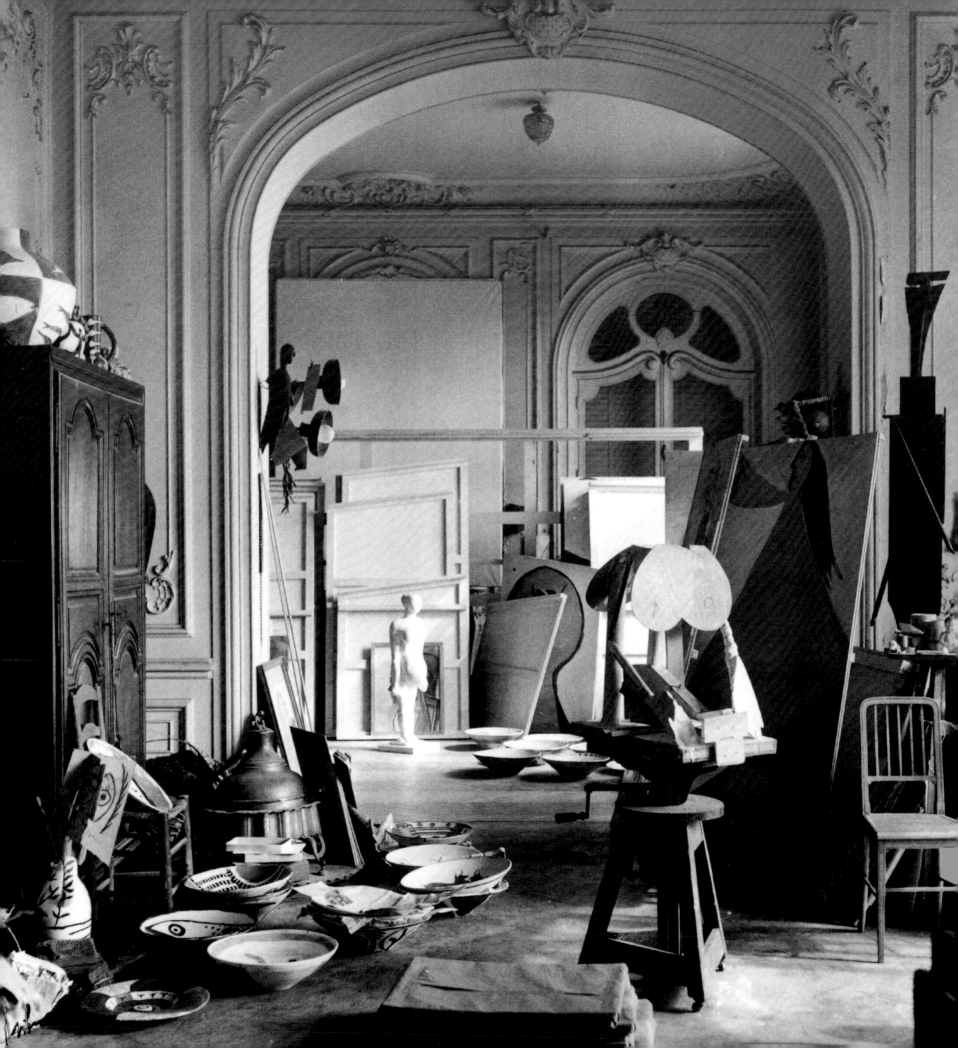

ALKALI, from the Arabic *al-qâli,* a soda or ash of alkaline plants, is the name given to metallic hydroxides that, because they are very soluble in water, can act as energy bases. This chemical compound is used in the form of a potassium or sodium oxide, and is known to be one of the components of a large number of ceramic enamels and of specific materials such as porcelain. In siliceous ceramics, the alkali are the main mineral solvents, at both high and low temperatures.

"Volatile alkali" is the ancient name of ammonia. Analyses of Egyptian glazed earthenware have shown that the alkali was more often a sodium than a potassium oxide.

ANTIMONY is a hard, brittle metal of a bluish white color. It is alloyed with other materials in small amounts to increase their hardness. In ceramics it is often used to give opacity and to color glazes or enamels. The fine particles of calcium antimony give enamel a white opaqueness, while plumbic antimony bestows a yellow opacity. Its use in the opaqueing and coloring of vitreous enamels was not described until the sixteenth century, when it was replaced by tin.

ASH is the residue of combustion, or the material left after the burning of wood or other plants, following the combustion of carbon. Chemical and mineral elements are present in lower amounts in ash than in the original plant. Ash is used above all in producing enamels. In northern Europe, wood ash is rich in potassium, while ash from plants used in the Mediterranean and Near East regions is rich in sodas (alkalies).

BALL CLAY is a very plastic type of clay, only slightly ferruginous, usually originating in England or the United States.

BENTONITE is a soft, porous, moisture-absorbing rock, often formed from vitreous particles of tuff or volcanic ash. It has a low fusion point. When it is added to pastes and clays, its high content of colloidal matter greatly increases their malleability. However, it can be used only in small amounts (five percent or less) because it contracts so greatly during firing.

BISCUIT or **BISQUE,** from the Old French, *bes* (twice), and *cuire* (to cook), is the name given to earthenware that has been fired but not glazed. The purpose of this preliminary firing is to allow the glaze to adhere better to the object.

BLUE COLOR.

EGYPTIAN BLUE is a term that designates both a color and its origin. It has several literary synonyms: cerulean blue, blue of Pompeii or Pompeian blue, Vestorian blue, blue fritted glass, and frit of Egyptian copper.

NATURAL BLUE refers to the natural mineral substances used in ceramic paints and glazes to achieve blue.

In Ancient Egypt, from the IV Dynasty onward, blue was obtained with azurite, dark blue with cobalt oxide, and greenish blue with malachite and chrysocolla. Lapis lazuli is used to obtain blue in painting. According to Dr. Jaume Coll, "When referring to blue, medieval Valencian documents quote various terms such as the Latin *lividus,* the Catalan *blau, safre,* or *acafre,* or the Italianesque *azur.*"

SYNTHETIC BLUE describes a blue or greenish blue substance obtained and manufactured artificially, thanks to knowledge of vitrification.

BRONGNIART, Alexandre (1770 – 1847). Brongniart was a French mineralogist, geologist, and engineer who carried out the first attempt at classifying ceramics. In 1800 he was appointed director of the Sèvres factory, and in 1827 he founded his own museum of porcelain. Brongniart wrote several treatises on ceramics and its components; among his works are *Mémoire sur les kaolins au argiles à porcelain* (1839 – 1841) and *Mémoire sur la peinture sur verre* (1829), *Traité des Arts Céramiques au des Poteries, considérées dans leur historie, leur practique et leur théorie* (1844) and *Description méthodique de Musée céramique de Sèvres* (1845).

BRUSH. Brushes are devices made of the bristles of either domestic or wild animals, such as the whiskers of hares or bristles inside the ears of oxen or pigs, or of synthetic materials. In ceramics, brushes are used to apply enamel, slip, or designs

to pieces. The type and number of bristles, as well as the dimension and shape of the tip of a brush, varies depending on how the brush will be used.

BURNISHING is a method of smoothing a surface, making it shiny and lustrous through being rubbed by a pebble or other smooth object. Burnishing compresses the minerals of the clay, producing a strong, homogeneous exterior surface. It is also employed to fix pigments such as hematites.

CALCAREOUS refers to a type of clay containing more than five percent lime, in the form of calcite. This kind of clay was used in

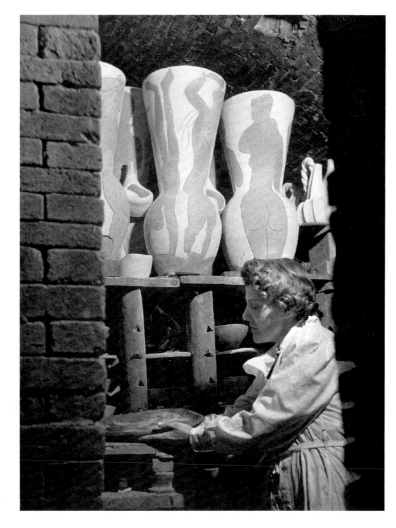

Suzanne Ramié is pictured here with Picasso's ceramics at the Madoura workshop in Vallauris.

ancient times in the Mediterranean and the Near East, as well as in the preparation of pieces such as *terra sigillata*. During the drying, the lime contained in this clay acts as a *chamota;* that is, during the first phase of firing it lessens the porosity of the ceramic paste, allowing it to melt and soften quickly during the following stages. Because calcareous clay melts and then vitrifies at very similar temperatures, only a slight excess of temperature can produce deformations in the pieces.

CALCITE, also known as calcium carbonate, is a mineral which is the main component of lime and of chalk, and which is found in calcareous clay.

CARBON is a chemical element found in most types of clay, giving the material a blackish color. Finished ceramic pieces can also be deliberately blackened by firing them in a smoky atmosphere, which impregnates the surface with carbon.

CEMENTING is a term usually employed in metallurgy. It refers to the process of bonding or fusion that occurs when one body is heated in contact with another material, whether in powder or paste form.

CERAMIC, from the Greek *keramos*, refers to articles made of moist clay which, after having been shaped, are subjected to a process of drying and baking. As a material, ceramic includes a wide variety of products ranging from porcelain to semiconductors, and from brick to materials used in nuclear power stations or for the thermal protection of spaceships. Ceramic objects can be classified, according to the composition of the paste, in two groups—*coarse ceramic,* used in building, and *fine ceramic,* which can be defined as a product manufactured from ceramic material containing particles with dimensions no larger than 0.05 millimeter. However, ceramic wares can also be classified according to their function, firing process, decoration, or provenance.

CHAMOTA is a heavy, clay-like, granulated material that requires firing at a high temperature. It is used to remove grease, and it also reduces the plasticity of refractory clay by increasing its

porosity. The majority of *chamotas* have previously undergone calcination at higher temperatures than those employed in the firing process; this gives them a stability which is then transmitted to the pastes they are added to. This type of ceramic is employed for the exterior surfaces of houses and for other technical purposes. It is also used by the Basque sculptor Eduardo Chillida in his *terra chamota* sculptures.

CLAY is an earthen material composed mainly of aluminum silicates originating from the decomposition of feldspars. Feldspars are double silicates of aluminum and an alkaline metal (often potassium), either found in the clay or added to it in the proportion desired. Clay is the basic material of pottery. Depending on the mother rock, a number of different clay types can be singled out, such as kaolinic, illonitic, and montmorillonitic, each of which presents a different crystalline structure. Clayish minerals of the illonitic and montmorillonitic types produce ceramics with increased durability, but a lower melting point, while clay pastes containing a high proportion of kaolinic material cannot be fused or liquefied at all. The varying quantities of quartz, feldspar, calcite, or iron oxide the clay contains give it its different colors. Bernard Palissy (1510 – 1589) compiled an inventory of types of clay, entitled *Des Terres d'Argile*.

Clay which is has absorbed water becomes very plastic, enabling it to be formed when pressure is exerted on it, or to subsequently be molded without breaking. If it is allowed to dehydrate and contract after being formed, it retains its shape and hardness. For this reason clay is the essential material in pottery.

The purest type of clay is kaolin, although it too includes different types, distinguished according to their degree of malleability and resistance to fire. According to the way they respond when fired, clays are classified as *refractory* if they suffer no deformation at 1580°C. In this group we may include kaolinic clays and those used in porcelain, for both resist temperatures of up to 1700°C. Another type includes clays that are susceptible of being fused, or illonitic clays, the firing temperature of which does not exceed 1000°C.

It is advisable not to employ the term *clay* to define the bodies that make up earthenware or ceramic pieces, as this term designates a natural raw material and not one that has undergone either physical or chemical transformation. M. Yon has pointed out that it is more appropriate to use the word *paste* in technical descriptions of such pieces, or when referring to archaeological fragments.

CRACKLE and *craze* are terms used to define the network of fine cracks found in glaze and paint.

DOLOMITE is a mineral consisting of calcium magnesium carbonate, related to limestone. It is usually either clear, white, or of variegated color.

EARTHENWARE is pottery baked at a temperature lower than that required to reach the point of vitrification, and thus it has a porous quality. For this reason, each piece is generally coated with a glaze after its first firing, usually one with a base of tin or lead. The clay material used in earthenware includes a high proportion of quartz, and glazes for earthenware are produced with kaolin, quartz, and alkalies. According to current French nomenclature, all ceramic objects having a clay-like, siliceous, porous, and more or less colored structure, and that present a shiny, vitreous coating that is capable of making them completely impermeable, should be classified as earthenware. The related Spanish term *loza* stems from the Latin *lautia*, meaning trousseau.

EFFLORESCENCE designates the phenomenon whereby alkaline salts and copper oxide migrate to the surface of a ceramic object and appear there during the process of drying. It also refers to "self-glazing," a process accomplished by integrating the raw materials of the glaze with the paste used in manufacturing an object. The prefix *self* is employed to indicate that the glazing is carried out by minerals in the substance *itself* during one single firing process. Consequently, this expression should not be mistaken for either enameling or enameling by cementing. When efflorescence combines with other elements of the paste (quartz or lime) during a single firing at low temperature, the result is a totally vitrified surface.

ELECTRON MICROSCOPE refers to an apparatus that projects an electron beam, rather than light, to explore various substances, and which produces a magnified image of them. It obtains television images in black and white, and is frequently used in pottery manufacture, as its degree of magnification provides a clear view of the chemical elements involved in the ceramic process.

ENAMEL, from the Old German term *smalts,* or fusion, is a hard, shiny, vitreous substance obtained by fusing enamel powder in a kiln at a temperature between 700°C and 850°C. It may be ground and polished, and can be either opaque or translucent. Enamel is prepared by mixing its components with water to obtain a thick, well-blended liquid cream. A porous article that absorbs water quickly requires a more finely ground enamel than one which is less porous or unable to absorb water.
The English term *glaze* designates both this vitreous coating and the substance used to produce such a coating.

ENAMELING is a general term used to designate any vitreous coating of a piece of ceramic. The term *glazed* is employed to specify the lead-based coatings covering clayish or siliceous ceramics. *Cover* refers to earthenware and porcelain coatings. Glazed earthenware can be classified in various ways, according to its color, shine, firing temperature, chemical composition, and so on.
Enameling is usually performed by dipping the piece into a watery solution containing vitreous components that have been finely ground and sifted. In order to achieve a uniform thickness, the enamel may be applied with a high-pressure sprayer. Nowadays, potters occasionally glaze with a spray gun.

FAIENCE is a French term for pottery originating in the Italian town of Faenza, near Bologna, Italy. Nevertheless, faience itself seems to have originated in the Hispano-Moresque potteries of the Balearic Islands and the southeast coast of Spain that exported their goods to Italy during the fifteenth century (see **Majolica**). It is a lightweight pottery, covered with a glaze made opaque by the tin oxide *(l'émail stannifère)* it contains; this opaque background can then be overpainted with metallic oxides, and fixed during firing at low temperature. By extension, the name is applied to all objects covered with a glaze containing tin oxide.
Many countries, including Germany, Sweden, and Norway, adopted *faïence* or *fayence* as a synonym for earthenware, while others such as Holland and England used the term *delftware,* a name derived from the Dutch city of Delft, another area devoted to pottery manufacturing. In France, *faïence* is used to refer to all glazed earthenware, as opposed to *poterie,* which is not glazed. The best-known types are *faïence blanche,* which presents large areas of white; *faïence parlante,* decorated with verses, proverbs, allegories, and mottos; *faïence patriotique,* which emerged at the time of the Revolution of 1789, and *faïence fine,* which is the French equivalent of English creamware or Spanish *loza fina.*

FIRING.

OPEN FIRING is a the way ceramics were baked in ancient times; in this method, the objects are in direct contact with the flames of a fire. One advantage of this system is that it requires less fuel; however, its main drawback is the fact that the pieces may become discolored by such direct contact with both fuel and fire. The number of articles that can be satisfactorily baked with this system is also limited, because the rapid increase in temperature may make them explode; climatic variation is another unfavorable factor, because it can limit year-round work.

OXIDIZING FIRING is a type of baking during which the oxygen in the air in the kiln is sufficient to insure combustion, and also to combine with the molecules of the elements contained in the different pastes and glazes.

The result of this phenomenon, known as oxidation, is especially perceptible with metal oxides. In oxidizing firing, for instance, a glaze containing copper oxide or carbonate of copper turns green or greenish blue, the usual colors of oxidized copper, while iron oxide tends to produce more rusty or red hematites than black magmatites. In addition, the oxidizing firing burns the carbon from the piece, so that earthenware articles baked at low temperatures usually adopt a reddish tone. The siliceous enameled ceramics of ancient Egypt were baked in oxidizing atmospheres.

REDUCTIVE or **REDUCTION FIRING** refers to a type of baking that takes place in a kiln atmosphere having a limited amount of oxygen and an excess of fuel and smoke. During baking at high temperatures, iron oxide particles in the clay body tend to produce black magmatites, which results in the adherence of the carbon to the pieces. Articles that undergo this baking process usually acquire black or grayish tones.

FLUX refers to a substance which, when added to another, facilitates its fusion or compactness, often by lowering its melting temperature. In ceramics flux is used to specify those elements in the composition of earthenware that are added to reduce the temperature (1750°C) at which quartz fuses and vitrifies. The first fluxes were the same components used in transparent glazes (lead) and in white enamel (tin), and that could also produce different color tones by means of the same oxide. Thus, with a lead glaze or varnish, copper oxide produces an olive green color, but with tin enamel results in a bright emerald green.

FRIT is a term related to the Italian *fritta,* or fried; it generically designates the basic materials, partially or wholly fused, for making glass, glazes for pottery, and enamel. It also designates a vitrified substance which, after being abruptly cooled and pulverized, forms part of the glaze as a source of alkaline oxides in an insoluble state (oxide of potassium or oxide of sodium, for example).

GLAZE is a generic term for the vitrified (glasslike) coating covering an object made of clayish and/or siliceous paste. To achieve such a coating, the objects may either be dipped in a glaze mixture or be covered with a finely pulverized "glazing mass."

A classification of glazes can be established according to color (colored or clear), translucence (opaque or transparent), shine (brilliant, semi-brilliant, or matt), degree of fusion (high or low), treatment or chemical composition (boric acid, lead, feldspars, salts, aluminum, etc.), and even appearance or decorative qualities. Depending on its composition, a glaze can be termed alkaline, fritted, lead (varnish), or tin (enamel). Its appearance gives rise to two descriptive terms, *enamel* (opaque glaze) or *varnish* (transparent glaze).

GREEN COLOR. "Natural green" refers to green substances of natural origin used in painting. In specialized studies, the color green is found to derive from minerals containing copper, primarily malachite and chrysocolla. It is important to note that the term "green" may be used to describe several tones. Malachite green or *verdigris* can designate green or greenish-blue hues, and E. Iversen has pointed out that in translating old Egyptian texts the terms malachite or *verdigris* can also refer to the blue color of veins in medical texts, while the expression "that which is very green" is often employed as a translation of *sea*.

HEMATITE, from the Latin *haematites,* and the Greek *haimatites*, refers to ferric oxide. It appears, following the oxidation of iron, as the ferrous component of clay, and gives ceramic pieces their ocher or orange-colored tonality.

INCLUSION refers to the introduction of hard, nonplastic particles in an article made of clay.

INGLUVIO is a Latin term that designates a white, clayish material colored by metallic oxides, sometimes called *englobe*. It is generally applied in a very liquid form to entire ceramic objects or to parts of objects before their first firing, to disguise the natural color of the raw clay, or to decorate it.

The methods of application are similar to those of enamel—dipping, sprinkling, or spraying—but the process is more difficult, as the *ingluvio* must be done quickly, before the water it contains penetrates and softens the piece. In English the term *slip* is used to describe clay mixed with water to a creamy consistency, used for decorating or mending ceramic pieces.

IMMERSION occurs when a vessel is submerged in an enamel solution.

KAOLIN is a fine white clay resulting from the alteration of feldspars and silicas. It name derives from the Chinese mountain Kaolin, where supplies for this material were first obtained for use in Europe, and the Chinese terms *kao* (high), and *ling* (hill).
Kaolin is used in the manufacture of fine earthenware (hard-paste porcelain and bone china) because it contains so little iron, titanium, and alkali that it produces pieces that are white after firing. It is also used as an enamel. Combined with water, it becomes a plastic substance that remains white and does not contract during baking. By itself, it produces a very porous type of porcelain, and so it is necessary to mix it with orthoclase, quartz, and gypsum.
In Europe acceptable porcelain was not produced until 1671, when it was achieved by the Englishman John Dwight. However, it was not until 1710 that ware truly analogous to that made in China with

kaolin was first produced by the German E. Boettger. In the nineteenth century, the pottery of Busturia in the Basque country owes the quality of its *opaque china* to the kaolin from Murueta.

KILN. A kiln is an enclosed, ovenlike heating structure for firing ceramics. It is usually lined with refractory material and consists of a chamber where the fire burns, a compartment where the pieces are stacked, and a vent for the exhaustion of gases. It permits slower increase and greater control of temperature than are possible with an open fire, and also shelters the pieces from direct contact with the fire.

The characteristics of a kiln are fundamental in determining the finish of the articles fired in it; the two main types of kilns are those burning coal or firewood, and those using electricity or gas.

LACQUER is a hard, glossy coating made from a resinous substance originating in India and extensively used in Japanese decorative arts. The beauty of lacquerwork made with this substance resulted in the creation of a flourishing craft. The resin is extracted from *Rhus verniciflua,* a Southeast Asian tree from the sumac family, by cutting through the bark. The sap is then collected, exposed to the sun, and stirred with an iron spatula to allow the water to evaporate. The resin is either used in a pure state or combined with iron sulphate from *toshiruu,* water saved from sharpening the blades used to cut tobacco plant on stone, pure oil, or pumice stone. The best gloss is obtained between the end of July and mid-September. In its pure state it is known as *kourume;* once it has been sifted it is called *seshimi ouroushi;* it is called *kouro* if it contains iron sulphate, but if it contains iron oxide—which gives it a vermillion tone—it is known as *sou.* The most important center of production was in the Japanese province of Yamato, at Yoshino.

LATHE refers to a machine used to shape or bore items that are attached to a horizontal axis; when the axis is rotated, by manual or mechanical power, the rapidly spinning items can be formed using templates or tools.

LEVIGATION is the process of separating fine from coarse or heavy particles of a powdered substance by dissolving it in water; the heavy particles are deposited in the bottom of the vessel.

Advertisement poster for cookware made in Vallauris. Designed by C. Valafseur for the workers' union Syndicat des Fabricants, *Poteries Culinaires.* Printed for Imbert & Cie, Grasse, France 1970.

LIME is the common name of calcium oxide. In low-temperature glazes it favors the creation of links with silica to form silicates (such as silicate of sodium), insuring their solidity. It is used as a flux in high-temperature enamels although it can assist the fusion of quartz at a low temperature if accompanied by other fluxes such as oxides of zinc, sodium, or lead. However, lime has a tendency to thin the color of glazes.

LOW TEMPERATURE refers to firing a kiln at a temperature of approximately 700 °C to 1160 °C. Self-glazed siliceous pastes are fired at low temperature (between 850 °C and 950 °C).

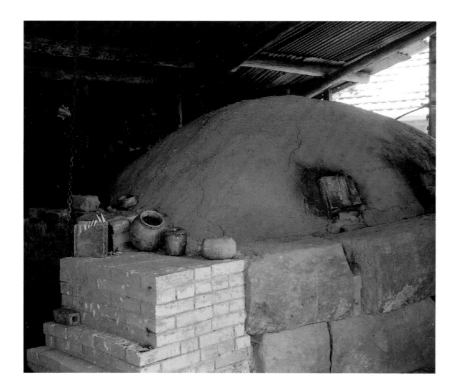

Ceramic kiln in the form of a tortoise shell, constructed by Eric Astoul. Its capacity is seven cubic meters and follows the tradition of steelyard kilns having a horizontal axis.

MAJOLICA, from the Italian *maiolica*, in its turn from the Latin *maiorica* and the island of Majorca, refers to a type of fourteenth-century Spanish ceramic ware, originally produced largely in Valencia, and brought for sale to Italy in great quantities in Majorcan ships. It designates a type of porous pottery with a golden luster, made following a tradition transmitted by the Arabic settlements on the Iberian Peninsula. From the year 1500 onward, a similar golden glaze began to be applied to pottery in Italy subsequently called Renaissance *maiolica*. To achieve the characteristic gold of such pieces, either silver or copper were employed; they produced brilliant yellow or ruby-red colors. The typically Italian style known as *istoriato* (story-telling) usually represents Biblical or mythological themes. Copies of Raphael's frescoes for the Vatican on certain ceramic pieces gave rise to the term *Rafaelle*. The most important centers to produce this type of work were Faenza (which would later result in much pottery being defined as faience), Orvieto, Florence, Siena, Deruta, Gubbio, Caffagiolo, Castel Durante, Urbino, and Venice.

MODEL means to shape a piece of clay either by hand or with a tool.

MOLD means to shape a piece of clay by introducing it into a mold.

NATRON is a whitish or yellow mineral that occurs in saline deposits and salt lakes and consists of hydrated sodium carbonate. It was abundantly used by ancient Egyptians for everyday chores (as a detergent, and for salting meats or fish), in medicinal preparations, as a preserving agent in techniques of mummification, as a purifying element in lustration rites during religious ceremonies, and perhaps in the manufacturing of vitrified ceramic products.

NEUTRON ACTIVATION ANALYSIS (NAA) is a method of analyzing elements, in which a small sample of ceramic powder is bombarded with neutrons in a nuclear reactor, and the resulting gamma radiations are measured in order to determine the concentration of groups of elements. Despite being considered a precise, exact, and detailed method of analysis of archaeological materials, the closure of nuclear reactors has led to the discontinuation of this method of investigation.

OXIDES.

COBALT OXIDE is a substance used in enameling that produces a deep blue color when it is fired. In order to achieve a brilliant blue, it can be combined with a vitreous coating known as tin enamel, composed of lead, silica, and tin. Like the other metal oxides, it is employed because even in very small amounts it can produce strong color, and so has little effect on the mechanical properties of the clay to which it is added. Cobalt oxide is a very effective and stable coloring, and a mere 0.5 percent of this substance is enough to tint a ceramic body. In Spain, the first pottery articles showing this pigment appeared in the thirteenth century in the *Nazaries,* in Málaga. In the fourteenth century, related work is found in Paterna and Manises in the region of Valencia. *Nazaríes* is a Spanish term designating the members of the Muslim family that ruled Granada between the thirteenth and fifteenth centuries, and their affairs. Here, *Nazaríes* refers to the Moorish quarter of the city of Málaga in Andalusia.

COPPER OXIDE is a metallic oxide that gives enamels

turquoise or green colors when firing takes place by oxidation; when used in reduction firing, it can also color enamels red. Research now indicates that most of the copper oxide found in primitive pottery was obtained by heating small pieces of bronze.

MANGANESE OXIDE is a metallic oxide that, when added to ceramic pastes, produces a black or brown color; it can also produce a purple or aubergine color when dissolved in enamel. Painted decorations made with this oxide appear in Egyptian pottery.

PASTE is the generic term used to designate the combined ingredients of which a piece is made. *Vitrified, self-glazed paste* describes the hard, opaque, and homogeneous (vitrified) body of ceramic objects having a superficial glaze (due to the self-glazing process).
Vitreous paste refers to the hard, opaque, homogeneous, totally vitrified material of certain Egyptian objects that are not coated with a superficial glaze.

PICASSURE is a term employed to designate flaws produced by a supersaturation of lead, which can appear both in the form of dun stains with aureoles and of massed crystallizations. The term is prior to Picasso and has nothing to do with the artist's way of working clay. As noted by the potter Georges Ramié, despite all the risks taken and investigations carried out by Picasso in his devotion to ceramics, he never encountered this flaw.

PICCOLPASSO refers to the nobleman Cypriano Piccolpasso (Castel Durante, 1524 – 1579), the author of *I tre libri del arte del vasaio* (1556 – 1559). The book describes each of the operations in the creation of lightweight enameled ceramics: the selection and preparation of the clays, the molding on the potter's lathe, the enameling by immersion, drying, painting, baking, and so on.

PIGMENT (from the Latin *pigmentum* and *pingere,* to paint), refers to coloring materials made from organic substances. Color in ceramic work is usually produced with such metallic oxides as iron, cobalt, lead, tin, antimony, and manganese.

PLASTICITY refers to the capacity of pastes to be shaped into a variety of forms. Clay is said to be "plastic" when it is easily modeled, molded, and can be finished on a lathe without cracking; this also implies that it has the ability to hold the amount of water needed to permit the individual clay particles to slide against each other without losing contact.

PORCELAIN, from the Italian *porcellana,* is a white, translucent, and vitrified type of pottery. Its translucency is its chief distinguishing feature. Porcelain is composed of clay, feldspar, silica, alkalies, and boraxes, in varying proportions. The optimum degree of vitrification needed to obtain this translucent quality depends on the temperature to which an object is subjected; if the object is not fired at sufficient temperature it will remain

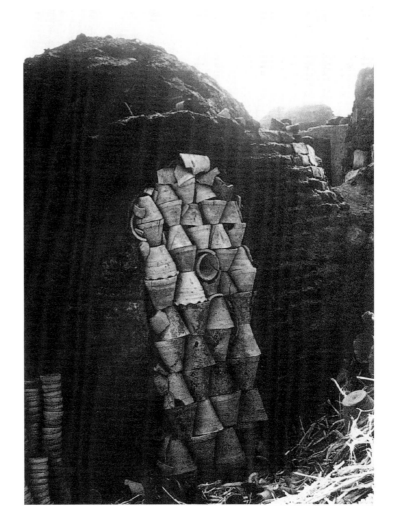

View of a ceramic kiln's central door. Discarded ceramic vessels are accumulated in a stack that is then sealed over with mortar and ashes. This creates a barrier to keep heat from escaping the firing chamber.

Porcelain plate from Sèvres, about 9 1/2 inches in diameter, signed by C. Develly in 1823. The image in the center shows the step of painting and glazing work in a ceramic workshop. This plate belongs to a place setting dedicated to the industrial arts, and is one of four Sèvres porcelain designs made at Napoleon's request. The four place settings are called "encyclopedic" because they include illustrations of the following topics: Views of France (1812 – 1815), Greek iconography (1812 – 1817), the French Departments (provinces) (1824 – 1829), and the Industrial Arts (1823).

such as metal, rope, or wood, thus giving it a different form. The impression must be made when the piece is still plastic enough to prevent it from breaking, yet solid enough to avoid the deformations caused by the pressure exerted. In England toward the middle of the eighteenth century a new method of printing was invented for ceramic decoration, known as "transfer-printing." This system consisted of placing the printing surface on the still-moist article and applying heavy pressure. Today, most relief decoration is produced by a mechanical process of this kind.

PROTOTYPE refers to an original model from which molds are elaborated.

QUARTZ is the common crystalline form of silica that abounds in Aswan and in the deserts of the Far East. In a pure state it can be translucid (rock crystal), opaque, or colored (tinted quartz, pink quartz, or amethyst quartz, for instance).

In ceramic pastes, its transformations are slow yet continuous, giving the paste a high degree of stability both during the process of drying and in firing, in spite of the fact that it crystallizes differently according to variations in temperature. Because quartz has a very high fusion point (between 1450°C and 1650°C), it is essential to introduce fluxes (for example, alkalies and lime) in the composition of the pastes in order to achieve a vitrified state at a lower temperature. In ceramics, the transformation of quartz under the action of heat is a complex phenomenon, one that depends both on the speed of heating and on the presence of other minerals. Furthermore, during a single firing process quartz in a pure state is able to irreversibly transform itself into tridymite (at approximately 870°C) and then into chrysoberyl (at approximately 1470°C); these transformations can also be effected at a lower temperature if the silica is combined with mineralizing elements such as lime or alkali.

SELF-ENAMELING (also called auto-enameling) is a process that begins with the introduction of dissolvents (primarily alkalies) and other necessary raw materials into the paste used for manufactured wares; when fired, these substances vitrify to form a very thin glaze at the surface of the object. A small

opaque. Porcelain is a Chinese invention that made its appearance approximately in the seventh century A.D., during the T'ang dynasty. It spread to Europe during the Crusades, where it was admired both for its elegance and because of the ancient belief in its magical powers. Depending upon the temperature of firing, porcelain is divided into two categories— *hard paste* and *soft paste*. Soft paste ware is that formed by a blend of clay and granulated glass and fired at temperatures between 900°C and 1200°C. Most French porcelain is of this type. Hard paste is composed of a combination of feldspar and kaolin and is fired at temperatures between 1250°C and 1450°C. Chinese porcelain, above all others, falls into this group, which is the type that Marco Polo named *porcellana* (after a type of white shell painters kept their pigments in) in his description of Chinese ceramics in 1295. European manufacturing of this variety of porcelain did not begin until the early eighteenth century.

PRINTING and **STAMPING** are two of the oldest decorative techniques; they are done by pressing the clay with a hard object

amount of clay can be introduced into the composition of pastes for auto-enameling in order to make them plastic and give them complementary raw materials (alumina, silica, feldspar, etc.). The English expression "self-glazing" was first used by J. Binns in 1932.

SGRAFFITO or **INCISION,** from the Italian *sgraffiare,* to scratch, describes a technique used in ceramic decoration. After a vessel has been given a top layer of slip or englobe, and before the vessel is baked, the top layer is incised with a design, using sharp metal or wooden instruments. The incisions reveal the ground or color lying beneath the coating, producing by contrast a decorative effect. The technique originated in Islamic pottery and was widely used in the Near East.

SILICA refers to crystals of quartz and other minerals forming silicates; for example, silicates of aluminum are the main components of clay. Silica can appear in either an anhydrous or a hydrated state (as in opal, for instance), and the anhydrous state may appear in crystallized (as quartz, tridymite, chrysoberyl) or amorphous (silicon dioxide glass) forms. When fused at 1710°C and then cooled, silica becomes glass; for this reason it is the basic element in vitrification.

SODA refers to the sodium carbonate found in the ash of plants growing on the shores of salt lakes, and above all in natron. It is essentially made up of sodium carbonate and sodium bicarbonate, although it contains other elements or impurities, such as sodium chloride, sodium sulphate, calcium carbonate, and magnesium carbonate.

STANNOUS is a term applied to glazes containing tin oxide. The invention of a semiabsorbent, white, tin-oxide glaze for use as a ground dates from ninth-century Islamic pottery.

STONEWARE or **GRÈS** (from the French term *grès* or sandstone), is a hard, opaque pottery fired at very high temperatures (1200°C to 1280°C). Stoneware does not require glazing as the firing vitrifies the clay so that it is not porous; however it is usually glazed for decorative purposes. Originating in the Far East (China), the most famous type of stoneware is

known as *celadon;* it was made in China, Korea, and Japan. Celadon ware is decorated with clear or colored glaze; the coloring is achieved by means of a wash of barbonite (semiliquid clay) with a high content of iron, which covers the piece before it is fired for vitrification. The iron fluxes with the glaze to produce the typical celadon tones. In northern China the celadons from Honan and Shensi present fine carved floral motifs; the shapes in Korean celadon ware were more imaginative and closer to nature in design. In Japan, celadon-glazed stoneware included vases either stamped or carved with floral patterns, covered with uneven brownish glazes.

TERRA COTTA, from the Latin *terra cocta* or baked earth, is a hard pottery made of porous, unglazed clay that when fired

This illustration was made by the chevalier Cypriano Piccolpasso, of Castel Durante, Italy, the author of *I tre libri del arte del vasaio* (1556 – 1559). The book describes the processes involved in creating lightweight glazed ceramics, from the selection and preparation of the clay and the modeling on the potter's wheel to the glazing, drying, and firing. The image shows workers making majolica ware.

acquires colors that can range from dark ocher to red. Depending upon the type of clay used, terra cotta objects range from brick to earthenware, stoneware, or other ceramic types. This is the material generally used in sculpture, reliefs, and various kinds of decorative and utilitarian objects.

TERRA SIGILLATA is a Latin term meaning "clay with stamped designs"; it is also known as *Arretine*. It is the typical pottery of imperial Rome and was made serially—almost industrially

Another image from Piccolpasso's book shows the master ceramist directing the firing of a kiln. A sand clock for timing the firing stands on the stool next to what appear to be a dog and a bird.

Egyptian pottery dating from about 2,400 B.C., as it appears in a relief in Ty's tomb at Saqquara. The illustration shows specific steps in the production of pottery wares; from left to right, modeling by hand, control of the form, modeling on the wheel, and control of the kiln. (Illustration from *Pottery in the Making*, British Museum, London 1997.)

manufactured—using molds. It was widespread in the western world until the late years of the Roman Empire (in Spain it is known as *barro saguntino* or clay from Sagunto). A variety of motifs, both abstract and representational, were employed for the relief decoration of the pieces. Its characteristic color is red, with a thin, brilliant exterior coating prepared with a solution of ferruginous clay. Such pieces are valuable references for the dating of archaeological objects found in the same site, since they include the potter's signature or *sigillata,* a term that stems from *sigillum*—the little figure or stamp of the workshop that appears on the bottom of the pieces.

VARNISH (often called glaze in English) is a crystalline coating on the surface of a ceramic piece. It can be obtained either by the application of a naturally colored clay, or of metallic oxides and vitreous components mixed with water to produce a slightly thick cream. Varnish is generally employed to cover pieces which are still moist, before firing. The term is also used to define a coating of organic origin, normally resinous, used to cover a terra cotta.

VITRIFIED is the term used to describe the hard, homogeneous state of materials that have been transformed into glass during the process of fusion. According to the thickness and purpose of the glaze, the vitrified material can be opaque (as in the case of the body of certain self-glazed objects, or of glazes containing tin oxides, for instance), translucent, or transparent (such as glass, and the alkaline or lead glazes of enameled objects). Stoneware and porcelain are examples of ceramic wares that are vitrified in the process of firing.

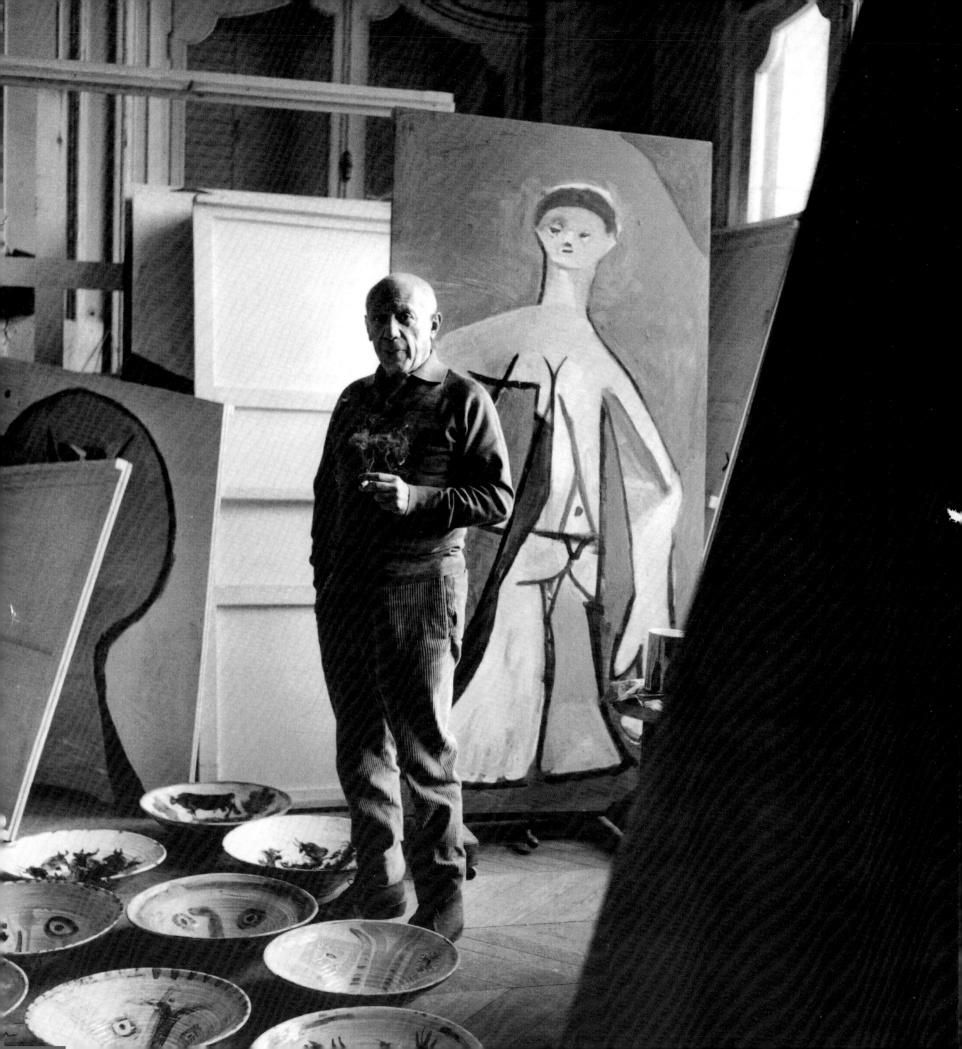

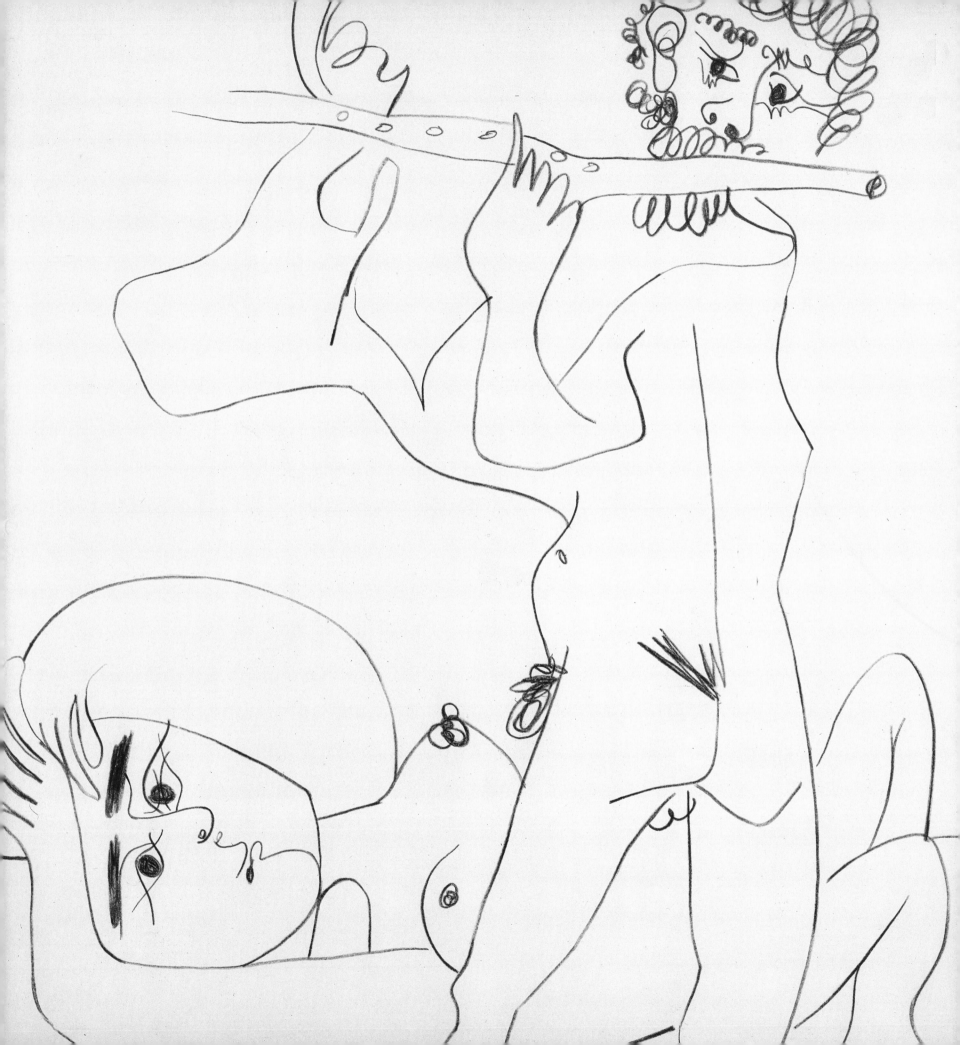

PICASSO'S STUDIO
DRAWINGS AND PRINTS

Picasso's Studio: Drawings and Prints

An exhibition organized by the Tacoma Art Museum, September 27, 1998, to January 10, 1999

Measurements of sheet sizes are given in inches; height precedes width.

Two Sculptors before a Statue, 1931
Etching
13 1/4 × 17 3/8
Museo Nacional Centro de Arte Reina Sofía, Madrid

Nude with Bent Leg, 1931
Vollard Suite, No. 8
Etching
17 5/8 × 13 1/4
The Grunwald Center for the Graphic Arts, UCLA at the Armand Hammer Museum of Art and Cultural Center, Gift of Mr. and Mrs. Milton E. Kahl

Beauty and the Beast, 1933
Watercolor, pen, and India ink on paper
15 3/4 × 19 3/4
Private collection

Sculptor, Model, and Sculpture, 1933
Vollard Suite, No. 40
Drypoint
17 3/8 × 13 1/4
Museo Nacional Centro de Arte Reina Sofía, Madrid

Sculptor, Reclining Model, and Sculpture, 1933
Vollard Suite, No. 37
Etching
17 3/8 × 13 1/4
Museo Nacional Centro de Arte Reina Sofía, Madrid

Sculptors, Models, and Sculpture, 1933
Vollard Suite, No. 41
Etching
13 1/4 × 17 3/8
Museo Nacional Centro de Arte Reina Sofía, Madrid

Model Leaning on a Painting, 1933
Vollard Suite, No. 43
Etching
17 1/8 × 13 1/8
Museo Nacional Centro de Arte Reina Sofía, Madrid

Sculptor with Goblet and Crouching Model, 1933
Vollard Suite, No. 44
Etching
17 3/8 × 13 1/4
Museo Nacional Centro de Arte Reina Sofía, Madrid

Sculptor and Model Admiring a Sculpted Head, 1933
Vollard Suite, No. 45
Etching
17 1/2 × 13 1/4
The Grunwald Center for the Graphic Arts, UCLA at the Armand Hammer Museum of Art and Cultural Center, gift of Mr. and Mrs. Fred Grunwald

Young Sculptor at Work, 1933
Vollard Suite, No. 46
Etching
17 3/8 × 13 1/4
Museo Nacional Centro de Arte Reina Sofía, Madrid

Seated Sculptor and Two Sculpted Heads, 1933
Vollard Suite, No. 48
Etching
17 3/8 × 13 1/4
Museo Nacional Centro de Arte Reina Sofía, Madrid

Sculptor Reclining before a Small Torso, 1933
Vollard Suite, No. 53
Etching
13 3/8 × 17 1/2
The Grunwald Center for the Graphic Arts, UCLA at the Armand Hammer Museum of Art and Cultural Center, gift of Mr. and Mrs. Milton E. Kahl

Family of Acrobats, 1933
Vollard Suite, No. 54
Etching
13 3/8 × 17 1/2
The Grunwald Center for the Graphic Arts, UCLA at the Armand Hammer Museum of Art and Cultural Center, purchase

Sculptor Reclining before a Young Horseman, 1933
Vollard Suite, No. 55
Etching
13 1/4 × 17 3/8
Museo Nacional Centro de Arte Reina Sofía, Madrid

Reclining Sculptor and Bacchanalia with Bull, 1933
Vollard Suite, No. 56
Etching
13 1/4 × 17 3/8
Museo Nacional Centro de Arte Reina Sofía, Madrid

Sculptor and His Model before a Window, 1933
Vollard Suite, No. 59
Etching
13 1/4 × 17 3/8
Museo Nacional Centro de Arte Reina Sofía, Madrid

Reclining Sculptor and Surrealist Sculpture, 1933
Vollard Suite, No. 60
Etching
13 1/4 × 17 3/8
Museo Nacional Centro de Arte Reina Sofía, Madrid

Reclining Sculptor II, 1933
Vollard Suite, No. 63
Etching
13 1/4 × 17 3/8
Museo Nacional Centro de Arte Reina Sofía, Madrid

Three Nudes beside a Window, 1933
Vollard Suite, No. 67
Etching
17 1/2 × 13 3/8
The Grunwald Center for the Graphic Arts,
UCLA at the Armand Hammer Museum of
Art and Cultural Center, gift of Mr. and Mrs.
Milton R. Stark

Sculpture of a Youth with Goblet, 1933
Vollard Suite, No. 70
Etching
17 1/8 × 13 1/4
Museo Nacional Centro de Arte Reina Sofía,
Madrid

Female Model and Two Sculptures, 1934
Vollard Suite, No. 75
Etching
14 5/8 × 11 1/2
Museo Nacional Centro de Arte Reina Sofía,
Madrid

Model and Sculpted Female Torso, 1933
Vollard Suite, No. 73
Etching with scraping
17 3/8 × 12 7/8
Museo Nacional Centro de Arte Reina Sofía,
Madrid

**Crouching Model, Nude, and Sculpted
Head,** 1933
Vollard Suite, No. 71
Etching
17 3/8 × 13 1/4
Museo Nacional Centro de Arte Reina Sofía,
Madrid

Sculptures and Vase of Flowers, 1933
Vollard Suite, No. 76
Etching
17 1/2 × 13 1/4
Museo Nacional Centro de Arte Reina Sofía,
Madrid

**Sculptor and Sculptural Group of Three
Ballerinas,** 1934
Vollard Suite, No. 81
Etching
13 1/4 × 17 3/8
Museo Nacional Centro de Arte Reina Sofía,
Madrid

**Blind Minotaur Guided by a Young Girl at
Night,** 1934
Vollard Suite, No. 97
Aquatint with scraping, burnishing, and
etching
13 3/8 × 17 5/8
Achenbach Foundation for Graphic Art, Fine
Art Museums of San Francisco, bequest of
Ruth Haas Lilienthal

**Youth and Sleeping Woman by
Candlelight,** 1934
Vollard Suite, No. 26
Aquatint and etching
13 3/8 × 17 5/8
The Grunwald Center for the Graphic Arts,
UCLA at the Armand Hammer Museum of
Art and Cultural Center, the Fred Grunwald
Collection

Winged Bull Watched by Four Children,
1934
Vollard Suite, No. 13
Etching
14 3/4 × 19 1/4
The Grunwald Center for the Graphic Arts,
UCLA at the Armand Hammer Museum of
Art and Cultural Center, the Fred Grunwald
Collection

Fawn Uncovering a Woman, 1936
Vollard Suite, No. 27
Aquatint and etching
13 1/2 × 17 1/2
The Grunwald Center for the Graphic Arts,
UCLA at the Armand Hammer Museum of
Art and Cultural Center, gift of Dr. and Mrs.
Ernest Grunwald

Study of Composition for *Guernica* **(I),**
1937
Graphite on paper
8 1/8 × 10 1/2
Museo Nacional Centro de Arte Reina Sofía,
Madrid

Study of Horse (II), 1937
Graphite and colored pencil on paper
9 3/8 × 17 1/2
Museo Nacional Centro de Arte Reina Sofía,
Madrid

Study of Weeping Head (III), 1937
Graphite and colored pencil on paper
9 × 11 3/8
Museo Nacional Centro de Arte Reina Sofía,
Madrid

Weeping Head (V), 1937
Graphite, gouache, and colored pencil on
paper
11 3/8 × 9
Museo Nacional Centro de Arte Reina Sofía,
Madrid

Weeping Woman with Handkerchief (I),
1937
Ink on paper
9 7/8 × 6 5/8
Museo Nacional Centro de Arte Reina Sofía,
Madrid

Head of a Boy, 1945
Lithograph
17 3/4 × 12 3/4
The Grunwald Center for the Graphic Arts,
UCLA at the Armand Hammer Museum of
Art and Cultural Center, gift of Mr. and Mrs.
Arthur Freed

Head of a Bull, Turned to the Left, 1948
Lithograph
25 3/8 × 19 1/2
Achenbach Foundation for Graphic Art, Fine
Art Museums of San Francisco, Bruno and
Sadie Adriani Collection

Figure Composition II, 1949
Lithograph
25 3/4 × 19 5/8
The Grunwald Center for the Graphic Arts,
UCLA at the Armand Hammer Museum of
Art and Cultural Center, the Fred Grunwald
Collection

Head of a Young Girl, 1949
Lithograph
15 3/8 × 11 1/4
Achenbach Foundation for Graphic Art, Fine
Art Museums of San Francisco, anonymous
gift in honor of Dr. and Mrs. Charles Del
Norte Winning

The Small Bullfight, 1957
Color lithograph
11 3/8 × 7 3/4
Collection of J. Gary and Marsha Robb

Lancing the Bull, 1959
Color linoleum cut
20 1/2 × 24 7/8
Achenbach Foundation for Graphic Art, Fine
Art Museums of San Francisco, purchase

Head of a Woman, 1962
Color linoleum cut
25 1/4 × 20 3/4
The Grunwald Center for the Graphic Arts,
UCLA at the Armand Hammer Museum of
Art and Cultural Center, gift of Norman Granz

Head of a Woman, 1962
Color linoleum cut
25 1/4 × 20 3/4
The Grunwald Center for the Graphic Arts,
UCLA at the Armand Hammer Museum of
Art and Cultural Center, gift of Norman Granz

Head of a Woman, 1962
Color linoleum cut
29 5/8 × 24 1/2
The Grunwald Center for the Graphic Arts,
UCLA at the Armand Hammer Museum of
Art and Cultural Center, gift of Norman Granz

Woman in Hat, 1962
Color linoleum cut
24 3/4 × 17 1/2
The Grunwald Center for the Graphic Arts,
UCLA at the Armand Hammer Museum of
Art and Cultural Center, gift of Norman Granz

Woman in Hat, 1962
Color linoleum cut
20 3/4 × 25
Tacoma Art Museum, fractional interest and
promised gift of J. Gary and Marsha Robb

The Model and His Painter, 1963
Etching, engraving, and aquatint
17 3/4 × 22 1/4
Museo Nacional Centro de Arte Reina Sofía,
Madrid

Painter and Model, 1963
Etching
17 1/2 × 21 5/8
Museo Nacional Centro de Arte Reina Sofía,
Madrid

Painter Working, 1964
Aquatint, etching, and drypoint
17 1/2 × 23 1/4
Museo Nacional Centro de Arte Reina Sofía,
Madrid

In the Studio, 1966
Etching and aquatint
19 5/8 × 25 1/2
Museo Nacional Centro de Arte Reina Sofía,
Madrid

The Portraitist, 1966
Etching
17 3/4 × 22 1/8
Museo Nacional Centro de Arte Reina Sofía,
Madrid

Reclining Woman and Flute Player, 1967
Blue crayon on paper
25 5/8 × 19 3/8
Private collection

Untitled (Painter and Model), 1968
Series 347, No. 22
Etching
17 3/4 × 22
Museo Nacional Centro de Arte Reina Sofía,
Madrid

Painter and Model, 1968
Series 346, No. 231
Etching
14 1/4 × 11
Museo Nacional Centro de Arte Reina Sofía,
Madrid

Untitled (The Painter and the Model),
1970
Series 156, No. 3
Etching, drypoint, and scraping
17 3/4 × 22 1/8
Museo Nacional Centro de Arte Reina Sofía,
Madrid

Untitled (Painter, the Model and Self-portrait), 1970
Series 156, No. 4
25 × 29 5/8
Etching
Museo Nacional Centro de Arte Reina Sofía,
Madrid

The Painter and the Model, 1970
Series 156, No. 29
Etching
14 7/8 × 17 1/2
Museo Nacional Centro de Arte Reina Sofía,
Madrid

Painter and Model, 1970
Series 156, No. 43
Etching
16 1/4 × 18 5/8
Museo Nacional Centro de Arte Reina Sofía,
Madrid